Images of Plague and Pestilence

Habent sua fata libelli

IMAGES OF
Plague AND
Pestilence

Iconography and Iconology

CHRISTINE M. BOECKL

SIXTEENTH CENTURY ESSAYS & STUDIES
VOLUME LIII

Copyright © 2000 by Truman State University Press
Kirksville, Missouri 63501-4221 USA
tsup@truman.edu
All rights reserved
Printed by Edwards Brothers, Ann Arbor, Michigan USA

Text set in Adobe Garamond 11/13 by Michael Murawski

Cover: *St. Sebastian Intercedes during the Plague,* Josse Lieferinxe, 1497–99. The Walters Art
Gallery, Baltimore.

Library of Congress Cataloging-in-Publication Data
Boeckl, Christine M., 1933
 Images of plague and pestilence : iconography and iconology /
Christine M. Boeckl.
 p. cm. — (Sixteenth century essays & studies ; 53)
Includes bibliographical references and index.
ISBN 0-943549-72-8 (alk. paper) — ISBN 0-943549-85-X (pbk. : alk.
 paper)
1. Plague in art. 2. Plague in literature. I. Title. II. Series

N8243.S5 B63 2000
704.9'496169232—dc21
 00-041760

The paper in this publication meets or exceeds the minimum requirements of the American
National Standard for Information Sciences—Permanence of Paper for Printed Library Mate-
rials, ANSI Z39.48–1992.

Contents

Illustrations

Preface

I gratefully acknowledge two generous grants from the Research Services Council of the University of Nebraska, which helped me pursue my studies over the last seven years and bring this book to completion. I am also grateful to the Graduate School of the University of Maryland for granting me a dissertation fellowship in 1989 that funded the original project. A number of scholars have shared their knowledge and given me valuable information for this interdisciplinary study. My sincerest thanks go first and foremost to the medical experts: Profs. Henri Mollaret and Jacqueline Brossollet, Pasteur Institute, Paris; John Bennett, M.D., National Institutes of Health, Washington, D.C.; Thomas Butler, M.D., Chief of the Division of Infectious Disease, Texas Tech University; and Franz Enzinger, M.D., Walter Reed Hospital. In the field of theology I am beholden to Profs. Helen Rolfson, O.S.F., St. John's University, and P. Lenders, S.J., University of Antwerp. I am particularly grateful to Professor Jean Caswell, University of Maryland, for her unflagging support of my art historical research and her editorial assistance, and to Dee Fischer, who spent endless hours preparing my manuscript for the publisher. Thanks are also due to my friends Drs. Edith Wyss, Shirley Bennett, Sally Wages, Lisa Hartjens, and Norma Uemura. Further, the expertise of my colleague Professor James May, University of Nebraska, who helped me with the production of some of the photographic images, was much appreciated. Finally, I thank my family for their help and patience during the years of research and the writing of the text.

Recent interest in epidemiology has generated a plethora of publications on the history of pestilential diseases, but studies on plague imagery are rather rare. In fact, the catalogue of the Library of Congress lists only a few book titles under "Plague in Art," none in English.[1] There are, of course, numerous published journal articles and some recent dissertations that discuss plague art.

Research on bubonic plague and its relation to the visual arts goes back to Emile Mâle's studies of the 1930s. His seminal work on plague iconography

(image description) was also the first of its kind to offer iconological inter-
pretations (the meaning of images). Since then, studies on medical aspects
and plague iconography were written by physicians, such as Roger Seiler, and
the majority of publications were issued by two medical historians, Henri
Mollaret and Jacqueline Brossollet—the first scholars to investigate scientific
facts recorded in plague images. As a team they published nearly forty essays
and books dedicated to the pictorial documentation of bubonic plague and
have amassed one of the largest photo collections of plague imagery. Several
years ago I was invited to peruse their holdings and found their collegial sup-
port invaluable for my own plague studies. Madame Brossollet described for
my book some of their research experiences, the successes as well as the frus-
trations encountered in their quest. Shortly before her untimely death, she
reviewed the essay. The scientific community lost in her an energetic scholar.
I mourn a dear friend and mentor.

Jacqueline Brossollet (Pasteur Institute, Paris) on Pioneering Plague Scholarship, translated by Michelle Rayburn

For many years there was a wide gap between the history of art and the his-
tory of medicine. So, when in 1966, at the Twentieth International Congress
of Medical History, I presented twenty-four plague illustrations and demon-
strated their importance for our understanding of what the ancient epidem-
ics were like, a number of doctors mockingly asked what credence could be
given to artists, too often carried away by imagination. Several years after the
first conference, while studying three canvases depicting the biblical plague
of the Philistines—then attributed to Nicolas Poussin—I asked Anthony
Blunt's advice about some inherent differences among the paintings. My
doubts concerned the knowledge that in 1630 Poussin lived in Rome, while
bubonic plague ravaged Milan and Venice. He answered me courteously that
these "details" were of no interest to him. Yet, these "details" in the works of
artists who experienced an epidemic firsthand became the focus of our initial
research.

At the beginning of the 1960s, Professor Henri H. Mollaret, director of
the Plague Section at the Pasteur Institute in Paris and a World Health Orga-
nization expert on this disease, set out to explore the history of previous epi-
demics to better understand those experienced today. For far from merely
being an illness of Europe and the Middle Ages, bubonic plague continues to

menace humanity. Even though the staggering numbers of human fatalities of earlier times have ceased—as the result of diverse medical achievements such as hygiene, vaccination, and antibiotics that provide protection and treatment—bubonic plague remains a potential danger. Although this disease is an epizootic that primarily affects numerous species of rodents, there is no guarantee that there will not be future plague epidemics also among humans. As H. H. Mollaret has proven, its bacillus, *Yersinia pestis,* remains potent for years, buried in the soil, making the disease ineradicable.

For centuries, numerous medical treatises have studied bubonic plague but they have not provided conclusive answers to the questions raised by modern epidemiology. Since earlier doctors attributed the outbreaks to airborne miasmas or to divine wrath or to the harmful conjunctions of planets, the role of the rodents and ectoparasites was never taken into consideration. We, therefore, have searched archives and chronicles seeking information describing the illness. To overcome the paucity of information, we also have consulted visual testimony of artists who lived during an outbreak of plague, examining primary documents that reflected what their eyes had observed.

Our investigation and fieldwork were extensive, taking us to curators of museums and to *curés* of parishes. We asked them to look at painted or sculpted works they had in their care. I must admit, the responses to our first letters were disappointing, probably because the relationship of plague and the arts had not been previously established—except possibly for ex-votos. But a second mailing, specifying precisely what symbols or representations could associate a work of art with plague (the arrow, the angel with the sword, the *danse macabre,* the Madonna *Misericordia,* certain plague patrons, "the sick mother and her child," and others), produced results and allowed us to establish an important collection of photographic documentations.

To recognize which of the paintings displayed plague-related themes, we studied the above-mentioned characteristic motifs as well as sources for allegorical figures. For example, in Cesare Ripa's *Iconologia* (1603) "Plague" was described as an emaciated old woman. The personification was portrayed as such by G. LeCourt in the plague ex-voto of 1630 for the high altar of Santa Maria della Salute, Venice, and again in the Viennese plague monument erected to commemorate the epidemic of 1679. Until these types of allegorical figures were established, "plague" was indicated in other ways. The categorization of motifs became a highly amusing game for us. However, in all earnestness, the painters unknowingly revealed to us some aspects of the disease which they themselves did not even understand, since the symptoms had been ignored by the plague physicians. Often the painters represented

what they observed in the appearance of the sick, and their renderings helped open our eyes to the past. For example, not until the end of the last century did it become common knowledge that bubonic plague was transmitted by fleas. The Pasteur microbiologist P. L. Simond, while observing scars of flea bites on plague patients, established the essential role of the parasite in 1898. Yet centuries before that discovery, some artists, B. Luini, Th. van der Schuer, and V. H. Janssens, had represented these plague marks, pustules or *charbons pesteux*. From other images we learned of the existence of certain clinical forms of past plagues, such as the sudden deaths striking the participants of the Gregorian propitiatory procession painted by the Limbourg brothers, or the grave digger's bubo portrayed by J. Lieferinxe, or the pseudointoxicated state of certain victims seen staggering in the paintings of M. Spadaro, as well as many others.

In our numerous articles, as in our presentations at conventions or medical conferences, Professor Mollaret and I always based our findings on visual documentation, and we found recognition by our audiences who long ago stopped smirking. "Works of art are of infinite solitude; nothing is worse than criticism as a means of trying to understand them," wrote R. M. Rilke to a young poet on 23 April 1903. His opinion is debatable when applied to the art evoking old epidemics. Texts and images complement and reinforce one another; the mass graves of the Neapolitan Piazza Mercatello during the bubonic plague epidemic of 1656, painted by M. Spadaro, find an echo in the terrifying photographs taken during the Manchurian outbreak of 1911.

In this Dantesque hell, filled with horrifying plague scenes, I had from the beginning a Virgil as my guide to whom I want to pay homage, all the more because he seems to be somewhat forgotten—Emile Mâle. In his works on religious art from the twelfth to the end of the eighteenth centuries, he discussed the presence of plague in detail, yet simply enough for us to understand. Because the scourge was always linked to heaven, religious art advocated atonement; prayers and processions were offered to spare a certain town from plague, to ask that the epidemic cease, or to relate the thanksgiving of survivors. These acts of faith were addressed to those who were believed to be capable of appeasing the anger of God. I counted 110 intercessory saints who were credited with having played this mediating role. Paintings and sculptures for each one of them recalled the communal spirit of a certain region, in a specific year. I am well aware of the restrictions imposed on the artists by those who commissioned these religious works—the choice of the patron saints, the implied meaning of the scenes pertaining to the Church or confraternities, along with the donors' wishes—but, by the same token, these facts

also are guaranties of the documented scene's authenticity.

For years I followed my passion, cataloguing all images related to bubonic plague of the city of Venice and the Veneto. Thanks to our efforts, the director of the Fine Arts Academy in Venice, who in 1978 searched for an exhibition theme, decided on the title "Venezia e la peste." For this purpose we resurrected numerous artworks from the vaults of dusty sacristies, canvases which had been darkened by centuries of candle soot. These neglected images needed to be cleaned and restored before they could be exhibited. At times we made new discoveries, or rediscovered forgotten works; also we found images that had not been recognized previously as plague pictures. From December 1979 until May 1980, the show in the Palazzo Ducale attracted large crowds from Milan, Florence, and Rome, as the officials of Assessorato alla Cultura e Belle Arti de Venezia had predicted. Today, the exhibition catalogue, to which we contributed several chapters, is one of the few illustrated plague publications in book format. In 1994 we also published the book *Pourquoi la Peste? Le rat, la puce et le bubon,* which shows art along with documentation of modern plague epidemics.

At this point, I also wish to acknowledge the staff of Antwerp's Musée des Beaux-Arts, who showed great interest in our inquiry and gave us the opportunity to publish repeatedly in the museum's yearbook. In the issue of the 1965 *Jaarboek Koninklijk Museum voor Schone Kunsten* we summarized, in a hundred pages and sixty-eight illustrations, the main themes of plague images as well as the often unrecognized influence they exerted. I remember one of Antwerp's museum curators remarking to me that he now understood why the charitable confraternities had added another duty as a new obligation for their lay members. Until then, their charges had been to clothe the naked, to visit the prisoners, to assist orphans, to nurse the sick, to feed the hungry. After the fifteenth century, "to bury the dead" became another required "act of mercy." This duty became important because towns struck by plague found their streets littered with bodies, and the grave diggers were unable to handle the task alone.

Additionally, we helped rectify existing misinformation; for example, a panel painting by Giovanni di Paolo, dated to the mid-fifteenth century, had long been displayed in the Louvre under the title chosen by Louis Hautecoeur, *Procession of Pope Clement VI to Castel Sant'Angelo in 1348.* We knew that this was an inaccurate statement because Pope Clement VI, who indeed had been pope during the plague of 1348, lived in Avignon where the papacy resided from 1305 until 1378; he never went to Rome. In reality, Giovanni di Paolo represented the procession of Gregory I, as described in

the *Golden Legend,* which took place during the Roman plague of 590. After the publication of our article in the *Gazette des Beaux-Arts* in 1969, the Louvre agreed to modify the painting's caption. Similarly, visitors to the same museum could hear, on an audio tour, an erroneous commentary on A. J. Gros's *Napoleon in the Plague House of Jaffa.* Most likely, its author did not know that Bonaparte had made two visits to the plague-stricken, one in March of 1799, in the euphoria of conquest, the other in May of the same year, when the army was in full retreat. The commentator evoked the second visit to the hospital, while the painter had illustrated the first encounter with the plague victims. Thus there were certain discrepancies between what the spectators saw and what they heard on tape. Following the publication of our study of this canvas, in the 1968 edition of Antwerp's *Jaarboek,* the audio guide was modified. In another instance, due to his thorough knowledge of seventeenth-century medical texts, H. H. Mollaret could prove in his preface to a new edition of Daniel Defoe's *Journal of the Plague Year* (which included several illustrations) that the author had not just invented the details about the epidemic but had utilized medical documents to support his narrative. Many literary critics had dismissed the novel as pure fiction. For a long time they refused to appreciate it for what it was, a report of the tragic events which befell London in 1665.

I have always informed those who consulted our rich documents of the danger of becoming totally immersed by the far-reaching ramifications of the plague topic, which touches on all domains of life. Its diverse manifestations—often unexpected—do not exist in the history of any other illness. I have frequently expressed this by saying, "The history of plague is a subject inviting possible failure." Christine M. Boeckl has averted in her book most of the common pitfalls of the vast, interdisciplinary field of plague studies by setting rigorous parameters for her investigation, by avoiding tempting digressions, by targeting the essence of a subject both abundant and yet neglected. I have found in her publications the confirmation of what Mollaret and I originally pioneered in our own research, and I am sure this knowledge will help her readers, as it has ours, to discern more fully the meaning in plague images.

Introduction

From the late fourteenth century on, European artists created an extensive body of images which related to the devastating effects of plague epidemics. In paintings, prints, drawings, sculptures, and other media, artists produced complex and emotionally charged works about the horrors of disease and death but also about hope and salvation.

Pestilence, like death, war, and famine, is a universal theme, mentioned in numerous books of the Bible and the works of Homer in antiquity. Early literature, in both classical civilizations and Judeo-Christian tradition, equates plague with divine punishment for human transgressions. Unfortunately, no contemporary illustrations of such texts have survived—if they ever existed. Plague scenes appear late in Western art. Possible reasons for the slow development of a specific plague iconography (image description) include difficulties in characterizing the medical symptoms and, more important, the absence of the disease from Europe between the eighth and fourteenth centuries. When a virulent strain of bubonic plague arrived from Asia in the late Middle Ages, the disease remained a constant threat for the next four hundred years. Because the pathogen that caused bubonic plague was not discovered until the 1890s, many unrealistic theories evolved about its origin and infectious nature; some of them are visualized throughout the history of plague art.

The study of plague iconography is unique because it has a distinct beginning, the year 1347, when bubonic plague struck Europe with such unprecedented force that it was later known as the Black Death. It is equally remarkable that the visual tradition begun in the late Middle Ages continues until today. Thus the value of this inquiry lies in the well-defined time frame and self-contained iconographic topic.

In this book, except when specified as bubonic plague, the terms *pestilence* and *plague* are used interchangeably to denote a deadly epidemic disease. Since bubonic plague is the only major illness for which an intricate iconography was developed, its images present a special opportunity to study

1

changing attitudes toward physical afflictions. Moreover, the value of many plague subjects is enhanced by their firm dates or links to a specific epidemic, contributing to our knowledge of chronology. The works discussed range from masterpieces created by Raphael, Titian, Tintoretto, P. P. Rubens, Anthony van Dyck, and Nicolas Poussin to minor works; however, all give important historic evidence and shed light on contemporary philosophies of life and death.

Images of Plague and Pestilence pursues three goals: one, to present for the first time an overview of various sources of plague iconography; two, to select a few significant paintings dating from the fourteenth to twentieth centuries and investigate their iconology (meaning of the image); and three, to highlight the most important innovative artistic works that originated during the Renaissance and the Catholic Reformation. This interdisciplinary study of the changing iconographic patterns and their iconological interpretations opens "windows" to the past. The discussion of style is of secondary importance. However, since the images are the primary documents, I have used the periodization customary in art history.

Each chapter begins with comments on the intellectual background that shaped plague images at that time. From ancient Greece through the eighteenth century, frequent epidemics evoked traditional religious practices and even superstitions, and those repercussions can be observed in the visual arts. As long as people felt they were at the mercy of an unpredictable deity, outbreaks of plague often reversed progressive ideas. By the time of the eighteenth-century Enlightenment, bubonic plague was finally on the wane in Europe. At that point artworks dealing with the subject of pestilence showed a trend toward greater secularization.

The achievements of Jacqueline Brossollet and Henri Mollaret are recounted in the preface. At first, many of their suggestions based on medical facts were rejected by museum staff and art historians alike. Today we cannot imagine plague research without their numerous publications.

The first chapter is concerned with medical questions. It incorporates scientific knowledge gathered during the Vietnam War, when thousands of people were infected with the bacillus *Yersinia pestis*. This section includes medical photographs illustrating the disease's symptoms, which can be compared to renderings of plague buboes and other pathological evidence found in paintings several centuries old. Because the symptoms have not changed over the years, this comparison gives the viewer a rare opportunity to measure the realism expressed in individual works of art. The reader will also be able to recognize whether the artists had firsthand knowledge of bubonic

plague or merely repeated *schemata*. Ancient medical theories are scrutinized for their influence on the visual arts. Moreover, changes in religious attitudes need to be considered in order to evaluate the reason for less realistic medical illustrations in the sixteenth and seventeenth centuries.

Chapters 2 and 3 detail the development of plague iconography, which drew upon literary as well as visual sources. Both sources are of equal importance since in the West the concept of sister arts, poetry and painting, are essentially connected. The reciprocal influences are difficult to separate. Additionally, we have to assume that a vital oral tradition helped shape the imagery. This section of the book is intended to be used primarily as reference material, presenting facts and defining terms that are referred to in later chapters.

Numerous classical writers, in addition to Homer, describe plague epidemics—among them Thucydides, Sophocles, Lucretius, Virgil, and Ovid. Christian authors include Procopius, Gregory of Tours, and Paul the Deacon, who related the story of the sixth-century Justinian pandemic. Giovanni Boccaccio's *Decameron* contains the most famous contemporary secular account of the Black Death. Geoffrey Chaucer, Giuseppe Ripamonte, Daniel Defoe, Alessandro Manzoni, and Albert Camus described later epidemics. The most pertinent religious texts were derived from the Old and New Testaments, Jacobus de Voragine's *Golden Legend,* other hagiographic accounts, and plague sermons. An original feature of this study is the comparison of historic texts with later translations or interpretations that register the people's rising concern about bubonic plague.

Visual plague motifs, both religious and secular, appear in many different media. This book does not examine the entire collection of known plague objects but discusses iconographic examples from a variety of media. However, the discussion of iconological interpretations is restricted to the analysis of paintings, drawings, and prints. Some of the plague symbols trace their written sources to antiquity, others to the seventh century. The year 1347 constitutes a *terminus post quem* as artists began to invent new plague imagery. Because of the sudden and traumatic experience of the Black Death, several existing themes, such as the "Dance of the Dead" *(danse macabre)*, "Triumph of Death," and the "Madonna of Mercy" *(Misericordia)*, also were adopted and later adapted for plague subjects. Most scholars are well acquainted with Raphael's scene of the Phrygian plague that depicts a dead or dying mother with an infant at her breast. It is less well known that this sixteenth-century motif was not repeated in a plague context until 1631 when Nicolas Poussin and his followers made it emblematic of the disease.

For hundreds of years the cliché was regurgitated in secular and religious works alike, lasting into modern times. However, this figural group is by no means the only indicator that a subject deals with pestilence. Establishment of a chronology for individual motifs will contribute to more accurate dating and a better understanding of yet-to-be-discovered works of art.

The four chapters that follow examine the iconological importance of paintings created in different time periods—the macabre Black Death of the late Middle Ages and early Renaissance, the cerebral High Renaissance, and the euphoric Baroque of the reformed Roman Catholic Church. Reverberations in the postplague era, the esoteric Romantic period, and AIDS images of the twentieth century are briefly reviewed in chapter 7. The iconological analysis of chapters 4 through 7 addresses the questions when, where, and above all why plague art was produced.

The appendix includes extensive quotations from literary sources that relate to plague epidemics, although such quotes had to be limited to those that have found visual expression over the centuries. These prototypes are of particular importance because the experience of a pestilential epidemic triggers the inherent human response to rely on earlier written documents. No matter how distant in time, scripture, chronicles, or poetic treatment of similar subjects were frequently consulted to ease the tension and anxiety of the people during an outbreak of disease. These accounts extend from antiquity to modern times and make fascinating reading in themselves.

Because plague literature in general is vast, the bibliography included here must be selective. This study emphasizes the latest international discussions on plague including a variety of sources taken from Internet compilations and publications not readily available in the United States. Studies on plague *art,* on the other hand, are not as numerous as one might assume; therefore, most titles of relevant books, journal articles, and dissertations have been cited either in the bibliography or in the endnotes. It was not possible to write a book of this scope until now because much of the scholarship is quite recent. Our knowledge has been enriched by a wealth of publications ranging from popular essays on historic pandemics, triggered by the AIDS crisis, to original documentary evidence on demographics, the latest medical facts, religious practices, and more. In addition, several current scholarly articles studying specific artworks in depth have produced a breakthrough in the interpretation of plague imagery.

For discussion purposes, plague paintings are organized into three categories. The first includes votive commissions that show the Trinity, the Virgin, and saints such as Sebastian, Gregory, Roch, and Charles Borromeo,

who were invoked as healers and intercessors. Since epidemics affected a whole region rather than an individual, the votives, although the gift of a single patron, would frequently represent the entire community. Some of these works included accurate topographical details and architectural renderings of the cities petitioning God. These devotional gifts were created to assure health, give thanks, and avert future epidemics.

The second group, comprising sacred and profane works, describes the devastation of the plague. They show greater diversity than ex-votos in both design and function. Most of these narratives report events from the lives of saints who had been actively involved in comforting victims of pestilential diseases. Such images rarely functioned as devotional art but frequently proclaimed didactic and polemic messages. The relatively rare secular plague themes generally depicted cities in the throes of an epidemic. They were displayed in private art collections rather than in religious settings.

A third set is even more difficult to classify because its themes are highly symbolic. Throughout the ages the word *pestilence* has suggested many different concepts. The late Middle Ages associated plague with eschatology. In the Renaissance, after the Protestant Reformation, "pestilence" served as a metaphor for heresy. In the Baroque period, Cesare Ripa included in his *Iconologia* the description of a female personification, *Peste/Pestilentia,* thus making us aware of the allegorical aspect of the illness. During the nineteenth century, plague paintings alluded to new threats such as cholera and yellow fever. Even today, the word *plague* is used as an analogy for a threat unknown to or uncontrollable by medical science. In this sense it describes the latest scourge: AIDS.

Throughout this book, the visual and literary traditions are stressed, along with select, recurring, plague-related topics that remained constant. Much of the catalogued plague art has not been previously considered beyond a literal reading. Closer examination, however, reveals changing artistic perceptions which depended largely on the transformation of prevailing ideas. Most important, this analysis shows that the theme of pestilence does not deal exclusively with death but touches on many aspects of people's lives.

My interest in the depiction of plague epidemics originated in Austria during World War II. What impressed me most at that time was not so much the sheer horror of the holocaust but the resiliency of humanity. Since then I have continued to investigate how people of earlier periods coped under extreme pressure. I found that the survivors and the creators of plague art frequently expressed positive sentiments; the reason for these pictorial conventions are explored here.

The research for this study began in Vienna when I investigated the decorations of several important plague churches in my native city, where bubonic plague is still part of the collective consciousness. I noticed that the two imperial votive commissions, the churches of St. Peter and St. Charles Borromeo which commemorate the bubonic plague epidemics of 1679 and 1713, were filled with images of plague saints. Conspicuously absent, however, were plague scenes. In my dissertation, "Baroque Plague Imagery and Tridentine Church Reforms," I addressed the functions of plague paintings that are not devotional images. The existence of a large number of these scenes, either still in situ or torn from their original locations, caused me to examine the variety of contexts in which plague art was originally displayed. Although these paintings had been part of mainstream art, they had been largely forgotten and neglected. However, recently when terminal illness has again become a topic of interest they sparked the curiosity of the general public.

Continuing with my focus on plague subjects, I began to compare and contrast plague iconography and iconology of different time periods, expanding my topic to its present scope. In the course of this investigation, I traveled extensively in Europe and the United States to study most of the originals and almost all existing photographs. I also addressed the content and meaning of individual plague creations in a number of journal articles and conference papers. As I began to organize my accumulated data, I realized that images created during the Renaissance and Catholic Reformation offered by far the most complex and sophisticated iconological interpretations.

This book systematically investigates facets of new meaning in the visual arts, many of which are far removed from the traditional votive association that has been reported in the older literature. Furthermore, this is the first attempt to create an overview of plague art, and it is the only book written primarily from an art historical perspective. This surely will help facilitate future scholarship in this enormous field. As Louis Pasteur said, "Chance favors the prepared mind."

At a time when detailed studies dominate scholarship, this book provides a broader view of its subject. Some of the information gathered here from various disciplines and across time lines, although relevant, necessarily must be flawed by generalizations. Still, the study provides a much needed historical perspective on the research of disease in a metaphysical context.

Chapter 1

Medical Aspects of Bubonic Plague and *Yersinia pestis* Infections

The History of the Disease and the State of Modern Research

The history of bubonic plague epidemics documents some of the worst disasters mankind has ever experienced. Over the centuries, hardly a European country or even a city has been spared from that dread disease, which is a severe bacterial infection caused by *Yersinia pestis*. Modern medicine distinguishes among at least three clinical manifestations of plague: bubonic, septicemic, and pneumonic. The three forms have different syndromes; the latter two are almost always lethal, yet bubonic plague is the most common. All three types have appeared simultaneously during epidemics.[2]

Although many epidemics have been mentioned in ancient texts, medical experts have ruled out most of the earliest reports as *Y. pestis* infections because the recorded symptoms do not match the criteria that twentieth-century scientists have established for that disease. However, the World Health Organization identifies three bubonic plague pandemics that gravely affected history. The first, the Justinian Plague, infected the Mediterranean basin from the sixth to the eighth century. The second, the "Black Death," entered the European continent from Asia in the fateful year of 1347, and remained a threat for almost four centuries, killing millions of people.[3] The third, and the least publicized, pandemic of bubonic plague is still expanding. It began in East Asia around 1860, but now, because of the increased speed of travel, it has spread through Africa and both of the Americas. The western third of the United States is a known endemic area; plague foci can be found as far north as Canada.[4] Thus, bubonic plague research still occupies the medical profession. Many of the investigations were conducted during the Vietnam War; thousands of cases were reported and studied by American and French

medical teams. Most recently, the Max Planck Institut, the Insitut Pasteur, and the American National Institute for Infectious Disease Control have joined forces in studying DNA of the plague bacillus which hopefully will result in some answers more traditional research methods could not supply. Historical data, supplemented by the research of twentieth-century epidemiologists, are the bases for modern plague literature. Because the field that deals with historic assessments of earlier epidemics is fraught with controversies, this chapter will concentrate on the medical aspects of the disease as it is reflected in the imagery.

Before the twentieth century, the diagnosis of a case described as *vera pestis* (true plague, i.e., bubonic plague) must have struck everyone with fear since it was the most deadly of all known diseases. Charles Gregg observed, "As the Third Pandemic began, humanity was no better able to defend itself against plague than in the time of Justinian, thirteen centuries before."[5] This statement is not accurate because it does not take into account all the empirical knowledge that had been accumulated over those years. But as long as the causative agent and the mode of transmission of the sickness were unknown, the fight against this invisible enemy seemed close to hopeless.

Not until nineteenth-century microbiology equipped scientists with the tools to isolate the disease-causing organism could they develop effective treatments against the "unholy trinity": the rat, the flea, and the plague bacillus. Yet even after 1894 when Dr. Alexandre Yersin discovered the pathogen *Pasteurella pestis* (in 1970 renamed *Yersinia pestis*), one piece of the puzzle was still missing—how the illness was transmitted from animals to humans. In 1897, Professor Masanori Ogata established the important role the flea played as vector in the vicious cycle.[6] Soon thereafter, at the turn of the century, the frightening situation changed. The Pasteur Institute began to produce plague serum to immunize people in endemic areas.[7]

In the early twentieth century, plague victims were treated with sulfonamides. In the late forties and the early fifties antibiotics, such as chloramphenicol and tetracycline, reduced the fatality rate. Today, streptomycin is recognized as the most effective drug in combating this disease (with a number of other antimicrobial medications available in case of an allergic reaction). Until quite recently, inoculations had proven fairly ineffective because they protected for only a very short time. The current choice of the United States health authorities, the "Plague Vaccine U.S.P.," works after two series of injections at one to three month intervals; booster shots are needed every six months as long as the danger of infection continues.[8]

An important area of today's research concerns the causes for the rise and

fall of human plague epidemics. Do people only become accidentally involved in the plague cycle, or do they play a role in its maintenance and persistence? Modern medicine is inclined to deny the essential involvement of humans and tends to consider the disease primarily as a zoonotic infection. Most bubonic plague epidemics take place in the wild, such as the isolated steppes of inner Asia, and do not even affect domestic animals or urban rats. However, we now assume that an epizootic must precede or coincide with a human plague epidemic.

In fact, some historical accounts of plagues open with reports of dying animals. Medical historians continue to debate the question of whether people—other than those in Asian countries—suspected the role of the rat in outbreaks of bubonic plague. None of the European plague treatises mentioned rodents as causative agents until the 1890s. However, long before the nineteenth-century medical breakthrough, sanitary rules ordered the extermination of small mammals in cities. Moreover, although nobody in either Asia or in Europe suspected that the flea transmitted plague, fleas' unusually vexing behavior during an epidemic were documented.[9]

The debate of historic communicable diseases shows a growing number of scholars who wonder whether "bubonic plague was the only or even the principal disease in 1348 and in subsequent strikes of high mortality during the later Middle Ages."[10] They base their doubts on the lack of written observations of massive deaths among rats. A. Lynn Martin, and other scholars, have made the valid observation—and I do agree with their *caveat*—that many symptoms, including buboes, are also characteristic of other illnesses and do not give conclusive evidence of a plague epidemic.[11] However, I do have some reservations about theories that negate the existence of bubonic plague because of failure to name a convincing alternative to the long-standing acceptance of *Y. pestis* infections. Strong evidence was recently reported that supports the theory of bubonic plague infections in Europe when French scientists established *Y. pestis* DNA in dental pulp in four-hundred-year-old bodies. Also, I assume that bubonic plague was the major killer during the Black Death because of the illness's characteristic slow yet relentless movement from one region to another.

The disease arrived in Europe from Asia, where bubonic plague was and remains endemic, and spread during the years between 1347 and 1353 from the Mediterranean Sea throughout the whole continent.[12] Later epidemics are more difficult to trace, but by studying the numerous dated documents compiled by J. N. Biraben and others—often in conjunction with additional scientific facts—we can be reasonably certain that some of the transmission

patterns are those of bubonic plague. Periods with unusually high death counts often recorded the source of infection in a busy harbor town. Pandemics frequently started in European ports and spread from there in waves to the hinterlands. Characteristic outbreaks were observed during the years 1575–78, 1629–33, 1656–57, 1664–65, and again around 1720–21, to list but a few of the most infamous European epidemics after the Black Death.[13] Finally, the visual evidence presented at the end of this chapter supports the theory that bubonic plague was a real threat in Europe between the years of 1347 and 1721, and most likely was responsible for the continent's depopulation in the 1300s. Undoubtedly, none of the later epidemics can compare with the losses suffered during the fourteenth century. Acquired immunity could be responsible for the decrease of human mortality during the later sieges.[14]

A number of independent, twentieth-century studies have observed the phenomenon that dogs, the natural hosts to infected fleas, seldom died of the disease. It has been suggested that canines, over centuries, may have become immunized by less virulent strains of the bacteria. This would explain the legend that St. Roch's dog was not afflicted by bubonic plague and was said to have supplied the saint with food during his illness. Similarly, birds may have developed some immunity as well. Birds were given to children as protection against the plague.[15] For the same reason, people carried ferrets and other pets, which probably were effective flea traps—at least as long as the animal lived.

Although modern science and technology make it easier to combat bubonic plague itself, the larger cycles of epidemics among wild rodents are still uncontrollable. In sylvatic foci, such as in the southwestern United States, ground squirrels and prairie dogs are the most commonly infected animals. From these reservoirs the disease can be transmitted to urban rats, pets, or even humans.[16] Insecticides and rat control reduce the threat of transmission to man; however, killing wild rodents is self-defeating because fleas prefer animal hosts to humans. If a rodent dies and its body cools off, the flea looks for a new host. When fewer animals are available, the rat flea *(Xenopsylla cheopis)* is more apt to bite humans. *Pulex irritans* (human flea) also has been proven to be able to carry live plague bacilli for a duration of about two months, without the help of a warm-blooded host.

Bites of infected fleas are now considered to be the cause of most *Yersinia pestis* infections. Recent studies on fleas have shown that optimal conditions for their life cycle include temperatures around 23.5° Celcius (74.3° Fahrenheit) and 60 percent humidity. Hot, humid summer months usually aggra-

vate epidemics because of increased insect population. Not surprisingly, many plague-saints' feast days are celebrated in the summer.

Fleas, after biting an infected, warm-blooded creature, are unable to digest the blood because the plague bacillus causes an obstruction in the flea's digestive tract. Becoming famished, the "blocked flea" will continue to bite different hosts, regurgitating thousands of microbes into the victims' bodies. Bubonic plague has an incubation period of two to eight days. Around the site of the flea bite, cream-colored blisters develop under the skin, usually surrounded by an inflamed red border *(erythema)*. The bacteria proliferate in the lymph nodes closest to the flea bite. The patient can experience sudden chills, fever—generally between 38.5° and 40.0° Celsius, and sometimes higher—weakness, and headaches. Within a day or so, the characteristic bubo, the nodule that gave the disease its name, appears and grows larger and more painful by the hour. The swellings develop most frequently in the lymph nodes on the side of the neck (cervical bubo), in the armpit (axillary bubo), in the groin (inguinal bubo) or thigh (femoral bubo). Febrile patients are alternately listless and frantic, and eventually become delirious; also, their pulse rates increase and blood pressures decreases. Some literature recorded unusual facial expressions and an unsteady gait. Other side effects are nausea, vomiting, diarrhea, and abdominal pain. Most patients die of cardiac arrest, and, prior to death, they frequently lapse into a coma. Dehydration is common to all forms of plague, causing unquenchable thirst. Lay discussions of medical symptoms of *Y. pestis* infections generally neglect to emphasize skin lesions as a warning sign of approaching death. Dr. Thomas Butler, America's foremost authority on bubonic plague, describes this condition as "purpura" in the medical textbook on infectious diseases. This phenomenon is characterized by purple splotches which represent bleeding into the skin from inflamed, fragile blood vessels. The darkened areas appear on feet and legs and are irregular in shape, and they vary in size from a dime to a quarter.[17] I know of no artistic renderings of these skin blemishes, although such paintings might exist. Many of the above-named manifestations of bubonic plague, including swollen lymph nodes, can resemble those of other illnesses; yet, the formation of a bubo—in conjunction with other distinguishing symptoms—is fairly characteristic of this deadly disease and appears to be the one token most often depicted in art.[18]

Most important, however, is the fact that *Y. pestis* can be passed on from person to person through coughing and sneezing, as in cases of the highly contagious, secondary plague pneumonia. Cold winters often meant a reprieve from bubonic plague because the fleas died; nevertheless, in some

cases heavy losses occurred even in January through March, possibly because people succumbed to the pulmonary type. The septicemic form also kills quite unexpectedly because of a massive growth of bacteria in the blood, even before the acute stage of bubo development is reached. The incubation period in such cases lasts only a few hours and the illness almost always proves fatal. Both forms of plague can kill patients within a day, causing apparently healthy persons to collapse suddenly. This characteristic manifestation was reported in literary accounts both during the Justinian plague and the Black Death—in other words, during the first and second pandemic. Historically, the fatality rate for bubonic plague was recorded as 45 to 65 percent, depending on the surgical treatment and general health of the patient; it is now less than 5 percent. The death rate of *untreated* pneumonic and septicemic plague was, and still is, 95 to 100 percent![19]

It has been estimated that during the years between 1347 and 1353 a third or a fourth of Europe's population died, though an accurate count is impossible to achieve. Better data have been collected since the sixteenth century; by the seventeenth century, many records included the cause of death, as well as the gender, profession, and age group of the deceased. The daily death tolls within a parish were also recorded. Some medical facts can be gleaned from these statistics. There seems to have been little difference in death rates according to age group or sex *if* the chance of infection was equal. However, this was generally not the case. The privileged class had the option of leaving an infected area; they had less-crowded living conditions, and they could afford the luxury of personal hygiene. Because exposure to sick people further reduced the chances of survival, numerous religious nursing orders reported heavy losses. In contrast, cloistered nuns, who were housed in buildings where stone floors were common, lost few of their members. An important study by Dr. Lien-Teh Wu in 1936 indicated that infants under five months of age were less likely to become ill.[20] The question of a natural resistance has been debated, but the findings are inconclusive. Other theories cite the simple fact that tightly wrapped babies are better protected against flea bites. Whatever the reason may be, long before our time, artists made the motif of a dying mother, holding a healthy infant in her arms, a symbol of pestilence.

During an epidemic, urban living conditions frequently resembled those of a city under siege because communication with the outside world was interrupted. Health boards prepared strategically for an epidemic as soon as the alarming news of an approaching wave threatened the area. The services of doctors and clergymen needed to be engaged. Food had to be procured,

along with bedding, clothes, and medicine. Furthermore, lime for disinfecting grave sites had to be sequestered in great quantity; this was particularly important for areas where the ground-water level was high.

To maintain law and order during an outbreak of plague, the government appointed sanitary commissions for a certain length of time, headed by a gentleman of rank. However, by the end of the fifteenth century health boards had become permanent establishments. Physicians also were men of status. They seldom exposed themselves to patient contact; because of their higher education, the doctors appeared only in an advisory capacity. The surgeons, who performed the actual physical examinations and offered treatment, were considered socially inferior.[21] They, along with the attendants of the pest houses, the messengers, guards, and grave diggers, who occupied the lowest rung on the social ladder, were more endangered than the rest of the population.

Disciplinary actions to enforce health laws were generally the responsibility of secular authorities. During an epidemic punishments were severe because the well-being of so many people was at stake. A book on civic regulations was entitled *Gold* (for public expenses), *Gallows* (for health-law violators), and *Fire* (to eliminate infected objects). Death sentences were meted out to those who were accused of having maliciously spread the plague. People frequently looked for scapegoats; for example, in the fourteenth century, innocent Jewish communities were committed to fire because they had been wrongly accused of infecting the Christian population. However, over the years, many "Others" were found guilty of causing the deaths of their fellow citizens. As late as 1630, three men were tortured and executed because they had been blamed for deliberately polluting the city of Milan with bubonic plague.[22]

One positive result of numerous recurring epidemics was the development and building of hospitals. The Ospedale Maggiore in Milan, founded in 1456, was fashioned in part after Arabic institutions. It retained the prescribed form of cubicles built around an open courtyard. Stone floors made cleanliness easier. When permanent hospitals became overcrowded, the authorities provided makeshift, open-air plague encampments which were located outside the city walls to avoid the spreading of the illness.

Knowledge about this most dreaded disease was painstakingly gathered over centuries and generously shared by scholars who used Latin as their international language. During the Black Death and in succeeding centuries, Arabic medical books became very important for their discussion of surgical procedures. They transmitted the scientific knowledge of the Greek and

Roman physicians via Byzantine authors to the medieval West.

To inform the population about the dangers of bubonic plague, printed health leaflets, written in vernacular, were distributed or read to the residents of an endangered region. Although these city ordinances generally began with the advice to depend on God's help, they also gave medical instructions. Today, few of the suggestions would be considered adequate or even pertinent. Generally speaking, plague discourses were divided into three sections: the causes of the illness, precautionary matters, and treatment procedures. With every new epidemic some of the old proven remedies were revived and others were added, but since the cause of the plague was an enigma, and its transmission equally mysterious, progress was slow.

Opinions about theories on the causes of pestilential diseases differed throughout the ages, and many probably were misdiagnosed as bubonic plague. In a short account a chronological discussion is not possible; instead I am grouping the causes as they were perceived both as natural and as supernatural.

Most ancient authors as well as Judeo-Christian writers considered pestilence a divine punishment for human transgressions which affected the whole population of a city rather than an individual. For example, Jacobus de Voragine writes in the thirteenth century that during the first pandemic, the sixth-century Romans had caused the epidemic by their lascivious behavior. The Genoese bishop recounts in his *Golden Legend* that after a pious observation of Lent and Easter, the people of Rome lapsed into sin. He writes, "Therefore God, offended by these excesses, sent a devastating plague upon them—a malady called *inguinaria* because it caused swelling or abscess in the groin."[23]

The majority of authors stressed moral issues; only a few stated that plague epidemics depended solely on natural causes. However, pagan as well as Christian sources gave much credence to the influence of astrological phenomena, an assumption that was based on an Aristotelian prediction that under the influence of Saturn and Jupiter whole peoples would be exterminated. In the fourteenth century, for example, the unprecedented loss of lives in 1348 was blamed on a malign conjunction of three major planets, Mars, Jupiter, and Saturn, in the sign of Aquarius. Comets concurring with rainbows, also, were thought to produce pestilence.[24]

The Roman author Lucretius (c. 99 B.C. to c. 55 B.C.) expounded in his *De rerum natura* several theories on pestilence, all based on the premise that the whole universe is filled with life-enhancing and life-threatening "germs" which can cause epidemics. The polluted air can manifest itself in three ways.

First, the "germs" can penetrate from the outer atmosphere into clouds, thus annihilating the inhabitants of the region below. Second, the "germs" are formed in the earth's atmosphere which differs from country to country; some territories were considered to have more "agreeable" air than others. And finally, the "germs" develop in soil made putrid by a long rain followed by blazing sunshine. Under such conditions the "germs" were expected to rise from the ground into the air.[25]

Another medical hypothesis, expounded since the Middle Ages, explained that pestilence was transmitted by rotten air resulting from decomposing animals (and humans), the so-called miasmas.[26] Therefore, people in plague pictures are most commonly depicted protecting their noses. The assumption that the disease was transmitted by air was *not* entirely wrong because the pneumonic type can spread through inhalation of the airborne bacilli.

Numerous other theories were generated—some observations might even have contained a kernel of truth. The Bible had already associated the appearance of plague with wars. Troop movements often transmitted diseases from one area to another. People also observed that trade and pilgrimages were to blame for spreading epidemics. The Silk Road and harbors open to Asian commerce were frequently the avenues through which bubonic plague, along with other diseases, infiltrated Europe.

Plague treatises had numerous suggestions for prophylactic measures. According to plague tracts, the most important precaution was to avoid contact with sick people at all costs! In case of pneumonic plague which was transmitted from human to human, this warning is quite justifiable. Flee fast, go far, return late, was also common advice.[27] All medical recommendations suggested light and nutritious diets that included fruits and meat. Fresh air and sexual abstinence were routinely prescribed.

Other effective preventive laws were quarantines, first imposed in Venice in 1348. Because of the city's eastern location and exposure to Asian traffic, these rules and regulations were constantly updated and improved. Venice remained the city with the most progressive laws and advanced sanitary practices, which were then adopted by other European countries.

Protective garments were first invented in 1619 by Charles de L'Orme, Louis XIII's personal physician, and became customary in Paris; later they were worn more universally. Long leather or waxed-canvas gowns covered the whole body. The head was protected with a birdlike mask, its beak stuffed with fragrant herbs; modern science has confirmed that repellent aromatics are quite efficient in fending off fleas.[28] The enveloping garments protected

the plague surgeons against insect bites and made them less vulnerable to infection.

Additional protective measures were sanitary laws that decreed the burning of all personal belongings of sick people, such as bedding and clothing. The houses where people had fallen ill had to be closed for a prescribed length of time, after which they were disinfected by fumigation with sulphur or gunpowder and then aired out before they could be declared habitable. Wind, cool breezes, fresh air, and cleanliness were recognized as effective tactics against the plague. Cleaning stone floors with mildly acidic chemicals, such as vinegar, was recommended as early as the sixteenth century. Modern medical scholars have confirmed that the plague bacillus has little resistance to antiseptics, heat, or direct sunlight.

Medical ordinances also informed people of their duty to separate the sick from the healthy. Infected persons were to be reported and sent to a hospital where they were housed in different units depending on their sex and the stage of their illness. If people refused to go to the pest house, they were locked up in their own homes without help or financial assistance. Since their families also had to remain in quarantine, some people most likely starved to death even though they were not victims of bubonic plague. The few lucky patients who recovered were kept, if at all possible, in convalescent homes before they were allowed to rejoin the healthy population. They had to receive new clothing, a matter of importance but also of great cost. The wealthy had to provide money for food and care for themselves, while the secular authorities had to reimburse the institutions for the care of the destitute. Persons who had been in contact with plague victims carried white (or yellow) canes, scarfs, etc., and infected houses were marked with large Xs or crosses.

Other precautionary measures concerned the collection and disposal of the dead bodies. Rules for plague burials were established. If feasible, a deep grave was to be dug to prevent dogs from unearthing corpses. The expression "six feet under" is the result of London's health ordinance during the devastating epidemic of 1665, but deep burial plots were already accepted practices. As early as 1348, it was thought essential to wrap bodies in winding sheets and place them in wooden coffins (with lids) to protect the surrounding air from the dangerous pollution of decomposing cadavers. Although this ordinance was intended as a health measure—rather than a question of piety—the ruling did not apply to the poor.[29] Other sources document that coffins were seldom committed to the ground but utilized again and again to take corpses to the grave site. These and other incongruences are frequently

found in plague literature.

Credit for stamping out plague in eighteenth-century Europe and rid-
ding the continent of this scourge must be given, at least in part, to empirical
remedies. At that time, physicians were still fighting a phantom; therefore
precautionary measures such as quarantines, disinfection, basic hygiene, and
some surgical procedures played an important role in fighting bubonic
plague. Stringent sanitary sanctions were imposed if there was cause for con-
cern in surrounding regions. To avoid contagion, trade was stopped and
travel forbidden. The harbors were strictly patrolled; boats, cargo, and crews
had to remain in quarantine from 22 to 45 days. Wool and other textiles
were recognized as being highly suspect and gave plague the name "sticking
disease." In 1718 the eastern land routes into central Europe, were blocked
with a 2000 km border, lined with military posts and reinforced by numer-
ous watchtowers. Traders and their merchandise were allowed to pass
through designated checkpoints only after they had been cleared of any sus-
picion of infection. This sanitary cordon was not abandoned until the
1870s.[30]

Health passes were issued routinely, and forgeries could result in severe
physical punishments along with heavy fines. Since the state of quarantine
brought grave economic consequences, the authorities often persuaded doc-
tors to suppress information about illnesses. In retrospect it seems likely that
the epidemics of 1656 in Naples and 1720–21 in Marseilles, each killing
thousands of people, could have been avoided if proper precautions had
been observed.

By modern standards, the proposed cures were completely unsatisfac-
tory. Since the cause of bubonic plague was unknown, few effective remedies
were available, and even in the early twentieth century cures were inade-
quate. The most successful procedures dealt only with the symptoms of the
disease. Fourteenth-century medical practices were based primarily on ideas
about infectious diseases proposed by Hippocrates (c. 460 to c. 370 B.C.)
and Galen (129 to 199 A.D.), though neither had firsthand experience with
bubonic plague. In the late Middle Ages, medical opinions were still
grounded on theories of the body's correct humoral balance.[31]

Early diagnosis of an illness frequently involved a urine analysis to check
for discoloration. Many old manuscripts and woodcuts show doctors exam-
ining flasks, though this procedure was not limited to plague. Once plague
was diagnosed, physicians prescribed purgatives and bleeding although the
doctors were aware that such treatments weakened patients. Plague carbun-
cles could be drained by surgical incisions to advance the healing process.

Untreated, the buboes could rupture, which increased the danger of a general sepsis. Herbs, for the preparation of ointments, were discussed under "therapeutic medications." The oldest and most consistently cited medicine was Theriac. This concoction had mythological origins, and Galen specified that it was of the greatest importance for any apothecary. In the seventeenth century, Theriac existed in two forms: *Triaca di Venezia*, available only to the rich because it contained opium, and *Theriac pauperum*, comprised of less costly ingredients. Leaves of the fig tree also were considered to have curative powers.[32]

Medical Facts and the Visual Arts

I must remind the reader that all modern medical observations concerning historic epidemics are hypothetical assumptions and, as noted above, are prone to controversies. I concede that in written accounts it is almost impossible to distinguish between an outbreak of bubonic plague and other epidemic diseases. Still, even if many of the minor epidemics were caused by different bacilli or viruses, the sheer wealth of images presents overwhelming evidence of the Europeans' consistent fear of bubonic plague, the only disease for which a specific iconography has been developed. In the vast majority of plague images that I have studied, I found that if the artists depicted physical symptoms at all, they portrayed buboes; the patients seemed to suffer from glandular swellings rather than from rashlike illnesses. On the other hand, diseases that were illustrated only occasionally, such as leprosy, syphilis, and smallpox, were generally characterized by figures covered with sores.[33] Because the classic symptom, the bubo, was so frequently represented, we can assume that the continent was at times infected with *Y. pestis*, although the disease never became endemic. Therefore, I support the generally accepted theory that *Y. pestis* infections were present in Europe from the fourteenth through the eighteenth centuries. My contribution to plague research consists of providing new comparative material: medical photographs of bubonic plague patients which are juxtaposed with historic depiction of the symptoms. However, the discussion of clinical facts will have to be limited to those theories and practices reflected in the visual arts—the manifestation of the symptoms and their treatment as well as the conditions experienced during epidemics.

Many of the examples selected in this chapter are treated at length later in a different context. To reiterate, although bubonic, septicemic, and pneumonic plagues were caused by the same microbe, they manifested themselves in different ways. Therefore, the images can portray—in theory—not one

syndrome but several different ones. Since the bubonic variety had the most characteristic physical symptoms, it has been identified in literary as well as visual documents. Moreover, it was—and still is—the most common form of *Yersinia* infections.[34]

Comparisons of twentieth-century medical illustrations with historical renderings of bubonic plague victims are instructive. In the photograph of a cervical bubo (fig. 1.1), the nodule resembles in its oval shape and its placement on a young man's neck the swelling depicted in a detail of Josse Liefe-rinxe's fifteenth-century painting *St. Sebastian Intercedes during the Plague* (fig. 1.2).[35] In both, the victims tilt their heads to relieve their discomfort. A comparably realistic depiction of a cervical bubo appears in a fifteenth-century Sebastian's Chapel.[36] The fresco *Plague Scene* (fig. 1.3) represents a surgeon operating on a woman's neck. Several patients are waiting in the background. Two, a man and a young boy, have their arms raised in the typical gesture that indicates that they suffer from the intensely painful axillary

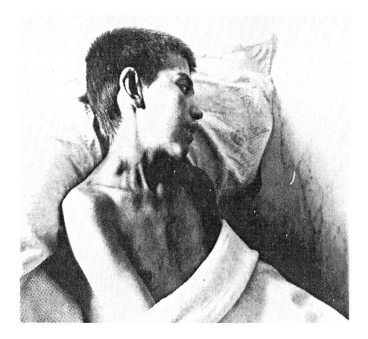

Fig. 1.1. Photograph of a cervical bubo. Collection Mollaret & Brossollet, Paris, France. Used by permission of Le fonds H. H. Mollaret/J. Brossollet.

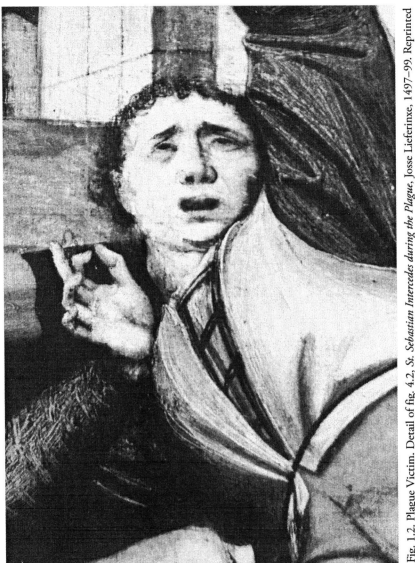

Fig. 1.2. Plague Victim. Detail of fig. 4.2, *St. Sebastian Intercedes during the Plague*, Josse Lieferinxe, 1497–99. Reprinted by permission of The Walters Art Gallery, Baltimore.

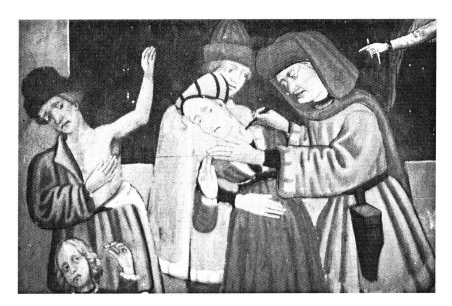

Fig. 1.3. Detail of *Plague Scene*, unknown artist, before c. 1518. Fresco, St. Sebastian's Chapel, Lanslevilard, Savoy. Reprinted by permission of The Granger Collection, New York.

infection. The photograph of an axillary bubo (fig. 1.4) shows a little crying boy extending his arm in a similar fashion.[37] The comparison reveals a startling verism in the religious painting; it seems evident that the artist had firsthand experience with plague patients.

Modern medical research concurs that the standard manifestations of bubonic plague are femoral infections because fleas are most likely to bite exposed legs. St. Roch's thigh bubo is portrayed countless times in religious paintings as well as in sculptures. Western artists recorded the different stages of the disease and some procedures designed to heal. Carlo Crivelli's fifteenth-century *St. Roch*, for example, illustrated a boil before surgery.[38] The master of the Söflinger Altar depicted the lancing of a bubo. Illustrated here is a detail of the panel *St. Roch Cured by an Angel* (fig. 1.5). The heavenly messenger drains the sore with a surgical instrument. Again, the comparison with a photograph of a femoral bubo (fig. 1.6) reveals a similarly enlarged lymph node close to the groin.[39] Numerous prints present the third stage of the healing process, the application of ointments after surgery.[40] Luca Giordano, in his *St. Gennaro Frees Naples from the Plague* (fig. 1.7), expresses the futility of medical science. The artist recorded his frightening impressions during the lethal epidemic of 1656. Only a few years

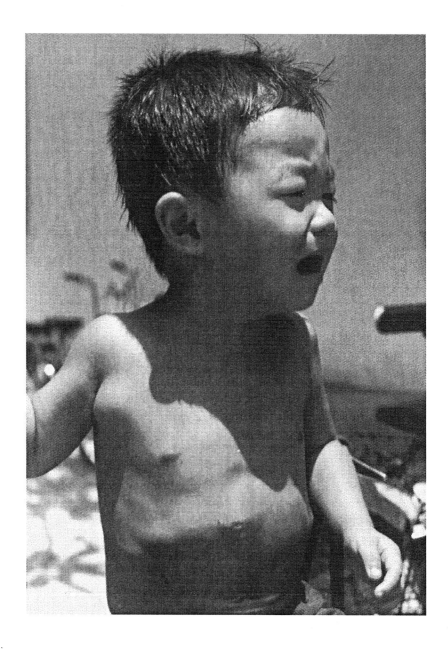

Fig. 1.4. Photograph of axillary bubo. Photograph courtesy of
Thomas Butler, M.D., Texas Tech University.

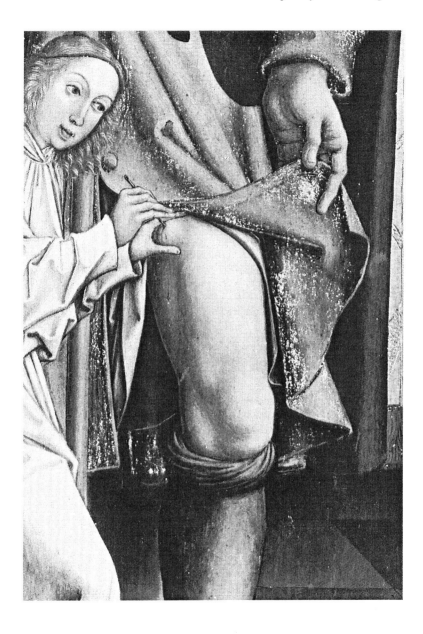

Fig. 1.5. Detail of *St. Roch Cured by an Angel*, unknown artist, c. 1490. Bayerisches Nationalmuseum. Reprinted by permission.

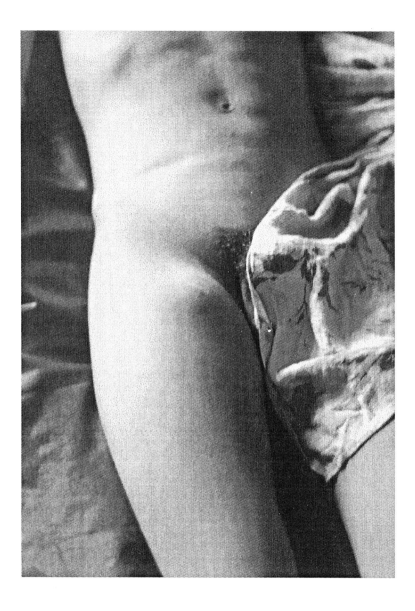

Fig. 1.6. Photograph of a femoral bubo. Photograph courtesy of
Thomas Butler, M.D., Texas Tech University.

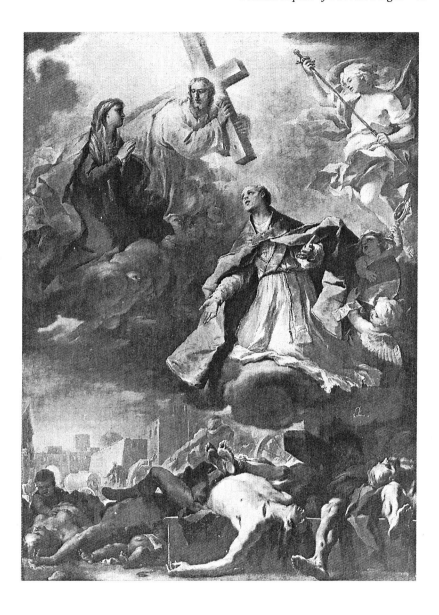

Fig. 1.7. *St. Gennaro Frees Naples from the Plague*, Luca Giordano, 1662.
Naples. Reprinted by permission of Ministero per i Beni el i Attività Culturali.

later, circa 1662, Giordano painted almost life-size, lacerated corpses in the foreground of an altar painting, displaying ghastly bubonic plague carbuncles, skin discoloration, and gashing scars of failed surgical interventions.[41]

Different from the lymphatic swellings are the inflammations or pustules that appear where the flea originally bit the victim. Medical photographs taken during the Vietnam War document these aspects of bubonic plague. In art, the pustules are best observed in a Flemish altar painting by Victor Honoré Janssens. His *St. Charles Borromeo Intercedes before the Virgin for the Plague-Stricken* depicts the symptoms on a patient's chest. Mme. Brossollet alluded to this painting in the preface.[42] Illustrations of pneumonic and septicemic plagues are difficult to identify in paintings because the sick develop few symptoms before they collapse and die.[43]

Sixteenth-century prints describe sickrooms that give us some insight into patients' care and the people's attempts to fight the feared disease. Rich and poor were affected. The woodcut *Plague Victims* (fig. 1.8) shows the interior of a hovel. A human corpse and the carcasses of dead farm animals are lying on the floor in front of a simple bed. The infirm resting on the

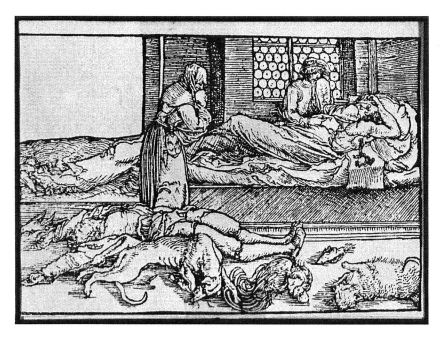

Fig. 1.8. *Plague Victims*, woodcut, from Francesco Petrarca, *Artzney Beyde Gluck* (Augsburg, 1532). Reprinted by permission of the Library of the College of Physicians of Philadelphia.

bunk is obviously infected with bubonic plague since his underarm bubo oozes pus onto the mattress. Two other figures watch, impotent and horrified, while they protect their noses against the miasmic vapors.[44]

Another illustration, taken from a medical treatise published in 1512, follows closely the suggestions of physicians' handbooks. The woodcut *Doctor's Visit to a Plague Victim* (fig. 1.9) portrays a wealthy patient and his caretakers; all signs indicate that we are looking at a person suffering from bubonic plague. The gentleman reclines in his bed, his upper body bare. The whole bedstead is raised from the ground, a move that was considered advantageous to the sick. The head of the plague-stricken man is wrapped in linens, suggesting headache.[45] To escape infection the attending surgeon with his left hand presses a vinegar-soaked sponge to his nose, and with his right hand measures the victim's pulse. Most of the attendants protect themselves from contagious air by squeezing their nostrils. On the other side of the bed, from a safe distance, a turbaned physician supervises the examination; because much of the medical knowledge had come from the Arab world, numerous Turkish doctors appear in plague scenes. A woman offers the sick man a bowl of food to keep him from losing his vital strength. A young assistant carries a container for urine analysis. Braziers were commonly depicted in plague scenes and recommended in literature as effective therapeutic measures. Although people did not know it at the time, the higher temperatures and the odor of smoke probably dissuaded fleas from settling near the flames.[46]

In the plethora of plague paintings, sacred and profane, depictions of medical doctors are scarce. However, a variety of protective garments and masks were commonly illustrated in prints. The most popular engraving was entitled *Plague Doctor of Rome in 1656* (fig. 1.10). A similar bird-beaked mask is worn by a figure in Johannes Lingelbach's *Carnival in Rome* (fig. 1.11). In this painting the plague surgeon is almost indistinguishable from the masquerading crowd; however, the rider in front of him turns in his saddle and draws the viewer's attention to the masked public servant. In the foreground, another rider, with a sign "doctor" on his back, is dressed in the costume of the *dottore*, a popular character of the *Commedia dell' Arte*.[47]

The chaotic conditions in a large city during an epidemic were depicted by the Neapolitan chronicler Micco Spadaro, also known as Domenico Gargiulo, who filled his canvas with disturbing anecdotal details. His *Piazza Mercatello during the Plague of 1656* (fig. 1.12) was also mentioned in the preface. The painting records a microcosm of suffering which the artist, who had served as health deputy, must have witnessed in person. The drama takes

Fig. 1.9. *Doctor's Visit to a Plague Victim,* woodcut, 1512. Reprinted by permission of the Library of the College of Physicians of Philadelphia.

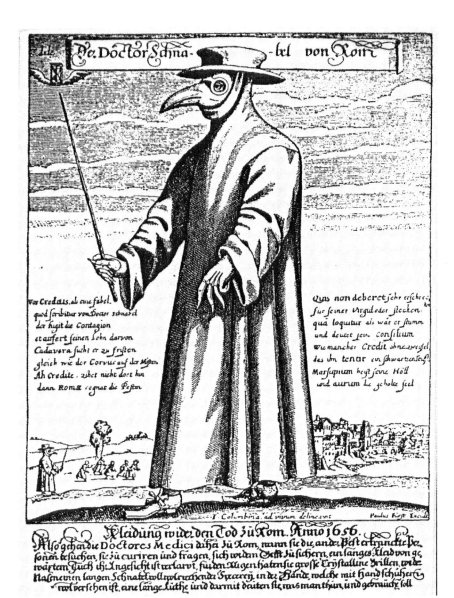

Fig. 1.10. *Plague Doctor in Rome,* engraving, P. Fürst, 1656. Reprinted by permission of Medicinsk-Historisk Museum, Copenhagen.

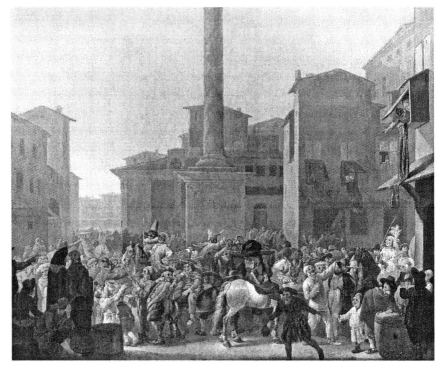

Fig. 1.11. *Carnival in Rome,* Lingelbach, c. 1656. (details below).
Used by permission of Kunsthistorisches Museum, Vienna.

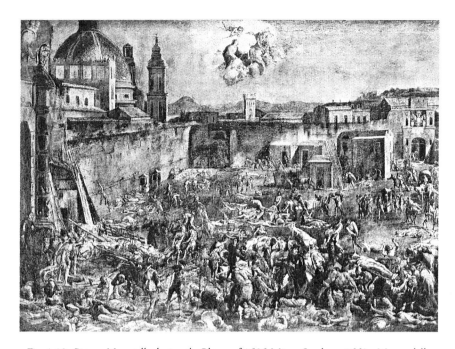

Fig. 1.12. *Piazza Mercatello during the Plague of 1656,* Micco Spadaro, 1660s. Museo della Certosa di S. Martino, Naples. Alinari/Art Resource, New York.

place outside the city walls where an official, in a superhuman effort, directs galley slaves to clear the area of decaying corpses. The workers wear muzzles over their noses to protect them against polluted air as they drag the bodies with ropes and other crude implements.[48] Many of the plague-stricken have collapsed in the foreground. Each individual group of people tells of another tragedy. For example, a woman—forsaken by all—is shown about to give birth. Since this motif appears in many of the secular plague paintings, it must have been based on real observations. Twentieth-century medical studies have sustained the findings that almost all pregnant women miscarry at the onset of a plague infection.[49]

Sampling of Western art established visual proof that bubonic plague was perceived as the most horrendous threat to humanity, an idea frequently expressed in historic documents. At times people believed that, as an act of God, many life-threatening illnesses could turn into the dreaded bubonic plague. It seems that over the centuries, the disease's physical symptoms became the *symbol* of these frequent scourges. Therefore, by the fifteenth century, the characteristic buboes were included in the traditional plague

vocabulary; so were the gestures of avoiding miasmic air, the postures of raising an arm to relieve pain, and the depiction of sudden death. It is difficult to assess how many of the art objects portrayed plague symptoms since much of the material was lost over the centuries. However, we know that many Catholic villages had a chapel, and numerous cities had at least one church, dedicated to therapeutic saints. For the art historian, knowledge of major epidemics' dates and in what regions these visitations occurred are of importance. Yet our awareness of medical facts only prepares the foundation for understanding the complexity of plague iconography. The next two chapters will investigate the roots of the rich pictorial tradition and its literary sources which contributed further to the formation of this unique subject in art. Consideration of all these elements is needed in order to gain a deeper insight into plague imagery.

Chapter 2

Literary Sources of Plague Iconography

Throughout the iconographic discussion in this book, the terms *plague* or *pestilence* denote a lethal epidemic disease but not necessarily bubonic plague.[50] This chapter on written sources, and the following one on the origins of the visual material, present facts and define terms applied in later chapters. Literary texts are especially important in Western art because figurative paintings were frequently based on a specific quotation taken from a printed text. Jürgen Grimm maintains that the topos "pestilence" in literature was primarily Mediterranean, with the exclusion of the Spanish peninsula. Generally speaking, a lack of literary tradition in a particular region also corresponds to a paucity of plague subjects in the visual arts.[51] Although it is sometimes difficult to avoid repetition in the discussion of the two sources, the textual and pictorial roots need to be considered as parallel developments. Furthermore, within European culture, one must assume that a persistent oral tradition helped shape the thoughts and artistic ideas presented in plague images. In discussing plague iconography, the art historian has to ascertain, first and foremost, how a specific plague text might relate to an already established visual tradition.

Times of pestilence have always placed an extraordinary strain on ethical behavior; therefore, some of the ancient plague literature contains philosophical and religious discussions. Certain topics were already established during the Greco-Roman era and frequently repeated in later years. The questions most often raised concerned the origin of the disease and the meaning the scourge held for the populace. Many authors commented on the reaction of the people who had been struck by an epidemic. Ages ago, writers noted the omnipotence of contagious diseases and the equality of human beings as they faced death. They lamented the breakdown of family life, abandonment by spiritual authorities, the lack of medical attention, and the disregard of burial

customs. Numerous poets, by choosing this subject, used pestilence as a literary genre and the horrifying events as a foil to explicate their views on life and death. For these reasons, it seems, many books on plague contained similar themes. Since these primary sources were seldom written during an epidemic, they cannot be the eyewitness accounts they often claimed to be. The latest research shows that even Boccaccio most likely was absent from Florence during the carnage of 1348.[52] Therefore, since few anecdotes can be taken at face value, one must use caution in judging the authenticity of the reports. Each new recurrence of an epidemic caused people to look back to earlier literary traditions. This can be observed during all ages. Reprints and special editions of older plague texts frequently coincide with the dates of major epidemics, when the news of an outbreak in another part of the world rekindled an interest in the subject. Similarly, Europe's nineteenth-century cholera epidemics, the many casualties of bubonic plagues during the Vietnam War, and now the new threat of AIDS, stimulate research on the history of epidemiology. Humans tend to cope with overwhelming experiences by reverting to testimonies of earlier generations.

In seeking historical accuracy, one is best served by reading between the lines of medical treatises, city ordinances, death records, last wills and testaments, diaries, and bank transactions, as well as the Roman Catholic Church's instructions to priests on procedures during an epidemic, evidence that did not have its own hidden agenda to alter the truth. However, the purpose of this book is not to reconstruct the conditions that existed during any particular epidemic, but to describe the sources for the complex, elusive plague iconography, to examine the facts, and to note to what extent literary accounts inspired painters and sculptors. This chapter presents the most important historic, fictional, and religious writings dealing with pestilence. The passages that have contributed to the formation of plague iconography are cited verbatim in the appendix. Other quotations are included in the text in order to elucidate the circumstances and ideas implied in some of the imagery. In short, these passages supply the reader with the information needed to interpret the images correctly. The original dates of the publications are not as important as evidence that these sources were available to the artists; for example, many ancient authors were quoted only in paintings between the sixteenth and the twentieth centuries. In this chapter the discussion of the text sources is further divided into two categories, sacred and profane, because the artworks' functions reflected a similar dichotomy.

Secular Texts

Ancient writers in Greece and Rome

None of the ancient texts had contemporary plague illustrations. Homer's *Iliad* contains the earliest mention of pestilence in Greek literature (see appendix). His description of the plague sent by Apollo to avenge Agamemnon's rape of Chryseis emphasized the death toll in the camp which kept Greek funeral pyres burning. Sophocles, too, in *Oedipus the King*, explained the pestilential epidemic as the result of human transgressions. In Oedipus's case it was a heresy, that of disregarding divine oracles, which angered Apollo. The intent of the play, most likely written in the wake of Athens's Great Plague in 427 B.C., was to argue for the necessity of reestablishing older religious customs.[53] The Greeks believed that the arrows of the Delean god caused illness and death, imagining Apollo as the avenger, the purifier, and the healer since they also prayed to him to grant relief from pestilence.

Thucydides, also writing in the fifth century B.C., describes an epidemic in the *History of the Peloponnesian War*. He was the first to use a documentary approach when reporting disease. The clinical descriptions are invaluable not only for medical historians—although the nature of the illness remains a mystery—but for accounts by later authors, many of whom seem to echo Thucydides's observations. For example, the horror that the author felt when he saw corpses left to rot without proper burial would be repeated over and over again in plague literature. Even as late as 1720, during the last major European epidemic, Bishop Belsunce of Marseilles wrote to his congregation during their ordeal, "we have seen all the streets of this great city at the same time bordered on each side with dead bodies half corrupted...all the doors of the churches obstructed with heaps of putrid corpses."[54] Thucydides also mentioned the impiety of pleasure-seeking survivors—a topic restated by Boccaccio, among many others.

The Roman historian Livy listed numerous epidemics dating back to the fifth century B.C. His writings, too, would influence medieval authors but not necessarily the visual arts. Ovid, in the *Metamorphoses*, mentions two different epidemics. The poet described The Plague of Epirus (Aegina) in book 7, and, at the end of book 15, he told how the Romans came to honor Aesculapius's cult (see appendix). However, only in a few isolated instances are these two passages illustrated in art. Virgil, on the other hand, inspired Raphael in the sixteenth century to design the *Plague of Phrygia*, which became the most influential of all plague pictures. The scene was taken from a passage in the *Aeneid* (see appendix). Virgil recounts a mythical epidemic

experienced by Aeneas on the island of Crete. The incident, however, is not to be understood as punishment but rather as divine counsel to compel the Trojan refugees to search further for the promised homeland, resulting in the founding of Rome. Grimm compared the pagan story with the events in the second book of Samuel, maintaining that a similar Messianic message concerning the House of David was related in the biblical text, which is discussed below along with other religious plague topics.[55]

Medieval literature

The first authenticated medical account of the sixth-century bubonic plague is found in Procopius of Caesarea's *History of the Wars*. A number of historians, such as Paul the Deacon and Gregory of Tours, described the Justinian pandemic in Italy and France.[56]

The most famous secular masterpieces written after the Black Death include Giovanni Boccaccio's *Decameron*, describing the plague in Florence (see appendix). The influence on the visual arts of Francesco Petrarca's poem *Triumph of Death*—probably composed after his beloved Laura had succumbed to pestilence in 1348—is yet to be determined. Another written source on plague is Petrarca's letter to his brother discussing the ethical and moral aspects of an epidemic, showing his sustained interest in that subject.

Among the earliest illustrated chronicles dealing with the Black Death in the north are the annals of Gillis li Muisis's *Antiquitates Flandrae ab anno 1298 ad annum 1352* (written between 1368 and 1400) and Giovanni Sercambi's *Chronicle* (written in Italy c. 1400). Although over the centuries many medical treatises were composed, few of them influenced the arts. One of the most interesting tracts was published in 1363 by Guy de Chauliac, a doctor who contracted bubonic plague but survived the attack.[57]

The seventeenth through the twentieth centuries

Emblem books, on the other hand, exercised a great deal of influence on plague iconography, in particular the countless editions of Cesare Ripa's *Iconologia*. However, the first illustrated version published in 1603 still did not include a picture of the allegory *Peste;* in fact, she was not portrayed in Ripa's emblem books until the late eighteenth century. Thus, the written description is primarily responsible for the allegory's appearance in the visual arts (see appendix). Ripa described the disease as an ugly, old hag with pendulous breasts, veiled by dirty clothing. It is significant that this emblematic discussion mentioned dark clouds—miasmic air—that crowned *Peste's* head. The emphasis on clouds seems to combine a long-standing eschatological tradi-

tion with some conjectural scientific theories on pestilential vapors. I will return to the importance of clouds as signifier of plague in the discussion of the pictorial sources.[58]

Plague fictions written by Daniel Defoe and Alessandro Manzoni were both based on seventeenth-century primary sources. The English novelist's *A Journal of the Plague Year: Written by a Citizen who continued all the while in London* has been widely read, then as now. The book was first published in 1722 when the news of Marseilles's epidemic reached England.[59] Defoe, who chose to write in the first person singular, was only a small child in 1665 when the events of the *Plague Year* were supposed to have taken place. Still, a six-year-old would have been mature enough to remember the dramatic impact the plague had on the city. Defoe used authentic sources, such as the *Diary of Samuel Pepys,* bills of mortality, and other evidence to establish the progress of the disease in London's inner city, the suburbs, the harbor, and the adjoining regions (for Pepys and Defoe, see appendix).

In contrast to Defoe's timeless tales, Manzoni's *The Betrothed* has lost some of the popularity it once enjoyed. The nineteenth-century novel, too, was based on historic documents, most significantly on the accounts in Giuseppe Ripamonte's *La peste di Milano del 1630,* published in 1641. Manzoni's work was particularly popular after World War II, when the experience of the plague was equated with the disasters of the recent war. Although Defoe's and Manzoni's texts were illustrated, few images influenced the fine arts. Furthermore, Albert Camus's *La Peste* inspired only a South American movie version. The 1992 production is loosely based on the novel as well as on Camus's political allegory *L'État de Siège.* It has not been established whether or not Edgar Allan Poe's story, "The Masque of the Red Death" (measles?), influenced James Ensor's macabre imagery. The list of modern plague texts relating to images would not be complete without mentioning Jean Louis Schefer's *Le Deluge, la peste de Paolo Uccello.* In this case, the postmodern deconstructivist's discussion of disasters and human fears is based on an existing image of Uccello's *Flood* (c. 1450) rather than on an illustration of an epidemic. Yet Schefer appropriated numerous plague accounts from Lucretius to Defoe in order to give the reader a sense of the magnitude of such a catastrophic event.[60]

Religious Texts

The Bible

The Judeo-Christian tradition can be explored through the pages of scripture, where the word "pestilence" appears frequently as *deber* in Hebrew, *loimos* in Greek (for quotes, see appendix).[61] The only passages commonly illustrated were 2 Samuel 24:10–25 and 1 Chronicles 21:1–28, recounting King David's story that relates how the ruler sinned against God's commandment (see appendix). However, the biblical account is less concerned with pestilence than with David's mission to prepare for the building of the temple in Jerusalem which was erected by Solomon on the very site where his father had raised an altar to commemorate the end of Israel's plague. Grimm suggests that an analogous *Zeitgeist*, prevalent in the first century B.C., fashioned Virgil's epic and the revisions of the Old Testament story. Because of the epidemic, the destiny of the Romans changed; similarly, David's deeds foreshadowed Christianity.[62]

On the other hand, Job's illness (Job 27:15), although sometimes translated as pestilence, was rarely, if ever, associated with bubonic plague because God had not sent an epidemic; Job was tested as an individual. In fact, St. Job became the patron saint of the syphilitics because he was generally depicted covered with sores.

The Ten Plagues of Egypt, divine retribution against Israel's enemies, too, were at times described as pestilence (Exod. 12:29–33). The last of the trials—death of the firstborn males—led to the institution of Passover; there is at least one plague monument that associated Passover with plague.[63] What is more important for the formation of plague iconography is the fact that the Plagues of Egypt entered into the language of apocalyptic literature and inspired parts of the descriptions of the events in the book of Revelation.

The New Testament was the source for yet another important plague topic: pestilence to herald the day of reckoning. The paramount importance of the eschatological theme in plague literature and thus in the visual arts cannot be sufficiently emphasized. According to Mark 13:28, Matthew 24:32, and Luke 21:25–27, pestilence, along with war, earthquakes, and famines, will precede the Last Judgment (see appendix). All three evangelists mentioned these ominous signs, just before their account of Christ's Passion. When Jesus predicted to his faithful the final days on earth, he followed the account with a parable: "From the fig tree learn a lesson; when it greens people know summer is approaching." Christ continued to stress the need for watchfulness "as for the exact day or hour, no one knows it … but the Father

only" (Matt. 24:36). In early Christian times and before the year 1500, there might have been real expectations that after an epidemic the world would come to an end. Later, however, the fear of immediate millennial retribution was supplanted by a sense of unpredictability of the exact moment the world would end. The theme of pestilence was merely used to raise awareness of the time when the Son of Man would be coming on a cloud. The biblical texts are responsible not only for depictions of clouds but also of a fig tree. Both chiliastic symbols have only recently been recognized as part of plague iconography.[64]

In the years following 1347, the Greek word *thanatos* (death) was frequently translated as "pestilence." Therefore, soon after the Black Death struck, the eschatological view of John's Revelation was interpreted as plague-related, even though the disease was not originally mentioned in the Bible. Of particular importance for the arts is the Apocalyptic Rider brandishing a bow (Rev. 6:1–8), although the figure was not always associated with plague. However, a very similar Old Testament text warned about four divine punishments—which could have inspired artists to use the archer on horseback to represent plague: "For thus saith the Lord: Although I shall send in upon Jerusalem my four grievous judgments, the sword and famine and the mischievous beasts and the pestilence" (Ezek. 14:21–22).

The book of Revelation also suggests the motif of "pouring of bowls which caused festering boils" (Rev. 16:2). Moreover, the opening of the Seven Seals (Rev. 6:1–17; 8:1), the Seven Last Plagues (Rev. 15:1–2; 18:8; 21:9), and probably those verses that mention winds, *all* may have contributed to link pestilence with the end of time (see appendix).

The last major revision of an Old Testament passage concerning bubonic plague occurred after 1630, when a severe outbreak infected most of Italy. Until then, sixteenth- and seventeenth-century Bible commentaries explained the ailment that struck the Philistines for capturing the ark (1 Sam. 5:4–6) as dysentery. Nicolas Poussin's *Plague at Ashdod* suggested a new reading. The rodents Poussin depicted in 1630–31, were mentioned only in some vernacular translations of the book of Samuel (see appendix). The rats have sparked a scholarly debate on their significance in describing bubonic plague in the seventeenth century.[65]

Hagiographic literature

Of all religious writings, apart from the Bible, the most influential textual source for the development of plague iconography was Jacobus de Voragine's *Golden Legend*. In the late Middle Ages, the only book more widely read was

scripture. It is important to remember that the Genoese archbishop's thirteenth-century biographies of saints predated the experience of the Black Death. However, since it was the only readily available Latin source that recounted at length the experience of the first (Justinian) pandemic, its text lent itself well to express the recurrent experiences in 1347. The *Golden Legend* was translated in the middle of the fourteenth century into Italian and other modern languages; thus the stories became accessible to a large number of artists. Although after the Council of Trent (1545–63) the Roman Catholic Church discouraged the reading of the *Golden Legend*, the book's continued influence is noticeable, particularly in plague subjects. Possibly because of frightening cholera epidemics in the second half of the nineteenth century, interest in Voragine's texts and its imagery was revived. The most important plague saints discussed in the *Golden Legend* were Sebastian and Pope Gregory I.[66] See the appendix for the texts, and for further discussion of the *Golden Legend's* importance for plague iconography, see chapter 3.

To research the iconography of any specific plague intercessor, one should consult the Church's own records, the *Acta Sanctorum* (1613–1867) and a more modern version, the *Biblioteca Sanctorum* (1961–1987).[67] Individual biographical details are often essential for the interpretation of the lives of plague patron saints as depicted in art. Sometimes the study of canonization processes and contemporary biographies can be of help to the art historian (see appendix).

Plague saints are legion.[68] A comprehensive discussion of all known intercessors would far exceed the format of this book; a few prototypes— each characteristic of a specific era—must suffice. Over the centuries, next to SS. Sebastian and Gregory, the legendary St. Roch enjoyed the most widespread popularity in the fight against pestilence. In contrast to Roch, Charles Borromeo was a well-documented historic figure who had gained his reputation as healer during the bubonic plague epidemic in 1576–78. A more comprehensive discussion of saints is presented in the next chapter.

Plague sermons

Although recorded plague sermons are relatively rare they constitute an invaluable resource for the religious interpretation of specific time periods. The most important among the earliest Christian authors who wrote on pestilence is Cyprian, bishop of Carthage. His *De Mortalitate* is presumed to have been delivered as a sermon during an epidemic. Cyprian started the chiliastic tradition, although he did not quote the evangelical passages discussed above. Nevertheless, eschatology became one of the long-lived themes

that influenced plague pictures. Cyprian explained the plague of A.D. 251–53 as one of the signs Christ had prophesied to indicate the end of time, "The kingdom of God, beloved brethren, has begun to be at hand," implying that the just are called to refreshment while the unjust are carried off to torture.[69] This prediction would have meant a joyful event for the persecuted Christians.

Of equal importance for later writers is Cyprian's appeal to his faithful not to neglect the Christian duties during a time of trial and tribulation:

> How suitable, how necessary it is that this plague and pestilence, which seems horrible and deadly, searches out the justice of each and every one and examines the minds of the human race: whether they will care for the sick, whether relatives dutifully love their kinsman as they should...whether physicians do not desert the afflicted begging their help...whether the rich, even when their dear ones are perishing and they are about to die without heirs, bestow and give something.[70]

Standard motifs in plague scenes are people nursing the sick and giving alms to the poor.

Eusebius, bishop of Caesarea, commented on yet another recurrent theme in Christian plague literature when he quoted from a letter of Dionysus, bishop of Alexandria, saying that those who give their lives in the service of others during a plague epidemic die "a form of death...little short of martyrdom," a thought that would be repeated in Catholic literature as long as bubonic plague ravaged Europe. This axiom was mentioned in numerous papal indulgences throughout the centuries.[71]

The importance of appearing before the stern judge without having had a chance to confess *(mors malo)* is stressed by the Catholic Church. Pope Gregory's famous plague sermon *(oratio)*, recorded in Gregory of Tours's *History of the Franks*, expressed these worries:

> May our sorrows open to us the way of conversion: may this punishment which we endure soften the hardness of our hearts.... Behold how all the people are smitten by *the sword of divine wrath;* one after another they are swept away by sudden death. No gradual sickness cometh before death, but as ye behold, death forestalleth the slow steps of sickness. The blow falleth; the victim is snatched away before he can turn to bewail his sins and repent. Consider therefore,

in what guise he shall appear before the stern judge of all, having no respite in which to lament his deeds.... Let every one of us therefore betake himself to lamentation and repentance before the blow is fallen.... Let us recall before the mind's eyes all that in which we have gone astray and done amiss, let us chastise ourselves with tears for all our evil acts.... Let no man despair by reason of the immensity of his offenses.... Let us therefore change our hearts.... *For God is full of mercy and loving-kindness.* [emphasis on the two sections added][72]

It is noteworthy that Christian plague sermons, throughout the ages, stressed contradictory concepts of the Supreme Being. This dichotomy derived from the God described in the pages of the Old Law who will strike his people "by the sword of divine wrath" and "God is full of mercy and loving-kindness," mentioned during the time of Grace. On the other hand, pictorial plague rhetoric *always* chose one image over the other. From the fourteenth through the sixteenth century the stern and vengeful Godhead was emphasized. The message of a loving God was not visualized in plague scenes until the positive images of the Tridentine world became popular in Italy around 1600 and spread from there to the north.

During the late Middle Ages, plague sermons frequently compared the bane with Noah's times, since Christ had warned not to repeat the sins of the people before the Flood (Matt. 24:37–38). The *exemplum* was used repeatedly in plague sermons to equate the devastating effect of the high number of lives lost. Most important, the didactic value of the typological analogies of God's wrath and his punishment for human sins during the Old Law could then be related to more recent events.[73]

In the modern era, we know of no sermon delivered orally that was immediately committed to paper during an epidemic. For example, St. Charles Borromeo's famous plague epistles of 1576–77 have not been preserved. Obviously, his faithful staff was too busy caring for the sick to document the long sermons preached by their pastor. We have further proof of sermons to be published after the disaster in the case of the great preacher Abraham à Sancta Clara, who had given courage to the devastated imperial city of Vienna in 1679. He did not publish his book on the plague experience, *Mercks Wienn,* until a month after the epidemic had ceased.[74] Although his writing may not have influenced the arts in a decisive way, it is helpful for the understanding of religious ideas of that time period. These two examples would suggest that the earlier plague sermons, too, might not

have received their final form until the epidemics had subsided.

Bishop Belsunce's printed plague letter, dated 28 October 1720, was addressed to the diocese of Marseilles. It was to be read or posted "the earliest day possible."[75] The episcopal sermon reflects a new era in church history. Since for health reasons large assemblies were discouraged, the reading of prepared texts had to be postponed until it was safe to congregate. Again, Belsunce's sermon is more valuable as a historic document than as a source for the arts; however, the bishop's proclamation of the new feast of "the sacred heart of Jesus," is shown in some history paintings, proving once again that the written word was essential in developing plague pictures (see appendix).[76]

Liturgical Texts

Another theme closely related to pestilence was that of the eucharistic sacrament. Immediately after the Black Death struck, a rise in demand for masses and communions was reported.[77] The importance of the Corpus Christi theme can be seen already in fifteenth-century works and increases after the Council of Trent. Many of the Baroque plague scenes were based on religious ceremonies described in the *Rituale Sanctorum Gregori XIII* (1584–1602) or *Rituale Romanum*, sometimes abbreviated as the "Rubric."[78] This official Roman publication on sacraments, rituals, and prayers was known to clergy and informed laymen. The plague narratives' close adherence to the *Rubric* make them historical records, not because they give us a journalistic account of the situation in an infected city but because many of the rites were no longer practiced after the revisions of Vatican II went into effect.

Plague Prayers and Poems

Prayers written on ex-votos or broadsheets *(Pestblätter)*, litanies, and poems should be studied because their wordings may be important for shedding light on individual artistic creations.[79] Also, the text may contain a date in the form of a chronogram. On the other hand, not all literary sources emphasizing the power of death have to deal with plague. For example, it has been assumed that Jean le Fèvre's poem *Le Respit de la mort* was inspired by the plague epidemic of 1374. However, recent scholarship shows that the poem in which the word *macabre* first appeared in the line: "je fis de Macabre la danse" was written by the poet after an undisclosed grave illness in 1376.[80] Le Fèvre's elegy was made visual in the Cimetière des Innocents in Paris in 1424—which, incidentally, was *not* a major plague year. This suggests that

the popularity of the *danse macabre* (Dance of the Dead) was not directly related to bubonic plague epidemics; the theme had probably been established before 1347, though its origin is far from certain. Since there is no proof that the imagery of the *Dance of the Dead* was based primarily on the experience of the bubonic plague, this theme will not be treated in detail.

Chapter 3

Visual Sources of Plague Iconography

Although the topos pestilence was well established in ancient and medieval literature, there was no equivalent in the visual arts. Plague iconography, images relating to an epidemic, did not exist before the momentous year of 1347, when the Black Death began its lethal march across Europe. At that time artists began to create a rich pictorial language describing the traumatic experience. At the same time, already existing religious subjects not related to pestilence, such as the Madonna of Mercy *(Misericordia)*, the Triumph of Death, and the Dance of the Dead *(danse macabre)*, became imbued with new meanings. However, this discussion focuses on the new images that denoted "plague" and mentions traditional themes only in passing.

Although we have a date for the emergence of bubonic plague imagery, it is difficult to analyze the multilayered symbolisms, diverse semantics, and visual associations that contributed to the evolution of this theme. This chapter covers the nonverbal, visual traditions of symbols related to pestilence along with numerous figurative inventions. It also discusses the iconic saints, the compositional schemata of ex-votos, the narrative scenes that describe the devastation brought about by an epidemic, and finally, plague allegories.

The following enumeration of plague-related symbols has been gleaned from the study of hundreds of photographs and original artworks. It is difficult to avoid some repetition because the material found in the written sources and the visual presentations frequently overlapped. Yet, as noted earlier, artists could assume that their viewers were cognizant of the fact that poetry and painting competed with one another. Typically the individual iconographic features were appropriated from miscellaneous sources and mutually influenced one another; religious, scientific, and popular explanations augmented the pictorial legacy. This chapter, as the previous one, is

intended to explicate some of the methodology and assist in quick references of terms.[81]

For the art historian the awareness of the date, the place of origin, the choice of subject, and its implications are most helpful in deciphering and interpreting plague pictures *(Pestbilder)*. Frequently, plague commissions displayed dated inscriptions, thus supplying information about a particular epidemic. Additionally, establishing the chronology of an individual motif (the year of its invention—if known—and changes in usage) provides new clues for understanding plague imagery. Admittedly, most of the plague signifiers have already been identified, yet modern research has neglected others.

There cannot be any doubt that the introduction of printing techniques played a decisive role in the evolution of the subject and the establishment of pictorial conventions. This chapter illustrates some of the most important graphic designs that helped proliferate the imagery. However, the subjects presented in prints often differed from those in the fine arts (painting and sculpture) because of the dissimilar functions ascribed to them.

Plague Symbols, Attributes, and Gestures

The formation of a visual plague idiom, developed during the late Middle Ages, depended largely on eclectic sources: classical myths became laced with Judeo-Christian terminology, scientific observations with folklore. Interestingly, this medley of ideas would survive for hundreds of years. The oldest emblematic sign of pestilence, the arrow, may have its origin in Greek mythology. Antique literary sources describe Apollo and his sister Diana shooting plague arrows to punish humans with a pestilential disease. However, long before the Black Death, this symbol became suffused with Christian meanings. Although the reason for the Christianization of arrows is still debated, it could have been aided by stories about early martyrs, such as Sebastian and Christopher, who suffered for their faith by attacks of pagan arrows. These saints were invoked as plague intercessors as early as the sixth and seventh centuries. Moreover, arrows as divine punishments appeared already in Judaic literature, although not associated with pestilence. For example, we read in Psalm 37: 2–4, "for thy arrows are stuck in me."

In scripture, the sword is frequently mentioned in connection with pestilence. Arrows, swords, lances, and sometimes hatchets were used to symbolize God's wrath. Images of God the Father, Christ, the Virgin, or even saints holding three or more arrows are not uncommon. Angels and demons, too, can wield weapons. The specific number—three arrows or spears—is derived from the *Golden Legend* (Vision of St. Dominic) combined with the

visual sources found in the *Speculum humanae salvationis*.[82] Both compendia predate the arrival of the Black Death, and the three weapons merely indicated God's displeasure with mankind. After the middle of the fourteenth century, the three arrows became associated with the Davidian Plague.

Darts and arrows falling from heaven—as described in the *Golden Legend*'s chapter on St. Gregory—often indicated plague.[83] At times the shower of arrows is intercepted by the cloak of the Madonna of Mercy, or by a saint, most commonly St. Sebastian. Bundles of arrows, resembling Zeus's thunderbolt, also were interpreted as the Lord's punishment (Ripa's *Flagello Dio*). Another token of divine retribution was the flagellum, a whiplike instrument which originally referred to medieval flagellants. These self-appointed fanatics tried to stop plagues by appeasing God through self-chastisement. Later, the instrument itself signified pestilence.

Death as a metaphor for plague was popular in medieval art and expressed *memento mori* (remember, you will die).[84] Its symbols—skulls, skeletons, scythes, crossed bones—are, by and large, indistinguishable from death iconography. In the Middle Ages, and in later periods as well, plague-related subjects made references to eschatology: pouring of liquids from containers; *arma Christi* (instruments of his passion and his wounds); signs of Christ the judge: sword and lily, rainbow, scroll and the *signa magna* (eclipse of sun and moon, falling stars, earthquakes, fiery rain from heaven, and other events mentioned in the Apocalypse). Clouds, on which the Son of Man will appear on judgment day, are also an integral part of plague iconography. Dark clouds, indicating pestilential air, are sometimes illustrated in secular works as well because so many treatises emphasized plague clouds. In fact, in classical Roman texts, we read that Phoebus [Apollo] dispelled plague clouds. These manifestations, along with the depiction of an isolated fig tree, appear frequently in Renaissance art.[85] In both cases one finds a synthesis of natural and supernatural explanations for plague emblems. The fig plant, for example, had practical applications in healing plague as well as chiliastic innuendos. Other quasi-scientific indicators of pestilence were astrological signs and comets foretelling epidemics. Ominous stellar conjunctions along with powerful winds played a role in plague scenes. Apart from their apocalyptic connotations, popular belief held that warm, southern winds brought the disease; northern breezes cleansed the air, as described in the *Golden Legend*.

Since bubonic plague generally struck a specific geographical region, and since the bane was considered a castigation for the whole community, a townscape was included in the traditional plague iconography. Two architectural

motifs became familiar elements in plague scenes. They were derived from Raphael's illustration of the Phrygian plague: a fallen, classical column and a stone vault, both are frequently quoted in pictures representing pestilence (though the vault cannot be claimed exclusively for this theme).

Several gestures appeared repeatedly in early plague pictures; for example, God the Father hurling darts or spears. In some versions, administering the punishment was delegated to Christ, the Virgin, saints, angels, or demons. Even more important symbols of plague in late medieval depictions were the gestures of Christ and the plague saints displaying their wounds (ostentatio vulneris). Also, the Virgin presenting her breasts (the suffering of Christ's mother) was intended to placate God's displeasure about the sins of the world.[86]

Gestures specifically denoting bubonic plague, discussed in chapter 1, are, for example, the arm raised to expose the swollen gland near the armpit. Similar poses can be observed over centuries, whether or not the carbuncle is actually represented. In the instance of a neck bubo, the victim tilts his or her head in a very characteristic fashion. A thigh bubo is rarely seen in plague scenes unless the victim was St. Roch himself. Since the swelling usually developed close to the groin, prudery can be blamed for its placement closer to the knee than would be anatomically correct. In some cases, St. Roch's wound was omitted altogether. If the symptoms were not depicted, gestures and body language became even more important for discerning the meaning of a specific plague scene.[87]

Although the gesture of pinching the nose—to avoid the smell of death—was an ancient convention, seen most frequently in the "Raising of Lazarus," it appeared in fifteenth-century medical illustrations to indicate specifically bubonic plague. Raphael introduced the gesture into high art. He and his followers made it into a familiar symbol for the most lethal disease known to mankind. In 1631 Poussin illustrated figures covering their noses to protect themselves against miasmic vapors; after that the gesture was repeated in plague pictures ad infinitum. The fact that plague killed swiftly and unexpectedly was expressed by the collapse of a person during a routine activity.[88]

Figural Motifs

Many characteristic figurative groupings appeared in religious as well as in secular works. The inclusion of sick people, the comatose, and corpses commonly signified that the subject was pestilence. Occasionally, partially visible legs indicated, pars pro toto, a cadaver; this motif continued for a long time in

pictorial accounts of plague. The individual victims displayed, at times, the symptoms of the disease, or if medical evidence was lacking, the accompanying symbols underscored their meaning.

Dead animals were shown in the Ten Plagues of Egypt which were rarely linked with bubonic plague. However, since so many fictional and historic accounts described how pestilence decimated livestock, carcasses appeared in some plague subjects even though they were not necessarily mentioned in their literary sources. This observation holds true primarily for prints because religious paintings were subject to the rules of decorum which discouraged such base subject matter as animal carcasses.

Raphael's drawing *Plague of Phrygia* presented, for the first time in the fine arts, a group of people suffering from bubonic plague. This important prototype is discussed more thoroughly in chapter 5. Shown here is Marcantonio Raimondi's reversed print after Raphael, known as the *Morbetto* (fig.

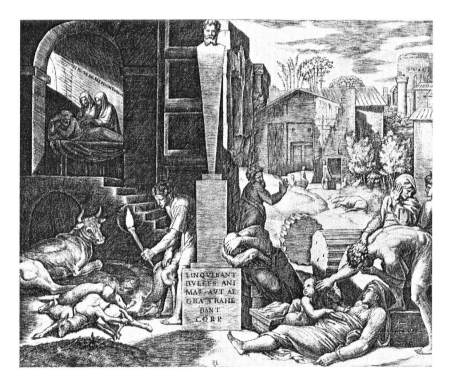

Fig. 3.1. *The Morbetto,* engraving, Marcantonio Raimondi after Raphael, 1520s.
Graphische Sammlung Albertina, Vienna.

3.1). All the actors in his multifigural composition—the ill mother with her healthy baby at her breast; a man about to save the infant while protecting himself from the dangers of miasmic air, and the horrors expressed by the people surrounding the main group, including a figure covering his head in despair—appeared again in later plague commissions.

Key dates for the development of the mother-and-child group include c. 1512–14, when Raphael drew his sketches for the *Plague of Phrygia*, and the 1520s, when the design was engraved.[89] In the seventeenth century, Cornelis Massy's print (after Raimondi) was responsible for further proliferation of its iconography in the north. To my knowledge, the image of mother-and-child was not used in a plague painting until Nicolas Poussin included the canonical figure group in his *Plague at Ashdod*. Since Poussin's picture gained instant fame, the design was engraved soon after the canvas was completed in 1631. This date may also be regarded as a watershed in the development of plague iconography. Shown here is S. Picart's reversed reproductive print after Poussin's painting (fig. 3.2).[90] Because of Poussin's innovative treatment

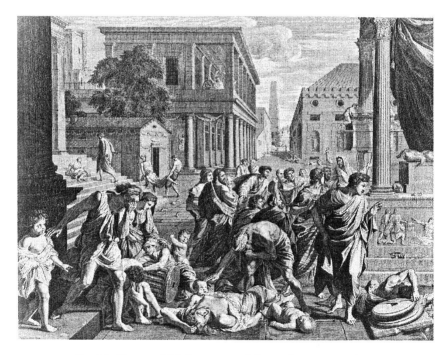

Fig. 3.2. *Plague at Ashdod,* engraving, S. Picart after Poussin, 1630s?
Collection of the National Library of Medicine.

of a plague subject, the French artist became inevitably associated with pestilence; hence Poussin's litter bearers *(Death of Phocion)* were often included in plague scenes.

A variation of the Raphael/Poussin motif of "mother-and-child" was "the seated mother with a child on her lap receiving the sacraments." Pierre Mignard invented this touching scene in 1657. Again, the image was engraved by numerous artists. Illustrated here is the graphic design by A. Bossé (fig. 3.3).[91] This and other printed versions, in turn, served as models for countless baroque paintings.[92]

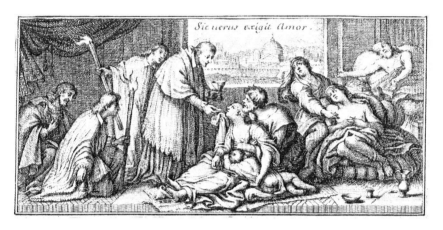

Fig. 3.3. *St. Charles Administers the Viaticum to a Plague Victim,* engraving, A. Bossé after P. Mignard, 1670. Graphische Sammlung Albertina, Vienna.

Religious Figures Most Frequently Included in Plague Art

The Trinity

The three divine persons, God the Father, the Son, and the Holy Ghost, often presided over plague votives. Several iconographic configurations existed. The "Seat of Mercy" showed the Father holding a large crucified Christ in his arms. The Dove of the Holy Spirit appeared generally above the Redeemer's head. The "Triumphant Trinity" depicted Father and Son enthroned side by side. The former was seen more often in the fifteenth and early sixteenth centuries; the latter was preferred in subsequent periods, but was less often associated with plague subjects. Generally speaking, the Trinitarian concept gained importance during the Roman Catholic Church's struggle against the Muslim Turks and the Protestant Reformation, which

coincided with numerous pandemics. In some of the plague commissions, the Throne of Mercy was juxtaposed with the Creation of Eve, a combination that may have referred to the beginning and the end of time. Moreover, St. Augustine associated the wound in Christ's side with Eve's creation from Adam's rib.[93]

Angels

Images of plague angels were derived from the Old Testament and the *Golden Legend*. Their appearance indicated either the threat of an approaching epidemic or the liberation from such a plight. Thus angels who administer the wrath of God—by wielding a weapon—should be distinguished from those with the more amiable gesture of sheathing the sword. In the Davidian plague, God the Father directs his Angel of Death to end the killing. Christ, on the other hand, frequently presided over two divine emissaries. They were mentioned in St. Sebastian's chapter in the *Golden Legend*: "a plague angel and a demon—or—bad angel" (depending on the wording of the text). They related, according to the *Golden Legend* (chapter on St. Michael), to the fact that "to every man two angels are given, one good and the other bad, the bad one to test him and the good one to protect him."[94] The Virgin is more often closely associated with the angel of St. Gregory's vision, the hope-inspiring messenger (St. Michael) flying over Castel Sant'Angelo. Plague angels and demons sometimes appear independently of narratives depicting St. Sebastian or Pope Gregory. After the Council of Trent, the Catholic Church discouraged demonic images and banned the *Golden Legend*. However, the nineteenth century saw a resurgence of the popular text which inspired some Romantic paintings.

The pictorial treatment of angels, in addition to those mentioned above, that played a part in plague iconography were St. Roch's angelic protector, the apocalyptic angels, and the Nine Choirs of Angels. Some members of the celestial orders, such as the Seraphim, Cherubim, Principates, and Potentates, appeared at times in plague-related subjects. Of the four archangels, St. Michael, guide of departed souls, was most frequently depicted in plague images. Although these heavenly hosts were not as commonly portrayed as the pair of spirits derived from the *Golden Legend*, all types of angels deserve careful consideration.

The Virgin

According to the *Golden Legend*, an icon of the Virgin Mary, believed to have been painted by St. Luke, was venerated by Pope Gregory. Whether or not

the Madonna was actually invoked during the Justinian plague is not known. That the disease frequently came from the East, for example, the port of Constantinople, may explain why Byzantine icons were associated with pestilence. However, there is no proof that the Western type of the "Madonna of Constantinople" originated in Byzantium. Other Marian images associated with pestilence are the *Misericordia* and Mary as the Apocalyptic Woman, frequently depicted as the *Nikopoeia* (the Virgin holding her son with both hands) seated on a large cloud bank. A *sacra conversazione* type surrounded by plague saints could also indicate a plague commission. It is difficult to assess to what extent the newly emerging images of the sixteenth and seventeenth centuries, the Immaculate Conception and the Rosary Madonna, were considered plague symbols.[95]

Plague saints

As already stated, over the last six hundred years *innumerable* saints have been associated with plague art. Local patrons were invoked along with the most popular intercessors.[96] This chapter discusses a few universally petitioned saints and their iconography. In devotional scenes plague saints frequently appeared alone or in pairs, and even in larger gatherings; they are often helpful in identifying a plague commission. In religious literature skull and flagellum were most often described as their attributes. In contrast, the visual arts depicted primarily the instruments of their martyrdoms or made references to specific biographical facts.

Although early Christian martyrs, such as Sebastian, Adrian, Christopher, Thecla, and many others, had not actually lived during an epidemic, they were venerated in plague votives.[97] The reasons for this association with pestilence have never been fully investigated. One possibility is the importance of the doctrine of satisfaction of divine justice through Christ's sacrifice. By analogy, the fact that these saints had suffered innocently for their faith was thought to recommend them to God. Also, a parallel can be drawn between their martyrdom and the risk involved in aiding plague victims, which may have influenced their selection as plague intercessors. Another important criterion for the choice of a plague saint was his or her reputation as a healer. For example, St. Anthony enjoyed great popularity immediately after the Black Death. In the fifteenth century he was joined by another powerful thaumaturge, St. Roch. After the Catholic reform the profusion of different intercessors was greatly reduced and replaced by historical personalities, such as Charles Borromeo and other church leaders who had proven themselves during the trying years of pestilential epidemics.

Because of their religious function, iconic plague saints represented the majority of the art production. However, narrative scenes chose to portray merely a few select plague saints. Most often depicted were King David of the Old Testament; St. Sebastian, the third-century martyr; St. Gregory, the sixth-century pope; the legendary St. Roch, champion of the pre-Tridentine Church; and, after the Council of Trent, St. Charles Borromeo.

King David

In plague scenes King David represented a secular leader involved in a health crisis. He was the most important biblical figure associated with pestilence because scripture defined the relationship between humans and the Divine during a disaster in 2 Samuel 24:10–25; in 1 Chronicle 21 and 22:1–12 (for an iconological explanation, see chapter 5). King David sinned against divine law when he ordered a census of his army, because his subjects belonged to God rather than to the king and only the Lord should know their number. For his disobedience David was given a choice of punishments: three years of famine, three months of war, or three days of pestilence (see appendix). Since the king chose the latter, innocent people suffered until David begged for mercy and God ordered the plague angel to stop the slaughter of the Israelites. To redeem himself, the king followed the Lord's command, conveyed by the prophet and seer Gad, to purchase the sacred site outside Jerusalem where the killing ended. There King David erected his altar of thanksgiving. The story continues in the pages of the books of Chronicles. Although David was not judged worthy to construct a permanent resting place for the Ark of the Covenant on the plague-altar site, because the king had shed too much blood (1 Chron. 22–28), Solomon had to execute his father's plans and built the house of the Lord (2 Chron. 3:1–2).[98] A series of consecutive scenes can be illustrated in painting and sculpture: David before God, the king before the angel choosing one of the three punishments, David with the prophet Gad, and the king purchasing land to build his votive altar. King David generally wore royal insignia; the harp was of lesser importance in plague scenes. To stress humility, David most often appeared bareheaded, his crown placed on the ground. God the Father—not Christ!—is associated in plague scenes with the Old Testament king. Often an angel held three arrows representing the three biblical calamities; at other times they were represented as stalks of wheat (famine), a sword (war), and a skull (pestilence). The flagellum, signifying pestilence, sometimes replaced the original symbols. Although "David's Remorse" was favored in book illuminations, in prints, and even in reliefs, the subject was rare in painting.

The reason for this may depend on the fact that the king of the Israelites was not chosen as the patron saint of a specific territory, by confraternities, or by nursing orders.

St. Sebastian

Pious legends recount that the early Christian martyr Sebastian had served as head of Emperor Diocletian's palace guard. However, during his short life, Sebastian was very active among the persecuted Christians and converted high Roman officials. Accused of treason, the saint was to be executed by a cohort of imperial archers who shot his body so full of arrows that he resembled a porcupine. Although they left the martyr lifeless on the field, Sebastian was revived by the care of a Christian widow. After his recovery the saint reproached the emperor once again, condemning the persecution of his fellow believers, upon which Diocletian ordered Sebastian to be clubbed to death. To keep the Christians from honoring him as a martyr, Sebastian's corpse was thrown into the Roman sewer system. Miraculously, the body was identified and recovered.

The development of St. Sebastian's iconography reflected some of the changes in his cult, which probably originated in Rome. The saint was portrayed bearded or clean-shaven, dressed or partially nude as he exposed his body to the portentous arrows. Leo Steinberg has likened him to "a 'lightning rod,' who draws the divinely launched arrows of the plague away from humanity, 'grounding' them harmlessly in his own body."[99]

The devotion to Sebastian began long before the fourteenth century. His commitment to the Christian faith is described in the *Golden Legend,* and according to this thirteenth-century book of saints, Sebastian was invoked against pestilence as early as the seventh century. However, before the Black Death, Sebastian was rarely shown with his arrow wounds. In his vita-cycles, "the encounter with Diocletian's archers" was treated merely as one of the episodes in his prolonged martyrdom. In fact, the Church speaks of two *martyria* and awards him two crowns. By the end of the fourteenth century, after several epidemics, the figure of the saint pierced by arrows began to dominate art; at times, Sebastian was shown with a myriad of arrows simulating quills. The saint's ordeal alluded to Christological analogies; Sebastian resembled the Man of Sorrow. The very fact that Sebastian, although mortally wounded, had recovered made him a favorite among the plague intercessors. St. Sebastian rarely, if ever, is depicted nursing patients, as so many other plague saints were. Nevertheless, the Christian martyr had earned his reputation as a healer at an early date. One of his biographical episodes of

interest here tells of a Roman prefect's sick-bed conversion. The saint's fight against heresy and its association with illness may have had some impact on later scenes describing pestilence.[100]

The Sebastian chapter in the *Golden Legend* also tells the pious tale of the saint's posthumous miracle, how the martyr successfully interceded for seventh-century Pavia, which is of particular importance for plague iconography. Most often depicted in scenes referring to pestilence were two heavenly emissaries, sent by God, to strike people's houses with the deadly disease. In Sebastian depictions of the fifteenth and sixteenth centuries, the arrows were often placed in the most vulnerable areas of the lymphatic glands: neck, armpits, groins, and thighs. The Tridentine tradition, on the other hand, stressed less the painful martyrdom than the kindness of the Roman women who healed the martyr's wounds. Over the centuries, Sebastian was elevated to one of the most lasting cult figures of all times.[101]

St. Gregory (A.D. 550–604)

St. Gregory was born a Roman patrician who turned his estate into a monastery and lived the life of an ascetic monk. In 590, when Pope Pelagius II died of plague, Gregory was elected pope, much against his own wishes. After his election to the papal throne, he became an influential leader of the Church. The pontiff built hospitals, implemented reforms, fought heretics, and raised moral standards within the papal jurisdiction. The institution of the Gregorian Mass, a service for the dead, was significant for plague victims. This great teacher, one of the four Western Church Fathers, was as influential as St. Augustine for medieval theology. Gregory the Great owed his popularity as a plague patron saint to the fact that he survived the epidemic. After the fifteenth century, most likely because of the recurrence of bubonic plague, Gregory appeared in plague narratives.

Most influential for these images was the *Golden Legend*'s account of Gregory's propitiatory processions. Frequently overlooked is the fact that in his chapter on St. Gregory, Voragine described two separate incidents. The first procession occurred when the saintly man was elected pope, and the second, after Gregory had been installed in office. The earlier event was marred by numerous sudden deaths; the latter narrated the pontiff's famous vision of the angel sheathing his sword over Hadrian's tomb—henceforth called "Castel Sant'Angelo." Examples are known from books of hours, missals, altar paintings, and even murals. Although most of the illustrations adhered closely to the text, the two processions are generally telescoped into one single event—as recorded in the chapter on St. Michael. Gregory generally

wears his papal tiara; only in a few non-Roman commissions does Gregory wear his pontifical cap.[102] The oldest known plague fresco depicting *St. Gregory's Procession* is preserved in Rome in the church of San Pietro in Vincoli (St. Peter in Chains). It was painted after the plague of 1476, and the votive included at its apex the angel flying over Castel Sant'Angelo. The pontiff appears in the foreground praying for the victims of the epidemic. To the right, the good angel and his "bad" companion mark the door of a house with pestilence. The foreground is littered with nude corpses. The mediocre painting is in poor condition and cannot be reproduced. For a more in-depth discussion, see chapters 4 and 7.

St. Roch (1350?–79?)

Based on three fifteenth-century biographical accounts, modern hagiography assumes that St. Roch was born into the ruling house of Montpellier. Roch was considered an exemplary figure of his time because the young nobleman abdicated and divided all his worldly possessions among the poor. Roch set out on a pilgrimage to Rome where he proved his thaumaturgical gifts when he saved the life of Cardinal Britanicus during an epidemic. On his journey back from the Eternal City, while nursing plague victims, Roch fell ill in Piacenza. The saint sought solitude in the woods where he was miraculously fed by a dog and nursed back to health by an angel. Continuing on to Montpellier, St. Roch was arrested in Lombardy and falsely accused of spying. He was incarcerated for five years but endured his unjust imprisonment with patience and humility. St. Roch died before he could be vindicated. Yet, after his death, he was recognized as a saintly person and was honored because he had lived in self-imposed poverty. More important, St. Roch's biographies stressed his Christlike qualities; he was said to have healed as Jesus did by the laying on of hands *(manus imponis)*. Artists have acknowledged this simile in some isolated instances by giving the saint the features of the Redeemer.

St. Roch has been invoked as a plague patron since the end of the fifteenth century; his cult developed primarily from popular devotion. Roch, just like Sebastian, was said to have recovered from mortal wounds. This, and the belief that his intercession had cured many plague-infected victims, made him the first choice among the sufferers in France and Venice. Although his canonization process lacked the necessary historic data, Roch became one of the few saints whose cult was declared by Urban VIII in 1629 as a *casus exceptus*. The reason for this preferential treatment was the pope's personal admiration for St. Roch; in 1624 he had contracted bubonic plague in Palermo, but he recovered.

Although Roch was said to have lived in the fourteenth century, the saintly pilgrim was neither mentioned nor even depicted until almost a hundred years later. An important date for Roch's iconography is 1485, when his *translatio* took place—that is, the transferal of St. Roch's body from Montpellier to Venice. Generally represented as a healer the saint wears pilgrim's garb with cockleshell and staff. St. Roch's other attributes included his faithful dog and the angel.[103]

Most images showed Roch—just like Sebastian—ritualistically displaying his wounds, a plague bubo on his upper thigh. As noted above, the symptoms of a femoral bubo are rarely depicted in common plague patients, and most certainly not before St. Roch's iconography introduced it to plague images. I believe that Roch's wound was an adaptation of a scene in the Aeneid passage, "Doctor Japyx removes an arrow from Aeneas's leg." During the battle of Troy, the future founder of Rome was wounded in his upper thigh, yet was miraculously healed through the intervention of Venus. The treatment of the subject, "St. Roch Healed by an Angel," may have been based on this ancient prototype. A fifteenth-century frontispiece portrayed the saint striking a semiheroic stance, leaning somewhat awkwardly on his pilgrim staff—instead of a lance, as in the case of the wounded Aeneas. The angel takes the place of Doctor Japyx, kneeling before the victim and treating his wound. In light of the classical tradition, it seems that the "medieval" hero of the Church was in reality a fabrication of the Italian quattrocento.[104]

Most of St. Roch's narrative scenes developed from cycles depicting his life; the pictures followed closely the texts of his popular biographies. Roch's miraculous survival was most frequently represented in icons and history paintings. On the other hand, the scene of the saint healing the animals in the wilderness was avoided after the Council of Trent.

St. Charles Borromeo (1538–89)

Charles Borromeo's mother, a Medici, gave birth to him in a small town in northern Italy. At the age of seven, Charles received the tonsure, as sign that he was destined to enter the clergy. He studied law, and in 1560 Charles was called to Rome where he was made a cardinal and served as secretary to his uncle, Pope Pius IV. When his older brother, the family heir, suddenly died, Charles refused to continue the house of Borromeo. The young and worldly papal nephew experienced a spiritual revival; he was ordained and in 1563, elected archbishop of Milan. In 1565, Charles started his reforms in the ancient diocese. Zealous to implement the newly established rules of the reformed Church, and born with an unusual gift for organization, the saint

became a model bishop of the postconciliar era, although his administration was at times quite controversial. During his nineteen years as head of the Milanese church, Charles competed with the spirituality of Calvin's Geneva. Charles died at the age of forty-six, a legend in his own time. He was known to have sacrificed his wealth and his physical strength during the plague epidemic. Thirteen years after his death, his canonization process was initiated, and in 1610 he was officially declared a saint.[105]

Whereas St. Roch, as miracle healer, expressed the religious values prevalent before the Council of Trent, St. Charles Borromeo, the ordained priest, represented the ideals of the Counter-Reformation. The official canonization decree commanded that the archbishop of Milan should be portrayed henceforth exclusively as Roman cardinal (wearing whenever appropriate a rochet, mozzetta, and biretta). St. Charles Borromeo's authenticated portrait was painted by Ambrogio Figino; the work displayed the saint's characteristic large nose and his ascetic, clean-shaven cheeks. Because St. Charles was a latecomer in the plague pantheon, his iconography became more fully developed. The famous *quadroni*, a series of forty large canvases, portrayed the most significant episodes in the archbishop's life, as well as some of his posthumous miracles. The paintings were commissioned for the canonization campaign and became the nucleus of the cardinal-archbishop's iconography; the series was copied a number of times.[106] Few other saints can boast a more complete and monumental cycle. After 1610 Charles Borromeo's images began to fill the churches of Catholic Europe where he inspired and enriched Baroque conventions with numerous plague *scenarios*. The emphasis of Charles's iconography rests on his reputation as a model shepherd of his flock, frequently risking his life during the terrifying plague years. The titles of plague scenes represented in the *quadroni* are *St. Charles Leads the Procession of the Holy Nail, St. Charles Confirms Adults during the Plague, St. Charles Visits a Plague Encampment,* and *St. Charles Adoring the Plague Crosses.* Every one of those four scenes adhered closely to contemporary biographies. Although the Church originally did not consider the events during the epidemic as important, later centuries gave preference to the illustration of plague topics. Charles was most commonly portrayed as a cardinal, dispensing the sacraments to the poor in out-of-doors encampments. Most numerous of all were variations after Pierre Mignard's *St. Charles Administers the Viaticum to a Plague Victim.* The engraved versions became the prototype for plague scenes for the next several hundred years. Since the woman receiving communion, depicted by Mignard, was not specifically mentioned by Charles Borromeo's biographers, she may have been derived from a summation of stories.

Female plague patrons

SS. Thecla, Francesca Romana, and Rosalia, to name but three of the most popular female plague intercessors, were rarely depicted in medieval art, partly because their cults and iconography had not been fully developed. In the Baroque period, these female saints were venerated as icons and frequently appeared in ex-votos rather than being depicted tending the sick, as did their male counterparts.[107]

Icons and Plague Votives

Iconic or devotional plague images can be recognized by the fairly static appearance of their figures; however, attributes were prominently displayed. If action was shown, it seemed to be suspended in time. Scholars have referred to such images as "reduced narratives." Devotional plague prints had become popular during the fifteenth century; frequently such woodcuts or engravings were commissioned—with or without prayers—as soon as the illness threatened a specific area. The custom of using prints as talismans for warding off plague continued well into the post-Trent era. An early German woodcut, a *Pestblatt* (fig. 3.4), invokes Sebastian's help against pestilence. The saint is surrounded by his armed tormentors and with a printed prayer decorated with the Greek letter tau—significant since, according to the *Golden Legend*, it marked those who did not have to fear the avenging angel—completes the plague sheet.[108]

In contrast to plague literature, rarely written during an epidemic, plague votives were frequently commissioned while the disease raged in a stricken city. These images were intended as peace offerings to God and considered an act of devotion. Whether these donations took the form of carved altarpieces, fresco cycles, apotropaic images painted over city gates, banners, prints, or simple devotional objects, they were commissioned generally by a town, its clergy, the secular government, lay confraternities, or a religious order to atone for the "collective guilt."

Many plague votives displayed established compositional patterns. They were characterized by a division between the terrestrial and the celestial zone. Heaven was reserved for the visionary appearance of divinities and angels, while the lower region was filled with interceding plague saints, donors, and victims of the disaster. The Trinity, the Holy Family, St. Michael, plague intercessors, and particularly the Virgin were supplicated for help. No time elements were implied and the mystical union of numerous plague saints often constituted a multiple *intercessio*. Anthony van Dyck's *Madonna of the*

Fig. 3.4. *St. Sebastian,* woodcut, 1437.
Graphische Sammlung Albertina, Vienna.

Rosary (1624–27) is a good example of a plague votive altar commissioned during an epidemic. It depicted St. Rosalia among other intercessory saints pleading before the Virgin and Child for the restitution of health in Palermo.[109] In the altar painting the reference of sickness was expressed by a little boy who pinches his nose with his thumb and forefinger.

Narratives, as History Paintings and Allegories

Narrative plague paintings or "un-iconic" depictions alluded to a written story. Such narrative subjects, sometimes also referred to as history paintings *(historiae)*, drew on literary sources such as those discussed in the previous chapter. The scenes were based on either recorded facts, legends, or even fictional texts. The proponents generally were chosen for their active involvement during an epidemic. Pure narratives generally observed unity of time, place, and action. History paintings that indicate temporal elements need to be interpreted literally.[110]

Nonecclesiastical plague scenes either reflected classical subjects or portrayed contemporary events. Profane plague topics were far fewer in numbers than religious depictions since they generally lacked a specific function. In the first two centuries after bubonic plague had become a real threat to the Europeans, the only secular depictions were illustrations in chronicles. In contrast, Raphael's sixteenth-century Renaissance rendering of the *Plague of Phrygia* illustrated the *Aeneid*, which is discussed in chapter 5. A few seventeenth-century artists also based their images on classical sources. Sweerts's *Plague in an Ancient City* and Pierre Mignard's *The Plague of Epirus* (Aegina) are the most famous secular plague subjects.[111]

At first glance, *The Plague of Epirus*, engraved by Gerard Audrans, seems to record many of the typical behavioral patterns experienced during a bubonic plague epidemic (fig. 3.5). Moribund patients and corpses are scattered in the foreground. The scene suggests that the artist chronicled his personal experience. However, one cannot overlook the fact that Mignard was inspired by Ovid's *Metamorphoses*. *The Plague of Epirus* illustrates, line for line, the ancient text (see appendix). To the right we see "Jove's temple, from its great stairs rising." On the left, a scantily dressed man escapes from his home—"they flee their household gods." In the background, "the walls of the great city" can be seen, and Mignard displays persons greedily drinking from a pool of water, lying in "any basin of water, in rabid thirst." In the gathering of people before the temple one also can observe figures "holding their arms to heaven."[112] Whether fact or fiction, to the seventeenth-century viewer all these occurrences must have seemed familiar.

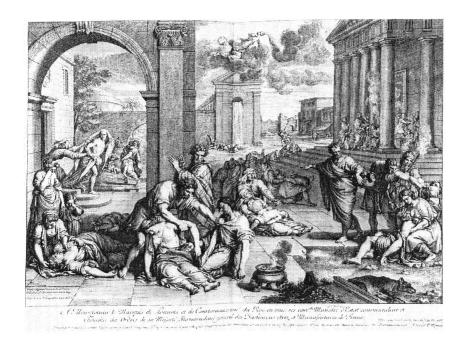

Fig. 3.5. *Plague of Epirus,* engraving, Audran after Pierre Mignard, 1670s.
Graphische Sammlung Albertina, Vienna.

Further study is needed to discern the innovative role plague scenes
played in recording contemporary events. Certainly, before the seventeenth
century, illustrations of specific epidemics had become fashionable. Many
realistic scenes were created by both well-known and anonymous masters.
Although many literary descriptions stressed the eeriness of ghostly, deserted
streets, few artists chose to depict this aspect of an epidemic. On the con-
trary, most secular paintings featured as many tragic occurrences as possible.
Part of the convention was the visualization of the sordid duty of collecting
the corpses. As doors and windows on the ground floor of quarantined
houses were barricaded from the outside, making the inhabitants literally
prisoners in their own homes, the dead needed to be removed through
upstairs windows. Thus, bodies are often shown being lowered on the out-
side of a building. The inclusion of plague funerals, although commonly
seen in medieval scenes, was eventually abolished in religious as well as in
secular art. By the seventeenth century, plague scenes increasingly depicted
human corpses as being brutally dumped from a bridge into a body of water
or into mass graves.[113]

In the 1660s Micco Spadaro painted *Piazza Mercatello during the Plague of 1656* (see fig. 1.12), a work already mentioned in the preface and chapter 1. It functioned, like Poussin's *Plague at Ashdod*, as a cabinet painting, that is, it was commissioned for private display. Spadaro's painting was a secular work, although a small divine apparition graced the sky.[114] His unidealized plague scenes had a following in Naples, and this tradition, in turn, must have been influential for Michel Serre's painted records of the epidemic in the south of France. Serre's large museum pieces seem to have been observed from life; his accurate views of Marseilles in 1720–21 portrayed the plague-stricken with great realism. Yet most of the individual vignettes were chosen from an already established plague vocabulary. The clergy giving alms, the dead mother with her infant, and the dogs sniffing dead bodies were all stock items in plague scenes. Even the topographical views of the city's thoroughfares, suggesting site specificity, had been an iconographic tradition since the fourteenth century. The increased secularization of the theme in the eighteenth century is apparent in the fact that Bishop Belsunce's celebration of an outdoor mass excluded any references to celestial visions. It would be interesting to assess further the influence of plague art that chronicled contemporary events, yet it is even more remarkable to observe the recurring religious innuendos in profane plague subjects. Over the centuries, religion shaped people's notions on pestilence; this aspect is discussed further in chapter 7.

Plague allegories, in contrast to narrative scenes, negated the formula of unified action in time and/or place by introducing personifications or even a gathering of nonhistorical figures. No matter how unified their compositions may appear, allegories require a metaphorical reading. Secular, as well as religious, plague allegories existed. The appearance of one or more allegorical figures in a scene frequently suggested a symbolic rather than a literal interpretation. From the late Middle Ages and well into the Renaissance, popular literature and the visual arts personified Pestilence in the guise of frightening male or female figures, demonic skeletons, and even batlike archers. Many of these creatures resembled depictions of Death. Although the tradition of the Grim Reaper, symbolizing "Plague," never ceased in prints, in the fine arts, skeletons became rare after the Council of Trent until the macabre imagery resurfaced in the eighteenth century. Thus the figure of the *transi* (decomposing body) does not necessarily belong to the plague rhetoric, since pestilence stressed the unexpected, *sudden* death, not speculations on the decay of the physical body or about life after death. These theological questions are treated in chapter 4.

By the seventeenth century, the allegorical figures became more standardized. Cesare Ripa's text on the female allegory *Peste* was responsible for this phenomenon (see appendix). As noted earlier, originally the personification was not illustrated in the emblem book *Iconologia*. The allegory first appeared in Giuseppe Ripamonte's title page *La peste di Milano del 1630*. Following Ripa's text closely, the frontispiece displayed the old hag, clothed in dirty rags. Peste reclined on a sheepskin which represented mortality. The personification of the disease wore a "wreath of dark clouds" allegorizing miasmic air. When, in an eighteenth-century edition of Ripa's *Iconologia*, the text of *Peste/Pestilentia* was illustrated for the first time, the figure of Plague was shown surrounded by a dark, nebulous mass (fig. 3.6). In the print, these billowing clouds—most certainly *not* part of the heavenly realm—enveloped most of the corpses lying in the foreground. The mist turns paler and hazier toward the back of the composition where the plague angel appears to King David. This second scene is intended as a moralizing comment on pestilence.[115]

Possibly the first plague allegory without the inclusion of personifications was created by P. P. Rubens. For example, in his famous *St. Roch*, an engraving after his altar painting for St. Martin in Alost, the imposing architectural framework does not suggest unity of time, place, and action (fig. 3.7). On the contrary, the master simply disregarded practices that characterize narratives and brilliantly conflated six major events of the thaumaturge's life.[116] Formed into one coherent composition, the following scenes are implied: St. Roch, the pilgrim, with his dog; visitation by an angel; healing plague victims; Roch's death in prison; the saint's reception by Christ; and finally his designation as plague patron. The print showed on the bottom, the dungeonlike setting which referred simultaneously to the saint's unjust imprisonment and to the sick, bedded like prisoners on straw. The large arch resembles the architecture in Raphael's *Plague at Phrygia*. In the upper half, above the plague victims, appears Christ on a cloud. The words "Eris in peste patronus" are inscribed on a tablet held by an angel. One can call Rubens's image epoch-making because it stimulated Baroque plague iconography by recording the psychological effects of the disease on its victims. Over the years, Rubens's emotional gestures, postures, and facial expressions were repeated in many plague scenes. Since most allegories are by nature idiosyncratic, they need to be explored in the context of a particular time period or geographic region.

Although the original publication dates of the literary sources seemed to have mattered very little, or even where the imagery derived from, over the

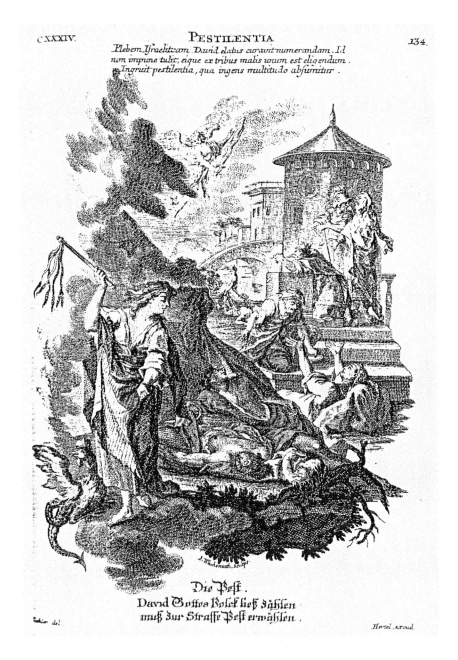

Fig. 3.6. *Peste/Pestilentia*, engraving, Cesare Ripa, 1750s, from *Historiae et Allegoriae* (Augsburg, probably 1758–60; reprinted, New York: Dover, 1971).

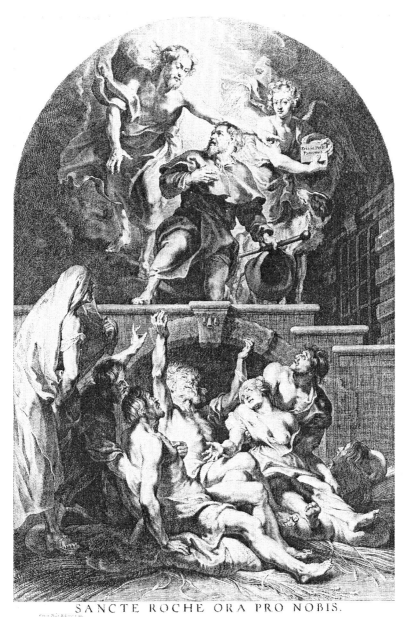

SANCTE ROCHE ORA PRO NOBIS.

Fig. 3.7. *St. Roch,* engraving, Paul Pontius after P. P. Rubens, c. 1623.
Graphische Sammlung Albertina, Vienna.

centuries an international repertoire was established and plague art eventually spread across the whole European continent. People were able to read these images and could relate them to their own frightening experiences. Today, the circumstances have changed and the meaning of the works is largely forgotten. Therefore, the chapters that follow are dedicated almost exclusively to the study of plague iconology; they will analyze and interpret individual plague paintings, drawings, and prints. For the sake of a more cohesive discussion, sculpture and other media are excluded, although their production was considered of equal importance.[117]

Chapter 4

The Black Death and Its Immediate Aftermath (1347–1500)

Death Imagery Preceding Outbreak of the Plague

The frightful experience of the Black Death coincided with an already noticeable preoccupation with human mortality. Scholars have established that death as a topos—such as the "Triumph of Death," "Dance of the Dead," and "Meeting of the Three Living with the Three Dead"—originated before the middle of the fourteenth century, although they rarely agree on precise dates. Thus, the cause of this fascination with the macabre *before* the outbreak of bubonic (and pneumonic) plague remains in part an enigma.

To attain a better historical perspective, the period prior to 1347 needs to be examined. Death imagery depicted in the early part of the disastrous fourteenth century seems less related to actual events than to the then current theological debate on eschatology. It is my contention that the trecento's increased fixation on *"memento mori"* was based primarily on doctrinal revisions concerning heaven and hell. Speculations about the soul's experience after death and the resurrection of the postmortem body after the Last Judgment are contained in fourteenth-century secular literature, such as Dante's *Divine Comedy* (c. 1320), but more significantly, Benedict XII, third of the Avignon popes, proclaimed *ex cathedra* in his constitution *Benedictus Deus* (1336) that the moment of death was followed immediately by an individual judgment—rather than a postponed universal judgment at the end of time—which is what his predecessor John XXII had proposed.[118] Benedict also ruled that the blessed would be allowed to enjoy the presence of God immediately after their demise, yet their bliss would increase to a more complete experience after the Last Judgment since at that time they would acquire an eternal body. The pope was equally authoritative when he spoke

of how the damned would suffer in the fires of hell.[119]

Caroline Walker Bynum concludes her recent book, *The Resurrection of the Body in Western Christianity, 200–1336*, with a discussion of Benedict XII's constitution, in which she confirms my hypothesis that his bull concerning the relationship between body and soul represented a watershed in Catholic theology. Bynum proposes that after 1336 a subtle change occurred, in which a greater emphasis on the soul becomes noticeable.[120] In the future, men would no longer think of the postmortem body as the sum of particles of human remains which the scholastics had deemed essential for man's resurrection.

Before we can discuss the impact of the devastating pandemic on the visual arts, we have to explore images of death produced earlier in the century. I have proposed in my article, "The Pisan *Triumph of Death* and the Papal Constitution *Benedictus Deus*," that the famous fresco (fig. 4.1) did not mirror the sudden recurrence of plague in Italy but reflected the Church's far-reaching decisions on life after death. Most scholars now date the *Triumph of Death* in the 1330s, thus anticipating the pandemic of 1347–53 by several years. The large composition presents no less than seven different

Fig. 4.1. *Triumph of Death,* Buonamico Buffalmacco? c. 1330s, Camposanto, Pisa.
Alinari/Art Resource, New York.

scenes. "Meeting of the Three Living with the Three Dead" are represented on the left, and "Death Threatens a Courtly Gathering with a Scythe" on the right.[121] In the foreground, cripples are clamoring for Death to release them from their pain, and further back some hermits are occupied with their devotions. A large portion of the mural is devoted to the depiction of a *psychomachia* (an allegorical combat between virtue and vice); angelic figures and demons fight a fierce battle over the souls of the dead buried below. *The Triumph of Death* was part of a larger program designed to line the route of the Camposanto's funeral processions.

A number of the episodes in the *Triumph of Death* seem to reflect Benedict's theological assumptions on afterlife. First and foremost, the Pisan fresco relates the traditional Western view of an immediate judgment after death. It portrays a devil pulling a somatized (human figured) soul from the mouth of one of the dead who is buried in the foreground, confirming Benedict's stern prediction that all who have died with a mortal sin will be condemned to eternal fire. A warning against mortal sins can be read on a banner in the center of the mural. Additionally, winged demons deposit lost souls at the gate of hell, which resembles a large furnace ablaze with flames, reminding us of Benedict's prediction that the wicked are already burning in hell. Moreover, similar ideas are expressed in the airborne *psychomachia* deciding the future of the souls right after their demise.

The cripples in the *Triumph of Death*, on the other hand, whose hard life on earth can only be relieved by death, look forward to their immediate, just reward in heaven, when they will be admitted into the presence of God and experience the Beatific Vision promised in *Benedictus Deus*. The downtrodden are eager to die, because their lives resembled the suffering of Lazarus which Benedict XII had used as an *exemplum*.

What is most important for later discussions on medieval preoccupation with decay and the depiction of the *transi* (*en transi*, the decomposing cadaver left in the ground after the soul had faced an immediate, individual judgment) is the vignette of the living meeting the dead. The three open caskets with bodies in various stages of putrefaction emphasize the importance of the immortal soul as stated in Benedict XII's *Visio Beatifica*.[122] The mural represents in these infested cadavers the mortal, "animal" body (*psychikon*) in contrast to the "spiritual" body (*pneumatikon*) promised by Paul in the first book of Corinthians; after the departure of the soul, the former is destined to return to dust, while the latter will be resurrected at the end of time.[123]

The hermits' pious lives are contrasted on the left with the frivolities of the courtiers on the right. The pictorial narrative stresses naturalistic accuracy

in the depiction of the individuals' reactions; some figures may even have been intended to portray historic personalities to make the message more persuasive. Yet, "the allegorical narrative" is, in Belting's words, "fictitious."[124] Indeed, the analysis of the *Triumph of Death*'s iconography reveals that the painting did not register the people's reaction to the frightening plague epidemic, as Millard Meiss had originally stated, but proclaimed the articles of faith concerning the immortal soul.[125]

Impact of the Black Death

The changes that occurred in postplague societies have occupied scholars for years and are much too large a topic to be addressed here. This chapter will merely summarize some of the latest art historical findings and propose some new theological ideas. One of the main issues is the question of how many of the changes reflected in fourteenth-century art can, de facto, be attributed to pestilence.

Unquestionably the Black Death was a cataclysmic event of almost unprecedented scale which changed medieval Europe forever when an estimated third of the Old World's population perished during the years of 1347 to 1353.[126] Moreover, numerous other outbreaks of disease were reported during the fourteenth century (in Italy 1362–63, 1373–75, 1383–84, 1389–91, and 1399–1400), with repeat performances for the next several hundred years. However, it is very likely that not all epidemics were caused by *Y. pestis*. The most reliable plague-impact studies are those for England and Italy. A demographic investigation into the depopulation of Florence, for example, showed that in c. 1300, the city had about 120,000 inhabitants; on the other hand, the census of 1427 registered only 36,909 heads. However, more significant for the arts than demographic and socioeconomic changes were modifications taking place in the field of theology.

As one would expect, in the spiritual world of the late Middle Ages transformations in religious rites occurred. For example, in England, the bishop of Bath and Wells—following the instructions of Pope Clement VI—wrote in January of 1349:

> The contagious pestilence of the present day...has left many parish churches without parson or priest to care for the parishioners. Since no priests can be found who are willing...to take pastoral care...visit the sick or administer the sacraments of the church, we understand that many people are dying without the sacrament of penance. [Therefore]...persuade all men...if they are on the point

of death...they should make confession to each other...or if no man is present, then even to a woman.[127]

Confession and, even more significantly, a contrite heart were the most essential aspects of a good death. It is important to note that medieval theology still emphasized that God—not priests—forgives sins, a concept that the Catholic Church, over the next several hundred years, gradually modified. The controversial question of the papal power of the keys will find expression in Baroque plague imagery.[128]

However, as previously stated, some of the ritualistic changes in the fourteenth century were recorded prior to 1347. For the last forty years researchers have studied information and have drawn conclusions from primary sources dated from before and after this fateful year. Documents that attest to modifications in funeral rites, testament and inheritance customs, requests for masses of the dead, large deathbed bequests to the Church, commissions for religious images, and the obvious increase of importance assigned to lineage and family have been investigated in detail. I believe only one author, Jacques Chiffoleau, has suggested a specific date and a place, though not a motive, for such modifications. According to his report, funeral customs changed c. 1330.[129] He proved that the first signs appeared in the region of Avignon—which indicates the importance of the papal residence in the south of France during the "Babylonian Captivity."

Records of an increase in pomp displayed at funerals preceded the outbreak of plague. It has been observed that, ironically, the zealousness exhibited in the "cult of remembrance," as Samuel Cohn referred to this phenomenon, was less directed toward life in another world than underscoring blood line and descendance, representing a testimony of stronger ties to life on earth. I want to interject a word of caution that our modern views may not be valid when we examine a time when secular and religious ideas were inseparable. However, even in the postplague era—although plague burials necessarily had to be kept simple—after the danger of infection had passed, "secondary funerals" became fashionable.[130] In fact, restrictions in the form of sumptuary laws had to be legislated.

Fear of damnation may have given rise to the death imagery in the fresco cycle of the Camposanto, and the sudden onslaught of the Black Death with its repeated waves of plague epidemics undoubtedly deepened the people's anxiety. However, quite unexpectedly, in the second half of the fourteenth century, the morbid images seem to de-escalate. Although it is true that a plague-related mural depicting the *Triumph of Death* was painted in 1447 in

Palermo, by and large the iconology of confirmed plague commissions changed.[131] Two factors might explain this more compassionate imagery: the development of the concept of Purgatory and what Louise Marshall calls "manipulating the sacred."[132]

Purgatory in the fourteenth century—a place between heaven and hell that was prepared for temporary expiation of the souls to alleviate the danger of total damnation—became an integral part of the discussion of eschatology. Although Purgatory had been accepted doctrine in the West since the Second Council of Lyon (1274–75), "the third place" was still being debated for another hundred years. This was in part due to the Eastern polemic. Since Greek Orthodoxy did not believe in an ad hoc judgment, they also rejected Purgatory. Benedict XII's official decree did not mention Purgatory by name but *Benedictus Deus* allowed for purification of the souls after death.[133] Deliberately or by default, Benedict's doctrinal writings paved the way for the institution of Purgatory in the West. Indeed, the waves of frightening epidemics may very well have functioned as a catalyst to fully establish the doctrine.

The introduction of Purgatory would explain changes in funeral and memorial services, since acquiring indulgences, prayers, and masses for the souls in Purgatory were pressing obligations for the living even before the onslaught of the Black Death. However, since the plague reduced the likelihood that relatives would survive who could carry out the necessary prayers, more precise instructions were recorded in testaments to assure the wellbeing of the deceased in the afterlife. To avoid the consequences of an unexpected death, special plague masses that guarded against a "bad death" were introduced. The layman's preparation (if a priest was not available) in the form of the *Ars moriendi*—which incidentally did not consider Purgatory— and deathbed bequests to religious institutions, all were phenomena designed to counteract the detrimental effects of pestilence on the prospects of salvation.

The constant danger of an ill-prepared death also might have given rise to a greater popularity of intercessory saints. According to A. Ronen, the movement did not reach its peak until about a hundred years after the arrival of the Black Death.[134] The idea of gaining indulgences for the dead already had been advocated by Pope Gregory I (Gregorian Mass series). His special concern for the unfortunate suffering after death for their venial sins made him also a fitting champion for plague victims of the fourteenth and the fifteenth centuries. St. Gregory shares this characteristic with other plague intercessors such as Nicholas of Tolentino who was also thought to be help-

ful in the release of souls from Purgatory.[135]

Apart from Purgatory and all its implications, the second most important concept that created a positive climate after the Black Death was the psychological defense against disease, attained by creating religious art. Louise Marshall, in her excellent dissertation and again in a more recent article, "Manipulating the Sacred: Image and Plague in Renaissance Italy," proposes most convincingly that after the recurring incidences of plague, the people no longer passively waited for the "Will of the Lord," but, in her words, "attempted to articulate and manipulate their situation: the images generated by experience or expectation of the disease."[136]

Obsession with mortality and its repercussions—after the Black Death struck—apparently also intensified a religious lifestyle. In addition to an increase in elaborate death rituals, observances of prayers, commemorative masses, and above all the celebration of the Eucharist are documented. Every individual epidemic after 1347 seems to have been followed by a flurry of religious activities. The plea for God's mercy by donating chapel decorations, along with smaller images, increased art production, although not necessarily its quality.[137]

One of the "psychological weapons" created by the visual arts alluded to the axiom of "satisfaction through Christ's sacrifice," briefly mentioned in the previous chapter. John Bossy summarized Anselm of Canterbury's concept of justification as dependent on the kinship and dual nature of Christ.

> The Original Sin had offended God, and men owed him restitution. Men could not compensate for the offense because everything was already God's property, therefore only God himself could satisfy the debt; but since the satisfaction was owed by man, a lawful offer of it could only be made by someone who was both God and man...the weight of the compensation Christ might claim for his death was more than the world might ever contain. Not needing it himself, he asked the Father that the debt be transferred to his fellow men, which the Father could not in justice refuse. So man was able at length to make satisfaction, to abolish the state of offense between him and God, and to be restored to favor and future beatitude.[138]

※ Resulting from this ideology it was assumed that God's mercy could only be influenced by invoking the memory of human suffering. Thus, the number of images depicting Christ's Passion increased, particularly in the form of the Crucifixion, the Man of Sorrow, and the Pietà. Moreover, plague panels

frequently portrayed images of Christlike saints because they had suffered as Jesus did. These images showed the saints displaying their wounds, for example in the form of Francis of Assisi's stigmata, which raised the hope of the beholders that God would recognize the sacrifices and sufferings and answer the victim's prayer.[139]

Plague Imagery Created after the Black Death

To reiterate, in the late Middle Ages, plague iconography and iconology reflected changing theological ideologies. An investigation into the art produced during the countless epidemics is well suited to explore the period's transcendental views on sickness and death. The dates of the first visual responses to the Black Death are still being debated. However, by the third quarter of fourteenth century, plague iconography seems to have been established; unfortunately few works are extant. Therefore, rather than present the art chronologically, I will group it by subjects and iconological themes.

Many of the altarpieces of the fourteenth and fifteenth centuries were dedicated to St. Sebastian. One of the earliest trecento plague altars was created for the Florentine Cathedral. Giovanni del Biondo's *St. Sebastian* can be dated, on the basis of style, to the 1370s and consequently associated with the epidemic of 1374. In the triptych's center panel, the saint's body is pierced by an unusually large number of arrows, which might reflect the growing popularity of the *Golden Legend;* the text describes how the saint's arrows resembled the quills of a hedgehog or porcupine. M. Meiss proposed that the multiple arrows expressed the experience of the violent attacks of bubonic plague, but there is no concrete evidence to support his assumption.[140] Most plausible—why St. Sebastian is presented suffering so many wounds—is the concept of "satisfaction" advocated by Louise Marshall. The saint appears to protect the city of Florence by offering his body as a "lighting rod" to save its citizens.[141]

The *St. Sebastian* triptych contained four narrative side panels. One of them, *St. Sebastian Saves a City from the Plague,* portrays in the foreground a pious burial which shows the traditional responses of the people toward human mortality. Although the importance of the soul vis-à-vis the body had been established, the time-honored rites for the dead remained prevalent in plague pictures until the Council of Trent. Iconography and iconology did not change over the next hundred years.

A large retable commissioned by the Sebastian confraternity in Marseilles displays a similar iconographic program. The extant contract recorded that Bernardino Simondi and Josse Lieferinxe executed the work in 1497–99.

Although a number of its altar panels are now lost and the rest of them scattered in museums throughout the world, the altar's original appearance has been reconstructed by Charles Sterling.[142] The center section (lost) was to display three *antipesteux* saints. In this case it was Sebastian, flanked by Anthony and Roch. The viewer was encouraged to draw parallels between Christ's suffering and that of the martyred Sebastian. Both figures were to be depicted partially nude, displaying human vulnerability. Also now lost, two lateral predella panels were to illustrate SS. Roch and Anthony's afflictions. An image of the *Pietà* was intended for the center of the predella.

Sebastian, the saint to whom the altar was dedicated, was honored with an eight-panel cycle depicting the following episodes: *Sebastian Destroys the Idols* (this will be discussed later), *Sebastian before Emperor Diocletian and Marxentius, Sebastian's Martyrdom by Arrows, Sebastian Is Tended by Irene, Sebastian Is Clubbed to Death*, and, most important for this discussion of plague iconography, a postmortem miracle, *St. Sebastian Intercedes during the Plague in Pavia* (fig. 4.2). Finally two more scenes would have been included in the program—*Pilgrims Visiting Sebastian's Tomb in Rome* and the eighth panel (now lost) probably represented *Sebastian Visiting Christians in Prison*.

The plague picture *St. Sebastian Intercedes during the Plague in Pavia* is based on the passages found in the *Golden Legend*. The fortified city surrounded by mountains suggests an idealized view of Pavia. The panel presents a vision in the sky portraying Christ, the judge, enveloped in a dark cloud. Holding an orb in the left hand, the Savior extends his right hand toward St. Sebastian. The martyr kneels in prayer before Christ, his body pierced by numerous arrows. Below, an angel instructs a demon to execute God's punishments. The two winged spirits face each other: the good angel is dressed in white, the demonic creature resembles a dark bat. These conventions hark back to medieval *psyochomachias* and the pair of plague angels described in the *Golden Legend*.[143]

St. Sebastian Intercedes during the Plague in Pavia also displays a number of genre details. From everywhere shrouded corpses, resembling cocoons, are carried to their burials. In the foreground, to the right, a church portal is visible; a priest and attending clergy exit the building. Their ecclesiastic paraphernalia are prominently displayed: a cross, a container with holy water, and the missal. People lamenting the dead are depicted on the left, among them "a pious man" praying. In the center two men are about to inter a body in a mass grave. The action takes place close to the picture plane. One of the grave diggers has collapsed, seemingly struck by a typical sudden attack of plague, his face pale and his body contorted. He is trapped by the weight of

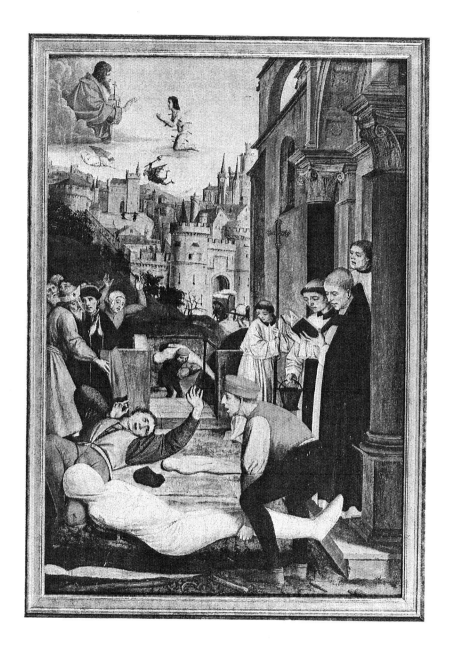

Fig. 4.2. *St. Sebastian Intercedes during the Plague,* Josse Lieferinxe, 1497–99.
The Walters Art Gallery, Baltimore.

the cadaver he has been carrying. The man's neck exhibits the characteristic token of the dreaded ailment, a naturalistically painted and correctly placed, reddish-brown cervical bubo. Also typical of bubonic plague is the man's pose, his head tilted to soothe the pain.

Lieferinxe heightened the drama with strong color contrasts of white, black, and blood red. Although the cope of the priest is dark; it seems to have been red originally and painted over at a later date. The two grave diggers are partially dressed in red, the liturgical color of martyrs, indicating that they, too, sacrificed themselves for the love of their fellowman. Special emphasis is placed on their headgear. The sick man's cap lies haphazardly strewn on the ground next to him. His colleague's hat, however, differs somewhat from the one of the sick orderly; the cap has a tiny white piece of paper exposed on the rim, possibly one of the popular printed plague prayers that were believed to save the bearer from the bane—it must have worked. Although this panel is part of a larger cycle, its realistic treatment suggests Lieferinxe's firsthand experience of a bubonic plague epidemic.

An early example of linking disease with heresy is expressed in the altar panel *St. Sebastian Destroying Pagan Idols*. The scene is vividly described in the *Golden Legend*. In the chapter of St. Sebastian the following story is told:

> The prefect of the city of Rome was afflicted with the same disease and asked Tranquillinus to bring him the person who had cured him. So Sebastian and the priest Polycarp went to the prefect, who asked them to restore his health, and Sebastian told him that he would first have to renounce the worship of the false gods and empower him to demolish his idols; then only would he regain his health.... So Polycarp and Sebastian...said to Chromatius, the prefect: "We have shattered the idols and you are not cured. This must be because you have not yet renounced your false beliefs, or also you are holding back some idols." The prefect admitted that he had a room in which the whole order of the stars was represented.... Sebastian insisted: "As long as you keep that room intact, you yourself will not be made whole." The prefect than gave his consent.... While the room in question was being taken apart, an angel appeared to the prefect and told him that the Lord Jesus had cured him of his malady.... So he and his son Tiburtius and fourteen hundred persons among his family and retainers were baptized.[144]

Lieferinxe chose to portray the moment when the idols are being destroyed and the angel informs the prefect that he has been healed. Although Voragine does not mention the name of the illness threatening Chromatius, there cannot be any doubt that in the fifteenth-century altarpiece, Sebastian is associated with bubonic plague. I will return to the phenomenon of metaphorical associations between pestilence and heresy in the discussion of the Tridentine world in chapter 6.

Another proof that St. Sebastian was frequently invoked to reduce the Lord's wrath can be found in an Italian quattrocento altar. Benozzo Gozzoli painted a Sebastian votive mural for San Gimignano, commemorating a recent epidemic. As far as one can reconstruct the events in 1464, it seems that the artist was released from previous duties in order to execute the large altar immediately; and to save time the images were painted on the altar wall *al fresco.*[145]

The patron, Fra Domenico Strambi, doctor of theology, wrote the program for the votive altar in which Sebastian dominates the lower half of the chapel wall. The inscription below the saint reads: "SANCTE SEBASTIANAE INTERCEDE PRO DEVOTO POPULO TUO."[146] Standing in prayer on a pedestal, the early Christian martyr shelters the kneeling people with his mantle spread, like that of a Madonna *Misericordia,* across the whole width of the image. Plague arrows, many broken, are absorbed by his *Schutzmantel* (protective cloak). The arrows originate from God the Father who holds one of the darts in his hand; he is framed by a mandorla and surrounded by angels, four of whom also wield threatening projectiles. We are beholden to the erudite donor who identified the heavenly hosts as *Potentates, Principates,* and *Virtutes.* Floating on a cloud appear Christ and his mother. In a double intercession, the Redeemer presents his wounds and his mother offers her breasts to placate the irate Lord. What may seem to twentieth-century logic as an overt miscarriage of God's command by the *Virtutes*— that is, breaking arrows above the saint's *Schutzmantel*—would, in the fifteenth century, have been considered proof of the efficacy of St. Sebastian's prayer, not a challenge of divine omnipotence. The appearance of the Dove of the Holy Spirit "reveals the unity of the purpose behind the apparent conflict of offended Father and petitioning Son. Threat of punishment and promise of deliverance are contained within one image."[147]

The importance of the altar's eucharistic function is the trompe l'oeil *Crucifixion with Deeisis and Donor Portrait,* similar to Fra Angelico's more famous *San Marco Altar.* The inclusion of the patron would indicate that we are dealing here with a private commission; on the other hand, the numerous

figures sheltered by Sebastian's mantle denote that the protection should extend to all citizens and reflect the concepts of collective guilt and shared redemption. Individual donations, although meant to protect the whole community, were thought to be appropriate expressions of wealthy patrons.

Another saint closely associated with bubonic plague was Gregory I, the Great. Not only had he survived the sixth-century epidemic but also the pope had organized the first plague processions recorded in Christian literature. For that purpose, according to the *Golden Legend*, the pontiff had instituted the Greater Litany—also called "Black Crosses." St. Gregory is frequently depicted in book illuminations. The most famous examples are taken from two books of hours illustrated by the Limbourg brothers. The subject, Gregory's Procession, appeared first in the *Belles Heures*, dated c. 1410–12. The production of the *Très Riches Heures* must have followed immediately thereafter since that book was started in 1413. Unfortunately, the latter volume was left unfinished in 1416 when the three brothers, Jean, Pol, and Herman, all died in the same year—along with their patron, the duke of Berry.[148]

A comparison between some of the illustrations found in the two manuscripts is instructive. The prototype, the *Belles Heures*, dedicated four miniatures to the Gregorian plague; these images were based on the *Golden Legend*. Several passages from the chapters of St. Gregory, St. Michael, and the "Greater and Lesser Litanies" were illustrated. The first illumination in the volume portrays the *Institution of the Greater Litany*. Shown is Gregory's divine inspiration (Dove) to stage a propitiatory procession. Banners displaying large, black crosses are being presented to the pope.[149]

The second image illustrates *St. Gregory's Procession*. The supreme pontiff leaves the city followed by the seven orders of the clergy, the monks, the women religious, the children, the laymen, the widows along with the unmarried women, and last, the married women. Voragine calls the Greater Litany also the Septiform Procession. Two people seem to have suddenly fallen ill; one person is lying quite indecorously in the foreground, another is about to collapse to prove that they suffer from the true plague. The *Golden Legend* recounts that in any one hour ninety men died; no angel is visible on this page.[150]

The third illustration in the *Belles Heures* depicts the *Flagellants* (fig. 4.3). Although the *Golden Legend* does not mention the *disciplinati*, they were rendered in chronicles of the Black Death, and the Limbourg brothers must have associated these penitents with plague epidemics. In the *Belles Heures*, the page portrays a rather unique dragon, representing the devil, carried

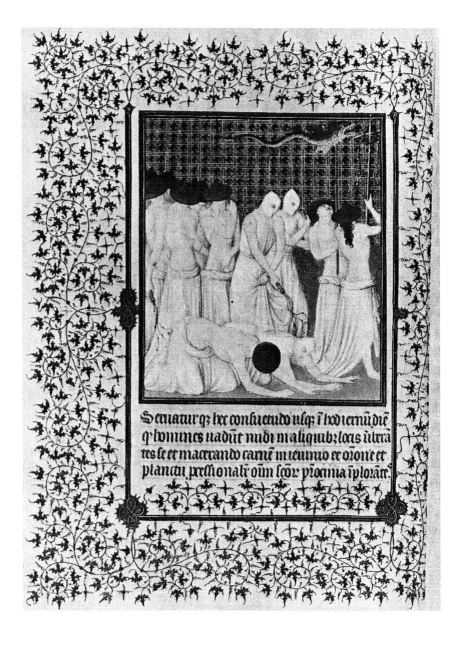

Fig. 4.3. *Flagellants,* Limbourg Brothers, in *Les Belles Heures,* fol. 74r, 1412.
The Metropolitan Museum of Art, The Cloisters Collection, 1954 (54.1.1).
Image © The Metropolitan Museum of Art.

behind the processional cross. The meaning is explained in the "Lesser Litanies" of the *Golden Legend:* in the time of grace, after Christ's birth, Satan became powerless.[151]

The last of the four folios shows the *Vision of St. Michael* (fig. 4.4). The archangel, sheathing his sword, emerges over the roof tops and presides over a large burial scene. Michael Camille wrote about this miniature: "Whereas Remiet's signifier of death was nearly always this horizontal line,...the representation of plague victims being suddenly struck down in the *Belles Heures*...makes death a deep diagonal thrusting into space."[152]

Speculations that the famous illustrators and their benefactor died in an epidemic would be supported by the fact that *St. Gregory's Procession* had not been originally planned for the *Très Riches Heures* and may have been commissioned when disease broke out. The illuminated text of the Greater Litany was ingeniously inserted between the Penitential Psalms and the Litany of the Saints; despite the improvisation, the miniature has a unified two-page layout framed by fancy Gothic architecture. The illustration only depicts the left page (fig. 4.5). Various representatives of Rome's populace are identifiable: behind the pope and his court of cardinals and monks appear men, women, and children. The crowd pours through the city's gate. The procession takes them in front of the walls where Gregory I, dressed in red and crowned with a tiara, raises his arms to heaven. The pope seems mesmerized by the apparition of an angel of the Lord, who was wiping a bloody sword and returning it to its sheath. The divine messenger stands on top of a round tower, Hadrian's tomb (Castel Sant'Angelo). Although the gilded nude idols displayed on the city gates may be later additions by Jean Colombe, painted around 1485, they were placed there to emphasize that the early Christian pope had to combat, along with pestilence, paganism—a heresy, obviously a topic of interest to the fifteenth century. We have just observed that in one of Lieferinxe's altar panels, *Sebastian Destroying the Idols*, the illness had been caused by the Roman prefect's heretical views.[153]

An apt description of the image's meaning was formulated by Rosemary Horrox: "The emphasis on the universal sinfulness of mankind, which merited a universal punishment, implicitly denied that plague strikes only the individually guilty."[154] Since some of the citizens of Gregorian Rome had defied God, the illness struck the community indiscriminately. In the foreground, a monk has collapsed, and one of his brethren bends down to assist him. Behind them a young boy is lying helplessly on the ground, and one of the women is about to faint. Two frightened children tug on their mother's skirt. On the facing page, one of the bearers of a reliquary also has fallen ill.

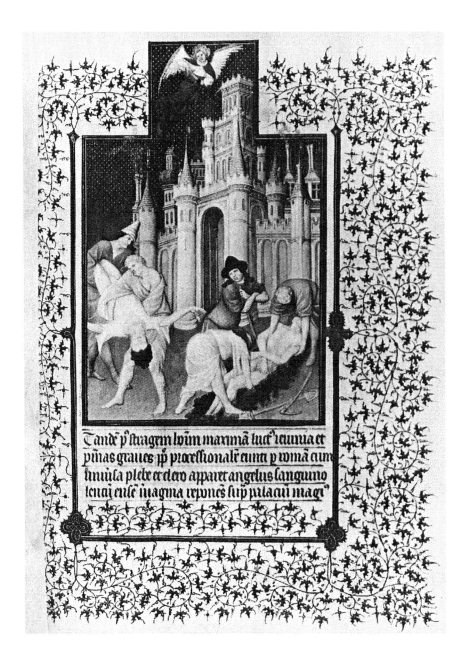

Fig. 4.4. *Vision of St. Michael,* Limbourg Brothers, from *Les Belles Heures,* fol. 74v, 1412.
The Metropolitan Museum of Art, The Cloisters Collection, 1954 (54.1.1).
Image © The Metropolitan Museum of Art.

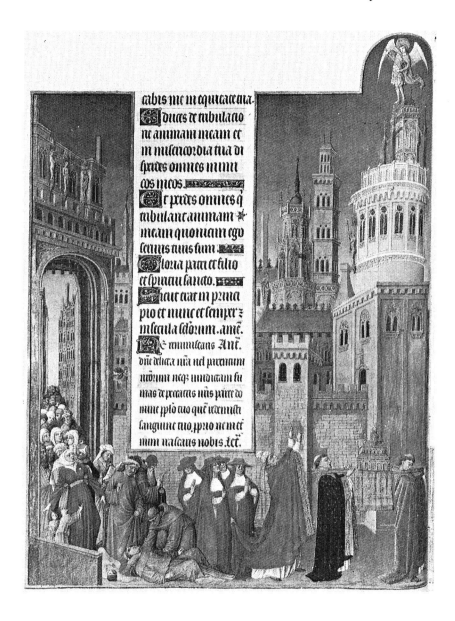

Fig. 4.5. *St. Gregory's Procession,* Limbourg Brothers, 1413–16, finished by Jean Colombe, 1485. *Les très Riches Heures du duc de Berry,* fol. 71r. Musée Condé, Chantilly, France. Giraudon/Art Resource, New York.

The double page is brilliantly colored in blue, black, and white; however, the reds of the cardinals' and the pope's vestments dominate the image of *St. Gregory's Procession*. Also shown is the Marian banner, mentioned in the *Golden Legend*. These details, too, may have been added by Jean Colombe. In the *Belles Heures*, the version finished in the early fifteenth century, the image of the Virgin was missing. *St. Gregory's Procession* displayed the crosses as symbols of the Greater Litany.[155] This iconographic change favoring the Madonna may indicate an increased devotion to the Virgin in the late fifteenth century in general and as plague intercessor in particular. Other differences between the two books of hours are that in the *Très Riches Heures* the flagellants and the burial rites were omitted.

Although I have tried to treat only four of the most universally petitioned plague saints, I want to make an exception with Nicholas of Tolentino (1245–1305) because his iconography is typical of minor intercessors after the Black Death. The saintly monk had been venerated soon after his death yet was not canonized until 1446. Nicholas had no intrinsic connection with bubonic plague but enjoyed a reputation of successfully intervening for souls in Purgatory.[156] Purgatory, as mentioned earlier, was the momentous innovation the Church had devised to give hope to the faithful during these times of crisis.

Nicholas of Tolentino was supported primarily by the Augustinian order and was most popular during the time of his canonization campaign. An important example is the image *St. Nicholas Saving Florence* (fig. 4.6) by Giovanni di Paolo. The panel is part of a vita altarpiece, produced for a convent church of Montepulciano. It is dated 1456, a year marked by an epidemic. The panel depicts one of the saint's posthumous miracles and shows Nicholas floating above the city of Florence assuring its people of his protection. In the foreground, to the left, a priest accompanied by a ministrant carries a veiled Gothic ciborium. A coffin and tapers are taken to a house on the right. The background shows a funerary procession; the acolytes bear the maximum allowable number of four torches in front of a coffin.

St. Nicholas Saving Florence is of special interest because it gives us a glimpse of fifteenth-century funeral preparations, but even more important, it shows a priest taking the viaticum (communion for the dying which prepares the way into the next world) to the sick.[157] Two points are critical for the reading of the image's meaning. One, that the bodies of the dying will be properly cared for by the community, and two, that the "Body of Christ" will save the person's soul, even if the mortal body has been destroyed by illness. The prominence of the sacraments for the diseased body also is

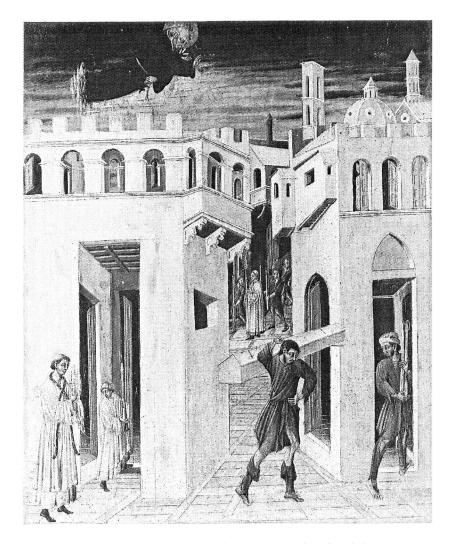

Fig. 4.6. *St. Nicholas Saving Florence,* Giovanni di Paolo, 1456.
Gemäldegalerie der Akademie der bildenden Künste, Vienna.

expressed in fifteenth-century literature. A book on the treatment of plague victims does not stress physical remedies but rather it prescribes: "the medicine of confession, viaticum, and final [extreme] unction."[158]

Throughout the centuries, eschatology was a continual subject in plague art. Just before the turn to the sixteenth century a powerful millennial movement emerged. It is exemplified in Albrecht Dürer's woodcut series of the

Apocalypse. Since the New Testament specifically stated that pestilence was one of the events to usher in the end of the world, the idea was even more appropriate in plague iconography. While specific chiliastic references were less pronounced in plague paintings they appeared prominently in print. For example, Philipp Culmacher's *Regimen wider die Pestilenz* depicts on the frontispiece *Christ the Judge* (fig. 4.7). The plague treatise was published before 1500.[159] The style of the woodcut is simple and direct, intended to be legible for people without formal education. Shown is Jesus "coming on a cloud," true to the description in the Bible. He floats on a large, stylized band of clouds, presenting his orb. On the judge's left appears the sword, and to his right, the lily. Below the Savior, St. Michael sheathes his weapon, according to Voragine's text. The archangel's sword divides the space between a Pietà and plague saints. Sebastian and Roch both display their wounds in an effort to intercede for suffering mankind. Below, in the terrestrial zone, a skeleton reigns supreme; he threatens the mortals with a scythe. On the left, we see a priest bringing communion to a dying man; and on the right, a bishop and another clergyman kneel in prayer in front of an open grave. Several corpses are being prepared for burial.

Culmacher's woodcut combines many of the most characteristic emblematic symbols, gestures, and figural compositions enumerated earlier. All of which are indicative of the plague iconography of the fifteenth-century Renaissance. Moreover, the images refer to the iconological themes associated with pestilence: the Second Coming of Christ and *ostentatio vulneris*, the showing of the wounds, alluding to satisfaction through suffering. *Memento mori* is portrayed by the Grim Reaper who warns the faithful of a sudden death. The significance of Christian burials, prayers, and most importantly the sacrament of the Eucharist are prominently displayed.

In conclusion, plague pictures after the Black Death share a number of topoi, and theological considerations are important for all interpretations. First and foremost, the concept of the satisfaction of divine justice is apparent in almost all of the above-mentioned examples. Moreover, intercessory and thaumaturgical saints performing miracles, the great supplication of St. Gregory, preparations for a Christian death, sacraments, and pious funerals will be repeated in numerous plague scenes. Even though the emphasis seems to be on the physical death, these didactic images must be read in the framework of their period. Religious duties of the living relate primarily to the afterlife of the deceased. Modifications of cults were possibly initiated by the papal doctrine of 1336 that reconfirmed the traditional Western belief of an individual judgment following death. According to Bynum, Benedict XII

Fig. 4.7. *Christ the Judge,* woodcut, title page of Philipp Culmacher, *Regimen wider die Pest,* before 1500. Reprinted by permission of the Library of the College of Physicians of Philadelphia.

defined the soul in his bull of 1336, "not as a self for which body is the completion or housing or garment, but a self of which body is the expression.... The *Visio Dei* controversy was thus the final episode in medieval discussion of the ontological and soteriological importance of body."[160] The Black Death in 1347 and the successive epidemics seem to have kept the spirit of *memento mori* "alive"! Also, greater importance is given to the Blessed Sacrament after the Black Death when increased numbers of Corpus Christi fraternities and eucharistic practices are documented. Although it is difficult to find passages in literature discussing a correlation between the malady of the physical body and the healing properties of the body of Christ, the thought is expressed visually. The association between the divine and diseased body may first have been a lay movement; however, the relationship will become more dogmatic in the years after the Catholic Reformation.

Although plague literature frequently described the loss of faith by the communities, abandonment by the clergy, doubt in divine justice, and other negative observations, such thoughts are never committed to a panel or canvas. The orthodox belief of the Roman Catholic Church permeated the artworks, and, in fact, was the premier reason for their existence. "For contemporary worshipers, images were an effective means of protection, ritually activated and manipulated in a process of confident negotiation and persuasion with the celestial powers."[161] This does not mean that the period presented uniform ideas. On the contrary, in each individual commission, one has to examine the multilayered symbolism and its spiritual message. Thus we find in the fourteenth and in the fifteenth centuries strikingly different, and often contradictory, functions assigned to the divine hierarchy. The people thought that the godheads can cause pestilence but also relieve the faithful of their affliction. Christ's role can alternate between stern judge and pleading intercessor. Even the Virgin and saints, on rare occasions, threaten humanity. A number of authors who discussed plague images of the period following the Black Death, for example Roger Seiler, warn against oversimplification in explaining the interaction between art and the disease.[162]

There cannot be any doubt that for the first hundred and fifty years after the return of bubonic plague to Europe, the images were created, almost exclusively, for religious purposes. However, the art was characterized by its diversity both in form and in function; iconic images as well as narratives can connote a variety of meanings. The discussion in the next chapter, the art of the sixteenth-century Renaissance, will present iconographical and iconological changes along with great innovations in style.

Chapter 5

The Sixteenth-Century Renaissance
(1500–1600)

Some of the most brilliantly innovative plague pictures originated during the High Renaissance, establishing the formal and iconographic bases for the next three hundred years. Votive art continued to be popular. Even more important, eschatological themes in plague art which had become prominent before the year 1500, as we have seen in the last chapter, were treated consistently throughout the sixteenth century. This may be due to a strong preaching tradition predicting that the end of the world was near.[163] On the other hand, in regard to matters of theology, prior to the Council of Trent artists were at liberty to create erudite imagery without the Roman Catholic Church's interference. Therefore, an increased tendency toward worldliness and elitism can be detected during the early years of the century. In Rome, religious fervor was at an all-time low. The first half of the sixteenth century, though by no means spared from bubonic plague epidemics, experienced other momentous historic events such as the Protestant Reformation and the ensuing wars. Later in the century, with the beginning of the Catholic Reformation, a decline of interest in humanism and a return to more spiritual values became discernible. Thus, numerous and often contradictory factors shaped the content of sixteenth-century plague art.

Artists invented novel *topoi* and even selected antique plague subjects. Raphael's *Plague of Phrygia*, which has been repeatedly mentioned for its influence on plague iconography, was not based on a Christian text but on Virgil's *Aeneid*. Prints, too, no longer had merely religious functions but became collectors' items and workshop aids for painters.

In the High Renaissance significant formal changes occurred as well. The most notable differences from the fourteenth to the sixteenth centuries

lie in stylistic development. In late-trecento and quattrocento works, deliberate discrepancies in figure sizes created a hierarchical scale. The divine persons invoked by the donors prior to 1500 were represented as spiritual giants to whom the patrons depicted in the paintings literally looked up in awe. A realistic, unified scale, adopted in the following periods, however, began to restrict some of the pious expressions customary in earlier examples. The proclivity toward crass naturalism, so noticeable in the fifteenth century—which, for example, compelled the artists to describe St. Roch's plague bubo in unprecedented verism—was sacrificed during the sixteenth-century Renaissance for more aesthetic formulas. Tintoretto, Parmigianino, and others merely depicted plague victims with skin blotches. Still, geniuses such as Raphael, Titian, Tintoretto, and Vasari contributed some of the most powerful and sophisticated statements on this harrowing disease. The era is illuminated primarily by the analysis of their masterpieces.

Plague images of the High Renaissance were most lastingly influenced by Raphael Santi. Between 1512 and 1514 the master created two plague subjects, the sketch for the *Plague of Phrygia* and the altar painting *Madonna di Foligno* (fig. 5.1). Since, at that time, only isolated cases of bubonic plague epidemics had been reported in Italy, Raphael's idiosyncratic explorations seem to have been academic. However, both creations are of utmost importance to the development of plague iconography.

Raphael's *Plague of Phrygia* represents the outbreak of a pestilential disease on the island of Crete. Because the drawing cannot be effectively reproduced, its imagery needs to be studied by looking at Raimondi's reversed printed copy, the *Morbetto* (see fig. 3.1). However, when I compared Raphael's original design with the printmaker's mirror image, I became aware that the messages of the *modello* and the engraving were different from each other.[164] Reading Raphael's drawing in its original sequence from left to right presents the only logical progression of the narrative and helps us comprehend the classical story. We see on the left the epidemic Apollo sent; yet hope for the future of Rome is explored on the right. In contrast, Raimondi's work shifts the emphasis toward the plague victims by positioning them on the right-hand side. More will be said about this altered effect below.[165]

To fully appreciate *Plague of Phrygia* and Raphael as the "mute poet," one has to recall the text in book 3 of Virgil's *Aeneid*. The passage tells how well the Trojan survivors, under Aeneas's guidance, had adapted to their new environment. They had just started to build a new city, Pergamea, "When suddenly from some poisonous region of heaven a pestilence fell upon our wretched frames."[166] Raphael visualized all the nuances of the

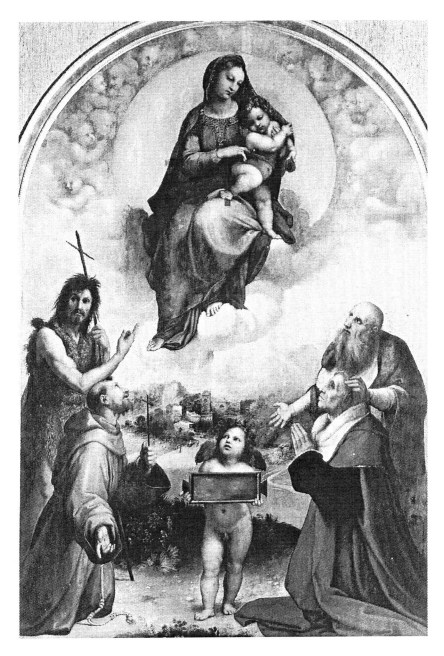

Fig. 5.1. *Madonna di Foligno,* Raphael, c. 1513, Pinacoteca, Vatican Museums.
Scala/Art Resource, New York.

poetic language, his sovereign manipulation of the sequential narrative lets the *Plague of Phrygia* appear as a unified scene. Yet, the composition portrays several events described in the text. The narration begins in the left middle ground with the description of the ravages of an epidemic, referring to the plight that had befallen "man, crop, and tree." We witness the litter bearers removing a corpse from a house and a dead animal that lies near a cluster of trees. In the background we see the unfinished buildings and walls of Pergamea. In the left foreground, Raphael illustrates the passage: "and that year death was the only yield we had." For this purpose the master consulted a Roman text which described Aristides's famous painting (now lost) that portrayed a wounded mother during the siege of a town. The ancient Greek artist supposedly had been very successful in describing the woman's efforts to protect her child from drinking her already "poisoned" milk. Although this episode of the dying mother and her child had been utilized earlier by Ghirlandaio in his *Massacre of the Innocents,* Raphael made the group immortal by associating it with a timely topic—pestilence![167]

Raphael divided the composition by placing a *herma* centrally in the foreground, thus juxtaposing the story of destruction with the promise of rescue. On the right, a man can be seen entering a stable holding a torch. This vignette alluded to "It was night and every creature on earth was in the grip of sleep"—not, as some scholars have assumed, that it represented animal carcasses killed by pestilence. Adhering even more closely to the text, Raphael then introduced Aeneas's dream in the upper right-hand corner. Divine light streams into the room where the future founder of Rome reclines. The two Penates reveal to Aeneas that they have come at Apollo's bidding to urge the leader of the Trojan refugees to look further for their promised homeland, "the Western land ... there lies your true home." Raphael modeled the vision after an illustration of the Vatican *Aeneid* to give the image authenticity. I want to draw attention to the fact that the illustrator of the fifth-century manuscript selected "Aeneas's Dream"—*not* the "Epidemic"—to represent the essence of the story. Moreover, in light of the founding legend, retold in Raphael's drawing, we have to perceive the child's rescue from the diseased region as a prophesy of Rome's future glory. Raphael's story was a novelty in sixteenth-century Rome. In closure, I pose the question, could Raphael have intended the *Plague of Phrygia* as an allegory of history? Could he have shared similar ideas—current in the seventeenth century—that defined "History" as having a twofold dimension: "the course of decay, the course of rescue."[168] More appears on this subject in chapter 6.

We will probably never know whether Raphael really intended the *Plague of Phrygia* as a preparatory drawing for a print. It has been confirmed that Raimondi's *Morbetto* was based on at least two more of Raphael's sketches. Unusual, however, is the fact that the engraving is the only known example where Raimondi produced Raphael's design in reverse. The publication date of the print is controversial, although most authors agree on an execution date after Raphael's death in 1520, yet, no one seems to have an explanation why the print was not executed soon after the subject's inception in 1512. Either quite deliberately or because Raimondi was unable to reproduce the design without altering the direction, the engraver obliterated Raphael's original intent of a literal interpretation of the text. Looking at the print's mirror image, and comparing it to Raphael's design, the *Morbetto's* meaning seems to change before our eyes. At first glance we encounter on the left the enigmatic stable scene portraying the animals in deathlike slumber. Then, our gaze gets drawn toward the right-hand side of the composition where the group of suffering people triggers our negative response to the disaster. Both scenes seem to become one. Also, since the episodes do not appear in sequence, "Aeneas's Dream," in the upper-left-hand corner of the engraving, carries little significance for the story.

By the process of reversing the original design, Raimondi reinforced the vivid description of a devastating epidemic and by supplying the base of the herm with a Latin caption, describing how the diseased suffered, the print focused almost exclusively on the morbid side of the myth.[169] The engraving's title by which the scene had become famous, the *Morbetto*, stressed death and disease, rather than Rome's founding legend. The segments of classical columns also add to the disparity of our association. In Raphael's drawing, the stone drums with dowel holes ready for the erection of the columns conjure up an image of the abandoned construction site of Pergamea. The fragments from now on signified pestilence, and to future generations the Pergamean ruins suggested primarily illness.[170]

I propose that Raimondi published the *Morbetto* at a time when plague, again, posed a real threat to the Italian public. After 1522 a new wave of epidemics arrived which lasted until 1530. Thus Raimondi's *Morbetto* would have found a ready market for his plague subject. The engraving addressed an important issue of the day; and because of the lingering infections, Raimondi's *Morbetto* was copied for centuries to come. Also, the print represented a rare example of a secular plague subject which was probably created for a different and more sophisticated clientele than the devotional images. In the sixteenth century, avid art collectors as well as artists were interested in

stylistic and iconographic developments.[171]

To return to Raphael's second plague topic, his *Madonna di Foligno,* one has to admire the versatility as the Renaissance master pursued a very different aspect of pestilence. According to a sixteenth-century inscription on the altar's frame, the painting commemorated the death of the papal secretary Sigismondo de Conti. The octogenarian, a native of Foligno, had died in 1512 of unknown causes. Until c. 1564, the painting graced the high altar of Santa Maria in Aracoeli, Rome, the church where Raphael's art patron had been buried.

Elisabeth Schröter recently recognized Raphael's *Madonna di Foligno* as a plague picture *(Pestbild).*[172] Indeed, the famous altar panel displays the characteristics of a votive composition. The two-zone format of the *Madonna di Foligno* is derived from votive paintings and plague gonfalons. In the heavenly realm, the Madonna of the Nikopoeia type faces the viewer holding the Christ child with both hands. Mary is enthroned on a cloud. A brilliantly lit circle of Seraphim surrounds the Divinities. Below stands an angel holding a tablet.[173] Also in the terrestrial zone are the figures of the donor and St. Jerome, who introduces him to the Virgin. Two more intercessors are depicted, John the Baptist and Francis of Assisi. In the background appears the city of Foligno which in 1511 may have been threatened by bubonic plague.

Schröter's seminal iconographic inquiry presented the complexity of the Marian altar in the context of other contemporary plague images. Her iconological interpretations work on two levels. On the one hand, the *Madonna di Foligno* explains the disease scientifically; on the other hand, Raphael's semiotics emphasize eschatology as the theological intimation of pestilence. Raphael's symbolism is as innovative as it is esoteric.

To explain the natural occurrences that generate pestilence, Raphael included in the *Madonna di Foligno* a rainbow along with the comet. The theory that such luminous heavenly bodies were responsible for pestilential air was widespread and originated in antique texts as well as in contemporary sixteenth-century hypotheses. Comets were believed to be dry, hot secretions of the earth that are drawn by stellar power into the atmosphere where they ignite. These speculations extend back as far as Aristotle. Later, Albertus Magnus distinguished three types of comets; Raphael's stellar body, because of its red color, could be identified with Mars, prophesying the worst disasters. Renaissance scientific literature generally depicted comets below a rainbow which was explained as a cloud saturated by moisture that gets its color from the sun's reflection. The meteorological combination of

the two phenomena—comet and rainbow—also was thought to change the atmosphere, causing miasmic air to form which, in turn, breeds disease.[174]

The supernatural interpretation of the *Madonna di Foligno* is equally complex. Santa Maria in Aracoeli, one of the oldest churches in the Eternal City, has been associated with plague from the time of the Black Death, when the people and the senate of Rome donated its grand stairway to thank the mother of God for ending the epidemic in 1348. Therefore, from its inception, the placement of Raphael's painting related to pestilence.[175] Identifiable chiliastic themes included the Madonna and Child engulfed by the radiant sun, representing the Apocalyptic Woman (Rev. 12:1–3). Furthermore, the conspicuous bank of clouds, onto which the Christ child descends, refers to him as the future judge. In Raphael's altar painting, the Son of Man in the arms of his mother, wrapping himself in Mary's veil, alludes to his passion (shroud). The angel with the tablet and rainbow also symbolize apocalyptic events. Additionally, Raphael may have used references to celestial indicators of the disease as metaphors for the Last Judgment.

Schröter did not address the problem of why the donor, who was most likely not a victim of bubonic plague, had chosen that subject. One possibility is that when a comet appeared in 1511, the year preceding the painting's commission, Conti may have expected an outbreak in the near future. Also, the imminent end of the world had been preached in Italy for some time. Therefore, either the donor or Raphael himself decided on an eschatological theme.[176] Although the iconography of the *Madonna di Foligno* is that of a *Pestbild,* the commission may or may not have been plague-related, and, therefore, one cannot speak with certainty of a plague-votive commission in the narrowest sense of the word.

While the subject of the *Plague of Phrygia* did not have an immediate following in Renaissance paintings, the repercussions of Raphael's plague Madonna are traceable throughout Italy in painting as well as in the graphic arts. Raimondi and other printmakers produced several iconic Marian images after their master's design, showing the Virgin with her Son on a large cloud, thus alluding to the Day of Reckoning. An unknown sixteenth-century artist produced a print after one of Raimondi's Madonnas which included a Marian hymn against pestilence. Such engravings may have helped popularize and disseminate Raphael's prototype.[177]

The influence of Raphael's *Madonna di Foligno* is equally noticeable in the fine arts. In fact, Correggio and Sodoma both produced altars for plague confraternities that resemble Raphael's Virgin very closely.[178] These

devotional paintings prove that sixteenth-century artists—and seventeenth-century painters such as Guido Reni (see chapter 6)—would have taken it for granted that the *Madonna di Foligno* was indeed a "plague picture."[179] A similar iconographic program appears in Titian's oeuvre; however, the question of what role engravings played in spreading Raphael's invention is still being debated.

Several authors have claimed that the *Madonna di Foligno* must have influenced Titian's *Gozzi Altarpiece*. How that was accomplished cannot be fully explained since Raphael's painting was still in Rome when the Venetian master painted the central section, the *Madonna and Child with SS. Francis and Aloysius and Alvise Gozzi as Donor* (fig. 5.2), for the altar in San Francesco ad Alto in Ancona. The names of the artist and the donor are written on a trompe l'oeil piece of paper. The inscription also includes the date of 1520.[180]

The painting's composition is divided into the characteristic two regions found in other ex-votos. Heaven displays the divine vision on clouds surrounded by angels; the intercessors and Alvise Gozzi remain below. Undoubtedly there are iconographic parallels with Raphael's Foligno altar. In Titian's work, too, St. Francis displays his wounds, and Bishop Aloysius presents the donor to the Virgin. Furthermore, a similar effect of glowing light as the one so highly praised in the *Madonna di Foligno* can be observed also in Titian's altar.[181] The city with a steeple has been identified as Venice, but more important for the apocalyptic reading is the fig tree that appears in the earthly zone just below the infant Christ. The shape of the foliage leaves no doubt that it is the budding tree Jesus referred to when he warned of the unpredictability of judgment day. Reference to eschatology is found not only in the fig tree but also in the future judge—characterized by the *descensus* motif—as he steps onto the clouds. Moreover, the choice of intercessors and the prominence of the cityscape also suggest the pictorial convention of a plague subject.

Although the circumstances of the commission pertaining to Titian's masterpiece are not known, its iconographic program suggests that in the sixteenth century plague and the final things were common subjects. The year 1520 was not marked by a major outbreak of plague, nor was the donor associated with a plague confraternity. Alvise Gozzi did not die until 1538, and he was buried in San Francesco, Ancona, in the church where eighteen years earlier he had donated the high altar. Again, just as in the case of the *Madonna di Foligno*, the commission was not directly related to an epidemic. The most likely explanation would be that the *Gozzi Altar* was one of

Fig. 5.2. Gozzi Altarpiece, Titian, 1520, Chiesa di S. Domenico, Ancona, Italy.
Alinari/Art Resource, New York.

the artworks donated by a pious person for his community, in anticipation of the countless visitations experienced during the Renaissance. Titian had painted a number of plague saints during his lifetime; he was no stranger to this dread disease. In 1510 Titian had fled Venice to escape the epidemic which killed Giorgione. He was less fortunate in 1576 when he, too, fell prey to bubonic plague.

Just as Raphael, Titian, and others executed plague altars in the sixteenth century, so did Giorgio Vasari. We stand on firmer ground when we analyze the function of his *St. Roch Altarpiece*. Dated 1536, it was commissioned by the confraternity of St. Roch for their church in Arezzo.[182] The main altar painting *Virgin and Child Enthroned with Saints* (fig. 5.3) depicts God the Father, who sends pestilence toward earth in the form of arrows. Below the image of a wrathful deity, the Virgin and her young Son are enthroned on a raised platform. Six saints intercede for the people; SS. Roch and Sebastian kneel in the foreground. The two famous plague patrons are characterized, respectively, by their attributes, the dog and the arrow. The other four inter-cessors are Anne and Joseph, as well as the martyrs Donato and Stephen. Compared to earlier depictions of plague saints, Vasari avoided the display of wounds so important in the fifteenth century. They surround the enthroned Madonna in a "holy conversation," an iconic type popular since the middle of the fifteenth century.

Just as in Raphael's *Madonna di Foligno*, so the images of Vasari's altar refer to pestilence as predicting the final days on earth. The central panel was dominated by an omnipotent, vindictive God. His powerful body is partially hidden by a voluminous, dark plague cloud and surrounded by angels who supply him with arrows for his punitive action. All these were common motifs in plague iconography. Additionally, the subject is complemented by a rendition of the Davidian plague represented in the predella. The three oblong panels recount King David's story, adhering closely to the biblical text of the Old Law.

The first scene, *The Prophet Gad Offers David a Choice of Three Divine Punishments*, alludes to the king's choice between war, famine, and pesti-lence. *God the Father Sends the Plague upon the People of Israel* again depicts the heavens darkened by clouds and the ground covered with plague-stricken. According to the Bible, seventy thousand Israelites were slain at that time. In this painting, Vasari chose the moment when God commands the angel to halt the destruction before entering Jerusalem. The third panel por-trays the important event of David making amends for his sin. In *David Acquires Land on Which to Erect an Altar of Thanksgiving* we see more

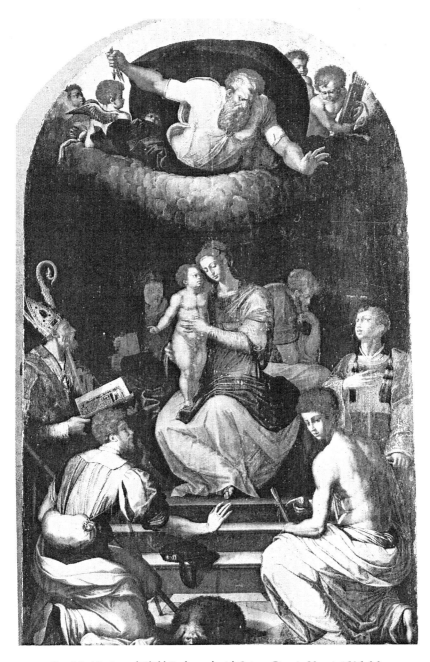

Fig. 5.3. *Virgin and Child Enthroned with Saints,* Giorgio Vasari, 1536. Museo Medievale e Moderno, Arezzo. Courtesy of Archivo Fotographico, Soprintenza per i Beni Ambientale, Architethonici, Artistici e Storici, Arezzo.

distinctly that Vasari based his painting on the text of 1 Chron. 21:1–28, which offers more anecdotal details than the second book of Samuel. "Now Ornan was threshing wheat; he turned and saw the angel, and his four sons who were with him hid themselves." One can make out two small faces of the Jebusite's sons hiding in the building on the right. In the foreground, Ornan alone kneels before David's royal party and the plague angel. As discussed earlier, the subject foreshadows the building of Solomon's Temple on this sacred site of restitution.

Stylistically Vasari is still beholden to his central Italian impressions. His formal qualities, particularly in the predella, show a mannerist lack of depth, thus enhancing the flow of the narration. The actors of the drama take up much of the picture plane, further supporting the story with their powerful rhetorical gestures. Also, Vasari may have been inspired by Roman funerary reliefs; sarcophagi frequently depicted the Niobe story. The gesture and posture of the plague angel shooting arrows resembles the image of Diana killing Niobe's children. In Western literature, the proud queen's punishment by Apollo and his sister, the sudden loss of her fourteen offspring, has long been associated with bubonic plague.[183]

Louise Marshall suggested that the chiliastic imagery in the main altar panel presented the sophisticated Renaissance viewers with a historical perspective on the meaning of the disease as part of God's providential plan for his people. This notion becomes even more meaningful when seen in light of St. Augustine's *History of Salvation*. The conceit may have been one of the reasons why Vasari chose this convoluted subject for Arezzo. The depiction of the Davidian epidemic is rare in monumental art, and I have posed the question elsewhere of why so few plague altar painters chose the subject.[184] Yet the fact that Vasari did select this enigmatic topic reveals his and his contemporaries' penchant for complex theological symbolism. Furthermore, the intermingling of religious and pagan literary sources is characteristic of the erudite taste in the sixteenth-century Renaissance. Vasari produced several other plague objects, among them a banner executed in 1568. By that time, the artist had studied Tintoretto's *St. Roch Ministering to the Plague Victims in Venice,* the famous painting which is discussed below.

Jacopo Robusti, generally known as Tintoretto, also contributed to plague iconography when he painted a monumental cycle on the life of St. Roch. His action-packed *St. Roch Ministering to the Plague Victims* (fig. 5.4) did not fulfill the function of an altarpiece. It is a wall decoration in a church dedicated to St. Roch. Since little is known about the circumstances surrounding this commission, a general introduction about Venice as a plague

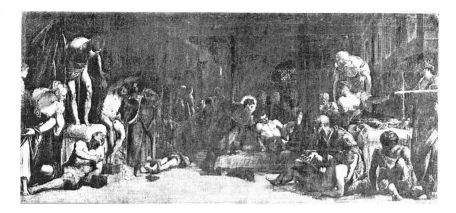

Fig. 5.4. *St. Roch Ministering to the Plague Victims,* Tintoretto, 1549. Chiesa di S. Rocco, Venice. Alinari/Art Resource, New York.

city might help to explain the scene. The city of the Serenissima had more than its share of epidemics because its harbor was open to the traffic from the Levant, and for that reason, its population was particularly fond of Roch long before the Roman Catholic Church officially accepted him as a saint. The diffusion of his cult cannot be linked to any specific religious order but was the people's spontaneous response to the devastating epidemics in the Veneto. St. Roch confraternities first appeared in the city of Venice during the plague year of 1477. The most important lay community was the Scuola Grande di San Rocco; construction of its building complex started in 1517. For the presbytery of its church, Tintoretto created *St. Roch Ministering to the Plague Victims.* The date of the painting is documented as 1549. The large canvas is now part of a series depicting the saint's life; the other scenes, however, were painted by the artist at a later date.[185]

Tintoretto's canonical work depicting St. Roch in a *lazaretto* created an impressive stage on which the drama of a miraculous cure unfolds. The large sickroom is filled with human misery. The saint appears, in a brilliant aureole, in the middle ground. He is about to touch a victim's thigh wound; the femoral bubo relates to Roch's own symptom. By "laying on hands," the saintly pilgrim will heal the man. Other patients look longingly toward St. Roch, their bodies also racked by disease. They point to, and examine their discolored skin lesions, making the viewers aware of their pain. I assume that Tintoretto did not have a personal encounter with bubonic plague because one of his patients points toward his biceps rather than at his armpit. Studying

some of the many medical illustrations available to the Venetian master, one can see how he may have misinterpreted their gestures.[186]

However, even the most dismal subject—such as pestilence—could not dim the splendor of a Venetian action scene *(Ereignisbild)*. The large plague ward bustles with elegant female attendants taking care of their nursing duties in great style, bringing food and medicine to the suffering. Some of the wealthy female patients are presented in a daring *deshabillée*. Narrative paintings depicting St. Roch remained relatively rare and are limited primarily to the succession of Tintoretto's celebrated prototype. Later, I discuss the iconological changes which were caused by the Roman Catholic Church in the wake of Counter-Reformational revisionism.

Fewer plague paintings were created in northern Europe during the sixteenth century, most likely because of some latent and later more overt iconophobic tendencies, meaning an adverse attitude toward religious imagery. Therefore, throughout the century, many artists trained in religious subjects, looked for work in Catholic Italy. This may have been the case with Simon de Wobreck, a native of Haarlem, who settled in Palermo in 1557 where he stayed for the rest of his life.[187] In 1576 Wobreck painted *Palermo Delivered from Pestilence*. The canvas depicts God the Father, floating in heaven, brandishing three arrows. Christ, seated on a bank of clouds to his right, points at his side wound. The Savior is surrounded by angels bearing the *arma Christi* as if preparing for the Last Judgment. However, in Wobreck's altar painting, one of the larger angels carries a lily instead of the customary sword, indicating that the epidemic has ended. Below, in a multiple intercession, kneel the Virgin, SS. Roch, Sebastian, and two female martyrs. A night procession takes place in the darkened city. Torch-bearing, hooded members of a plague confraternity add to the ominous atmosphere. In the foreground of *Palermo Delivered from Pestilence,* some dignitaries give thanks to the Divine.

Little is known about this altar's patronage. However, the date, 1576, marked one of the most severe pan-European scourges recorded in history. In the same year the "Borromean Plague" struck Milan, Titian died in Venice, and many other cities were gravely affected; the number of lives lost was staggering. Therefore, the imagery of *Palermo Delivered from Pestilence* seems self-explanatory. Its arrangement recalls earlier paintings depicting a specific city chastised by God. Although the altar belongs to the post-Trent era, it summarizes many of the doctrinal conventions first introduced in the fourteenth century. Its iconographic formula has been adopted from the repertoire of the *dies irae* and the late-medieval tradition of plague votives. Christ

presenting his wounds referred to the satisfaction of divine justice. The hooded laymen recall the fanaticism of the flagellants and are in keeping with the austere theology of Catholic Reformation. The tradition of a vengeful God in plague iconography was particularly strong among Northern artists and continued in the their works long after the Church had revised its policies favoring imagery of a benevolent deity.

The sixteenth-century Renaissance examples shared a number of characteristics. Even in a time when the study of antiquity was generally favored, most artists depicted Christian plague scenes. I have attempted to set forth the number of great artists who produced not only famous altarpieces but also minor liturgical objects, although within their oeuvres these devotional images are not well researched. All of the High-Renaissance artworks were executed in a dazzlingly elegant style; yet, many paintings alluded to the perils of the final days on earth. Wobreck's *Palermo Delivered from Pestilence*, among others, voiced the urgency of atonement. They differed from their quattrocento predecessors by their elaborate and erudite programs. For example, Vasari's *St. Roch Altar* interspersed religious ideas with references to secular sources. Furthermore, his altar followed Raphael's *Plague of Phrygia* in implying that pestilence revealed the working of a divine plan for the history of mankind. Raphael's *Madonna di Foligno* explained the plague phenomenon with contemporary scientific theories. This, however, should not distract from the fact that the altar reflected innovative theological features such as the Franciscans' emphasis on the Immaculate Conception. However, the emphasis on the virtue of suffering was eliminated. I do not believe that the formal requirements of the rule of decorum were solely responsible for neglecting to depict plague buboes; rather a subtle change in theology took place which became more prominent in the 1600s. Worth mentioning is that few of the sixteenth-century plague subjects related directly to a specific epidemic, but "pestilence" had become a topic, chosen by private citizens as well as by numerous confraternities, to ward off plague and to prepare for the Creator's final judgment. These High Renaissance masterpieces were characteristic of the brief hiatus between the iconographic tradition, developed in the wake of the Black Death, and the rise of religious schemata imposed by the Roman Catholic Church in the more restrictive Tridentine era. In contrast, although Wobreck's work was painted as late as 1576, it seems closer to the spirit of the late-medieval tradition.[188]

For mainstream plague art of the next centuries, the formal innovations of the sixteenth century proved more consequential than the cerebral Renaissance conceits. Particularly the ability to render the viable space needed for

multifigural compositions was an important artistic achievement. Raimondi's *Morbetto* became the prototype for outdoor plague scenes set among classical ruins. Tintoretto's *St. Roch Ministering to the Plague Victims* started a long tradition of realistically depicted hospital wards. His work shows St. Roch performing a miracle, a subject that was typical for the doctrinal tradition prior to the Tridentine world. Such occurrences alluded to conventions soon to be outmoded and revised by the teachings of the reformed Roman Catholic Church. The iconography and iconology would change quite significantly, once the Council implemented its innovative Church policies. The faith expressed in Tridentine theology recalls the fervor of the Middle Ages and found lasting expression in seventeenth-century plague art.

Chapter 6

The Tridentine World: Plague Paintings as Implementations of Catholic Reforms (1600–1775)

Outbreaks of bubonic plague continued to afflict western and central Europe until the 1720s, when the most stringent health measures seem to have averted further epidemics. Over the centuries medical science had pioneered some empirical strategies to cope with the devastating effects of the disease, and people had accepted the fact that simple prayers could not prevent contagion. These experiences, however, did not alter the generally held belief that God sent the scourge because of human frailties; most Christians still regarded plague as divine retribution for sin.

During the Age of Enlightenment, attitudes toward illness began to change. Slowly, bubonic plague was recognized by most people for what it was—not a sign from God, but an infectious disease for which medicine had not yet found a cure. A more "enlightened" view of disease is noticeable at the very point when bubonic plague vanished from Europe. It is difficult to say if a causal connection exists.

Some of the most famous historic epidemics depicted in the seventeenth and eighteenth centuries included two disastrous visitations in Milan: "the St. Charles" or "Borromean" plague in 1575–78, and the "Manzonian" epidemic of 1629–33, named after the nineteenth-century author; the devastations of Rome and Naples which occurred in 1656–57; and the final blow that was dealt to Marseilles in 1720–21. Of course, thousands of other cities were affected as the pandemics swept across the continent. For example, the "Great Plague" struck London in 1665, although that disaster was not represented in the fine arts; see below.

The most significant iconographic changes in seventeenth-century

plague imagery can be observed in narrative paintings that described the horrors of an epidemic. They rarely functioned as votives, and few examples related to dates of epidemics. In countless images the theme of pestilence was used to emphasize the correct observance of the sacraments and the willingness of the clergy to risk their lives in the service of God's mission on earth. The didactic altarpieces also stressed the ethical behavior expected of family and friends during such traumatic visitations. Since teaching catechism had become an important duty of the clergy, these doctrinal images lightened the task particularly in territories where Protestant interference had to be considered. They suggested a new topos: salvation of the common people during a time of crisis. The rhetoric of these plague scenes convinced the masses that they were in "good hands" and had nothing to fear—not even death. Plague allegories, although rare, differed from narrative paintings primarily in their interpretations. The introduction of allegorical figures transformed the established meaning of traditional iconographical types. These symbol-laden works cannot be read literally; their metaphorical content must be explored on an individual basis. The votive tradition, on the other hand, showed fewer changes in comparison with earlier periods. Ex-votos served the same function they had fulfilled for centuries. In fact, it is here that we can see a revival of medieval piety. However, all religious art needs to be explored from the perspective of a reformed Catholic Church.

Tridentine theology had a decisive impact on plague imagery and because production of plague creations increased during the seventeenth century, a greater number of illustrations are presented in this chapter. What made pestilence such a fertile subject during the Baroque period? The reason for this can, in part, be found in the changing patterns of European religious beliefs. One of the most significant modifications in plague iconography and iconology was triggered by Protestant and Catholic reforms. Although these ideological changes had been established fifty years earlier, the implementation of the laws, supported by new catechisms and compendia of rituals, did not make its impact felt in plague iconography until c. 1600.[189] However, at a time when iconophobic Calvinists, Lutherans, and the Church of England purged their religious buildings of images, and other monotheistic religions such as Judaism and Islam forbade or at least discouraged figurative art altogether, the Roman Catholic Church alone went on an offensive by commissioning propagandistic religious art. The rulings of the Council of Trent (1545–63) and the Counter-Reformation movement had restated the Church's traditional position on the veneration of images. This decree became the theological justification for all sacred art for centuries to come.

Rome's reaffirmation and insistence on religious imagery to educate the masses is most important for our discussion. Art was placed in the service of the Church to preach the Roman Catholic faith and was an important factor in creating the Baroque style in the early 1600s.

Art historians have long scrutinized the Tridentine Decree on the Arts and its later interpretations for clues on how the council had affected painting. The synod formulated its views on the visual arts in one of the last sessions in 1563. As soon as the Roman Church gave up its attempt to compromise with the Protestants on religious issues, the theologians began to underpin the foundations on which religious art was built. They argued that sacred art was far from being idolatrous and an important means of salvation. The Inquisition and other religious institutions censored the works so they would neither mislead Catholics nor give Protestants a weapon against the Church. As Anthony Blunt, the famous art historian, formulated it in his thorough analysis of the Church's position, "The decency of religious paintings was watched as carefully as their orthodoxy."[190] To ensure the success of these official policies, members of the Roman Art Academy of St. Luke, an art institution under the protectorate of the papacy, had to pledge to conform with its constitution. The written directives required that individual artists honor the demand for clarity in depicting religious subjects. Another important paragraph concerned the observation of "decorum" pertaining to the depiction of the human body and its dress code. Seventeenth-century painters ceased showing tantalizing, seminude victims of disease and they avoided the portrayal of disfiguring symptoms; hence Baroque paintings rarely displayed plague buboes.[191]

Tridentine theology did not differ essentially from earlier teachings because the Council of Trent made no revisions on already established dogmatic questions; it only interpreted and republished the doctrinal principles of previous synods. Therefore, we find, along with reinvigorated ideology, a resurgence of medieval beliefs. Yet, by and large, the Christian communities—Protestant as well as Catholic—were better educated than they had been previously. Over the centuries, the fear of dying and of hell lessened because the lucid judiciary system of the Ten Commandments had replaced the rather vague concept of the Seven Deadly Sins. Furthermore, the Catholic clergy emphasized a more merciful passage through Purgatory; formerly perceived as almost like hell, Purgatory was now presented as a place of purification where angels served the sacraments to the suffering souls. New catechisms specified the requirements for the faithful, which relieved the irrational fear of a "bad death." The Catholic Church was also better organized

to supervise the individual religious practices within a parish, demanding written proof of participation in the sacraments and requiring children to be educated in the ideology of their faith. However, since illiteracy was still rampant, the Roman Catholic Church recognized the advantages of presenting its catechistic teachings in innovative, impressive altar paintings that would be accessible to everyone.

Many of the plague paintings referred to the synod's two most fervently debated issues which needed redefining in the wake of the Protestant Reformation: the seven sacraments and the canon of justification. The former needed reaffirmation because the reformers recognized only two of the traditional sacraments, baptism and communion, and the latter, because the Church held dear the conviction—in direct opposition to Protestant doctrines—that man is not saved solely through faith and divine grace *(fide sola and gratia sola).* Free Will made Catholics responsible for an active participation in their own salvation; thus good works and petitioning the help of intercessory saints were believed necessary to achieve that goal. Moreover, the Church denounced the teaching of Anselm of Canterbury on Christ's satisfaction of sin.[192]

The very definition of a sacrament as an "outward sign" lent itself well to depiction. Yet, for enigmatic reasons, no continuous visual tradition of the seven sacraments existed in Western art. This gap was filled in the Baroque period by plague paintings which were singularly well suited to depict these sacred rites. Five of the seven sacraments could be illustrated in plague scenes: baptism, extreme unction or the last rites, confirmation, penance or confession, but most important, communion or the Eucharist. Marriages were forbidden during an epidemic, and the ordination of priests would never have taken place outside a church in a plague setting. Above all, the representation of the two sacraments that the reformers accepted needed to be differentiated from the representation of the new rites as they were celebrated by the Protestants.

The eucharistic theme had been an integral part of plague iconography at least since the fifteenth century. Carrying the *viaticum* to the dying has been depicted in plague art since the early Renaissance, as seen in figure 6.6.[193] However, after the Protestant Reformation, whose spiritual leaders had attacked the Catholic practice of allowing only priests to partake of the chalice during communion, the subject gained renewed favor and meaning. The Protestants served the whole congregation *communio utraque,* that is, communion in both species of bread and wine. Although the Protestant factions pursued more or less aniconic tendencies in church decorations, the few altar

paintings created after the schism depicted nontraditional (Lutheran) rites. For example, Otto Wagenfeldt (c.1650) portrayed in the *Lutheran Eucharistic Feast* two celebrants serving bread and wine (paten and chalice) to the congregation (fig. 6.1). The design for the altar is preserved only in two oil sketches.[194]

Because of the theological issues involved, the Counter-Reformation developed the eucharist topic further and in contrast to the Protestant sacramental altarpieces; the Catholic counterparts rendered lay communion in a single species, serving only the host. Bringing the blessed sacrament to the sick became by far the most popular subject in seventeenth-century plague paintings. The significance in each and every one of these communion scenes, the focal point of the composition, is the communion wafer presented for contemplation to its recipient. Moreover, since plague services did not take place in a church, the artist had the opportunity to depict the ciborium, a container for the consecrated hosts that was used outside of mass. Unlike the Gothic vessels depicted by Giovanni di Paolo (see fig. 4.6), in the Baroque period the liturgical object resembled a chalice with an ornamental cover. However, the artistic representation of a ciborium without its lid made the receptacle almost indistinguishable from the cup that the priest partook of during mass. In plague paintings, the chalicelike shape was intended to reaffirm the Catholic belief that Christ's body and blood are miraculously present in every morsel of the consecrated bread. These ritualistic details make plague communion scenes contentious topics; thus they were most frequently commissioned in Catholic regions that had to defend their ceremonies against the influences of Protestant practices.[195]

Moreover, the new genre of painting, "the last communion of a layperson," glorified the position of the Catholic clergy. These depictions stressed the qualities of the "modern saints," who were ordained priests and no longer just saintly laypeople. Since Protestantism had redefined the theological role of its ministers, these too were highly charged issues. None of the reformed sects accepted the belief that the priest, during mass, renewed the sacrifice of the cross (transubstantiation) and that the clerics—rather than God—forgave sins in the sacrament of penance. The debate over confession and the gradually increasing emphasis on the papal "power of the keys" was mentioned in chapter 4. To accentuate the special status of the Catholic clergy, Bishop Sadolet wrote in the sixteenth century: "It is through the *sacerdotium* that we are sanctified; the priest is mediator and interpreter of God's law, the vessel of divinity who conveys the promise and the means of salvation."[196]

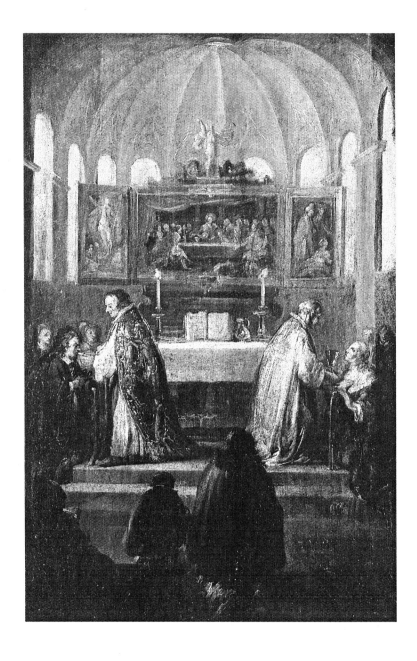

Fig. 6.1. *Lutheran Eucharistic Feast,* Otto Wagenfeldt, c. 1650.
Hauptkirche St. Jacobi, Hamburg.

Changes in the interpretation of the canon of justification affected the Roman Catholic Church's attitude toward death and salvation. By the seventeenth century, the concept of an angry deity demanding satisfaction through suffering, so commonly depicted in earlier plague scenes, was replaced by an image of a loving God, who looked kindly upon charitable actions and the celebration of liturgical rituals. For example, Bishop Belsunce preached in 1720 in Marseilles: "He [Christ] wills not the death of a sinner, but rather that he should turn from his ways and live[!]"[197] In the seventeenth and eighteenth centuries, the Church taught that during an epidemic heaven was possibly even closer at hand, since the pope would open "the treasures of the Church" and grant dispensations and possibly plenary indulgences to help the faithful. Papal bulls promised spiritual rewards for those who risked their lives in the service of others in heroic charity which was no less glorious than martyrdom.[198]

As Baroque plague scenes showed an increased emphasis on the acceptance of death in the hope of life everlasting, concern for the victims' health or efforts to miraculously heal the physical body declined in plague paintings. If religious persons are depicted, their significance rests on their personal sacrifices rather than on the hope for a recovery of the plague-stricken. Whereas the Catholic Church supported the faithful from the cradle to the grave with its carefully orchestrated rituals, funeral depictions in Baroque plague narratives are conspicuously absent. The late medieval preoccupation with bodily resurrection had gradually been supplanted by a more spiritual attitude that stressed the importance of the eternal soul. Yet the relationship between body, soul, and God still occupied the minds of Catholics. Their attitude can be summed up in the motto of St. Camille de Lellis (1550–1615): "Al corpo prima dell'anima, al corpo per l'anima, l'uno e l'altro per Iddeo" [attend the body before the soul, the body for the soul, body and soul for God]. In other words, the sick needed to be cared for in an effort to prepare their souls before they would have to face their Maker.

Consequently, many Tridentine reforms were concerned with the formation of religious hospitals. The council had spent a number of sessions reviewing the importance of charitable institutions. Two nursing orders were founded after 1563: the *Camilliani*—its founder the above-mentioned Camille de Lellis—and the Hospitallers, founded by St. John of God. Most of the seventeenth-century plague attendants seem to have been male; the absence of nuns in the sickroom is readily explained by Pope Pius V's imposed *clausura* for all-female orders in Italy. While the Catholic territories appear to have fared reasonably well under the care of their religious nursing

staff, many complaints about the lack of trained personnel were voiced in 1665 in Protestant England. In the final analysis it will be up to social historians to determine if the Catholic nursing orders had made, de facto, a real contribution during these critical times.

A large portion of the body of works discussed in this chapter were created in Italy. They constitute some of the earliest and most effective visual records of the reformed Roman Catholic Church. Indeed, one could call most of the plague scenes quintessential expressions of the Church's newly energized spirit. Although the topics are morbid, the paintings reflect changes in church policies and ethical values, and they provide insight into liturgical rituals practiced after the Council of Trent, which remained in effect until the revisions of Vatican II. As far as the accuracy of the rituals performed during epidemics is concerned, one has to keep in mind that sanitary rules had simplified the traditional ceremonies and the clergy's dress code. Therefore, the paintings reflect not reality but an idealized world to stress the care provided by the Catholic priests and lay brothers.

Most Italian sacramental plague pictures were created to reinforce the teachings of the *Tridentinum;* many images were concerned with the reestablishment of the traditional sacraments. As mentioned earlier, during the years following the Protestant Reformation, objectionable religious observances were curtailed in the hope of reaching a compromise with the dissenting Christians. However, after 1564, the directives of the Church encouraged bishops and lower clergy to intensify the emphasis on some religious traditions, yet minimize others. Therefore, Charles Borromeo's active fight against pestilence through the power of the eucharistic sacrament is most often depicted in plague scenes. Although this particular scene was not illustrated in the original cycle of the *quadroni,* the subject became popular soon after Charles's canonization in 1610.[199] Both Tanzio da Varallo and Carlo Saraceni portrayed Milan's cardinal archbishop administering the sacrament to laypersons before 1620. However it was not until the second half of the seventeenth century that prints after Pierre Mignard's *St. Charles Administers the Viaticum to a Plague Victim* (see fig. 3.3) gave this composition its canonical form. The image's doctrinal meaning relied on serving communion in a single species to a layperson.

In Mignard's composition a sick woman is seated on the ground with a child in her lap. The patient is supported by a member of her family who aids her in receiving the sacrament for the last time. Often the auxiliary figure shows the gesture of contrition, the left hand placed on the heart—the seat of sin—because the victim herself seems too feeble to demonstrate

remorse. St. Charles holds the communion wafer in his right hand; in his left, the saint presents a lidless ciborium. Charles is followed by some attendants and two acolytes carrying the prescribed torches and a bell to alert the people in the sickroom of the Savior's presence. All the other patients—assisted by the nursing staff—also express the desire to receive the viaticum before their demise. Mignard's original design also included almsgivers who taught the beholder the values of charity.[200] The scene reflects concern not for the high and mighty but for the underprivileged class during their hour of death.

Compared to the myriad eucharistic scenes produced as altar paintings, the remaining sacraments play a minor role in Tridentine art production. However, "infant baptism" was a vital issue since some of the Protestant catechisms illustrated adult rites. Second, and probably even more important, was the fact that Roman Catholics claimed unbaptized children were destined to remain in the *limbo infanti* rather than attain heaven. The Church was adamant about this belief; it ordered, under threat of excommunication, that children be christened before they were nine days old, even by provisional baptisms, administered by laypeople if the infant appeared to be in danger of death.

Lodovico Carracci's *St. Charles Baptizes an Infant in a Plague Encampment* represents the Catholic ceremony as specified in the *Rubric* in minute detail, which differed from the Protestant versions depicted in altarpieces and broadsheets.[201] The scene takes place in a plague encampment outside Milan's city walls. In the background are tents, the makeshift hospital space St. Charles had provided from his own funds. According to his biographer, the archbishop had bankrupted himself so that others might live. Yet St. Charles's main interest was not directed toward his congregation's physical health; the saint devoted his efforts to gain the time that would allow him to cleanse the souls entrusted to his care.

The episode depicted in *St. Charles Baptizes an Infant in a Plague Encampment* relates closely to the saint's biographical texts and refers to an incident of a girl born black ("nera come carbone"), supposedly because the disease discolored her skin. In the painting, however, the child is not dark, for such an abnormality would have been against the rule of "decorum." The orphan owed her life to St. Charles, who had the child nursed back to health. He provided the best possible nourishment for newborns by supplying goats' milk—the animals are prominently displayed in the foreground of the painting—since wet nurses often refused to take on infected children. It has been suggested that *St. Charles Baptizes an Infant in a Plague Encampment* not

only depicted the heroic deed of the archbishop but that the arrangement also alluded to a second theme, one of St. Charles Borromeo's posthumous miracles. His vita reported that the baptized girl gave birth herself in 1604 to a deformed, blind son who gained sight only after the mother invoked the saint's help.[202]

St. Charles Baptizes an Infant in a Plague Encampment, the altar for the Abbey Church of Nonantola, was an important ecclesiastical commission. The donor was Monsignore Alessandro Mattei, who wrote from Rome in 1613 that the chapel and altar should be dedicated to the new saint, whose fame and devotion grew daily in Italy. Lodovico Carracci, working mostly in Bologna, may have been influenced by Cardinal Paleotti's art theories. The cardinal expounded that the functions of the visual arts were to serve, to edify, and to move. He suggested that the painters should consider themselves preachers since the visible world depicted on the canvas was often more effective than the spoken word. The message Lodovico conveyed was that St. Charles made a supreme effort, risking his own life and the lives of his attendants, so that this tiny infant would not be condemned to the *limbo infanti*. By using a realistic and austere mode, *St. Charles Baptizes an Infant in a Plague Encampment* reflects simultaneously the spirituality of the reformed Church and the seriousness of the subject.

While it was essential for Catholic plague paintings to distinguish the communion and baptismal services from those of their Protestant neighbors, the popularity of some of the sacraments such as confirmation, confession, and the last rites, needed to be revitalized even in Catholic territories. For example, confirmation had incurred the Protestant reformers' contempt; therefore this sacrament, designed to convey grace and strengthen the recipient to lead an "adult" Christian life, had fallen into disuse during most of the sixteenth century. However, because the sacrament had been neglected after the Protestant Reformation, the *Catechismus Romanum* reemphasized its importance. Consequently, when St. Charles realized during the 1576 epidemic that many of the adult members of his congregation had not been confirmed, he went to administer the sacrament to large crowds. Camillo Landrini painted the historic scene in 1602 as part of the *quadroni* to show how successfully the saint implemented the new laws of the Church.[203]

The sacrament of penance was much debated in seventeenth-century theological circles because it concerned the position of the pope and the clergy. The suggestion of the bishop of Bath in 1349, that laypersons could hear confession in times of pestilence, was no longer an option. However, individual confessional scenes remained rare because during an epidemic

such preparatory steps were waived for dying patients. I know of only one plague painting that illustrates a priest hearing confession during the Borromean Plague.[204]

Extreme unction, too, had been neglected during the time of reforms as well as in Tridentine art. Various reasons can be cited for the paucity of illustrations of that theme: first, the Church insisted on a number of preparatory steps such as confession and communion, which required the priest to make more than one visit to the infirm; second, with papal plenary indulgences available, last rites were most often replaced with the viaticum; and third, previous abuses of indulgence practices had brought that sacrament into disrepute with the Protestants and caused its decline even during the sixteenth and the seventeenth centuries in Catholic territories.

However, in 1713, when specific issues of the Protestant Reformation were no longer fresh in the people's minds, a German prince commissioned the Roman artist Benedetto Luti to paint *St. Charles Administers Extreme Unction* (fig. 6.2). The large cabinet painting was possibly intended to honor the ruling Habsburg emperor. The sacramental scene represented Charles

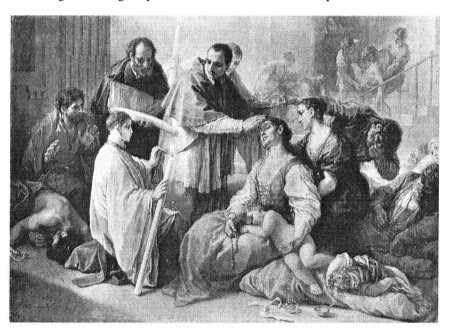

Fig. 6.2. *St. Charles Administers Extreme Unction,* Benedetto Luti, 1713. Bayerische Staatsgemäldesammlungen, Staatsgalerie in Neuen Schlosss Schleissheim.

VI's patron saint, and the date coincides with the last major plague epidemic in the imperial capital of Vienna.[205]

Luti created a variation of Mignard's popular figure group of the comatose woman with her child. The *Rubric* permitted the last rites to be administered even to delirious patients who were unable to make any sign of acknowledgment, *if* the infirm was known to be in the state of grace. We can see St. Charles performing the sacrament; shown is an abbreviated ceremony of anointing only the victim's forehead, since during an epidemic the applications of the holy chrism were reduced from five to only one or two. Although Luti recorded the liturgical paraphernalia in great detail, he made the saint and the devout mother the center of attention.[206]

In addition to sacramental scenes, Italian plague paintings depicted "good works" in altar paintings. Pietro da Cortona's *St. Charles Leads the Procession of the Holy Nail* shows the historic scene which had been treated in the *quadroni*. The painting was executed in 1667 for the Roman church of San Carlo ai Catinari. It gives a solemn account of the events described by one of St. Charles's biographers. The penitential mood of the procession is observed, depicting the cardinal wearing a rope around his neck like a condemned criminal and carrying the sacred relic because the saint "considered himself to bear upon his shoulders the burden of the sins of the people in imitation of King David."[207] In the preparatory drawing for the altar, shown here (fig. 6.3), Cortona portrayed St. Charles barefoot. The artist also sketched the contrite crowd, barely visible is the staffage figure of a woman who raises a child toward the saint.

In contrast, the altar painting observed all the rules of decorum. Although Cortona invoked artistic license when he changed the penitent's clothes to cardinal's vestments, he was in compliance with the canonization decree. Another change from the sketch is the placement of the mother from the right to the left—in front of the saint. Her touching gesture heightens the emotional pitch of the scene. The vignette refers to the cardinal archbishop's reputation of having accepted all living souls, sick or well, as long as they needed his help. The group of mother and child would be quoted, in a different context, by the French artist Jean-Léon Gérôme almost two hundred years later.[208]

In the painting, Cortona emphasized the importance of St. Charles. The saint's steadfast pace presents the only calm in the composition. The artist exploited the windblown baldachin in his *St. Charles Leads the Procession of the Holy Nail* for narrative purposes; during epidemics people prayed for wind to alleviate the danger of miasmic air. The burst of wind in Cortona's

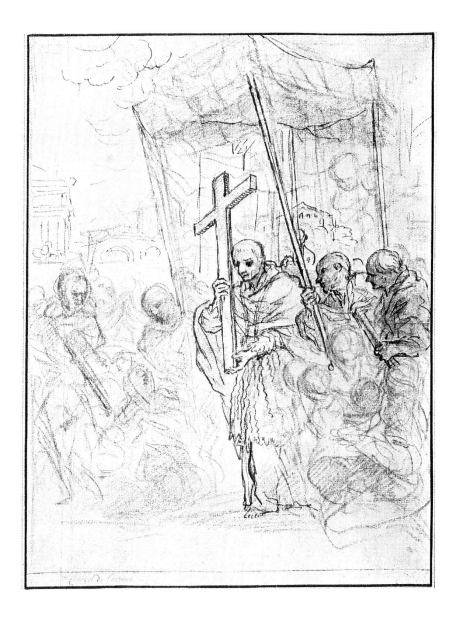

Fig. 6.3. *St. Charles Leads Procession of the Holy Nail,* drawing, Pietro da Cortona, 1667.
Graphische Sammlung Albertina, Vienna.

painting indicates to the beholder that the saint's prayers have been answered. The agitation caused by the elements, the flickering lights and the billowing drapery, and the frenzied movement of the crowd all contribute to the expression of religious fervor.

There is an interesting postscript to this commission. Pierre Mignard had originally entered his oil sketch *St. Charles Administers the Viaticum to a Plague Victim* into the competition for this altar. His design, however, must have been rejected; the reason for this is not known. Mignard's project was never executed; however, since his *modello* was successfully reproduced in print, in the long run, the design proved much more influential than Cortona's altarpiece.[209]

Although good works were important in Catholic theology and frequently shown in Tridentine hospital scenes, nonordained plague intercessors, such as St. Roch, the Blessed Bernard Tolomei, and others, had to be accompanied by members of the regular clergy. The clerics, because they were empowered to administer the sacraments, outranked laity. The change in the religious climate before and after the Council of Trent is best documented by comparing Tintoretto's *St. Roch Ministering to the Plague Victims* (see fig. 5.4) with Giacomo Lauro's version of 1605. The novelty in the seventeenth-century composition is the introduction of a priest into the sickroom. Lauro's St. Roch, the secular pilgrim, is no longer completely in charge. Nor are miraculous cures part of the Church's dictates; the clergy's mission was directed to fulfill the spiritual needs of the sick. The primary concern for the victims' physical health that Tintoretto conveyed in his plague scene had been emended.[210]

Another work advocating Tridentine propaganda is Giuseppe Maria Crespi's *Bl. Bernard Tolomei Comforting the Victims of the Plague*. He painted the scene around 1735 representing the city of Siena, where the lay brother had lost his life tending the sick during the Black Death. Although the event portrayed took place in 1348, the fashions and the ceremonies reflect eighteenth-century customs. The painting has two focal points—in the foreground toward the right, two Olivetan monks kneel in the midst of the suffering people; the other spotlight shines on the left-hand corner, where a bareheaded priest under an *umbella* carries a veiled ciborium. He is accompanied by an acolyte with light and bell. The plague patients and brother Bernard gaze, transfixed, as they watch the clergyman's arrival. The scene has been explained as representing the last communion of the plague victims and of the *beato*. The rhetoric of the image is forthright; despite the presence of death the people are never forsaken by the Church.[211]

The Olivetan Abbot Corsi had commissioned Crespi to paint *Bl. Bernard Tolomei Comforting the Victims of the Plague*, most likely to influence—although unsuccessfully—Bl. Bernard's canonization procedure. Until recently, when the master's original resurfaced, this popular design was known only in numerous copies. One of the variants, by an unknown Italian artist, differs considerably from Crespi's work, not only in its iconography but also in its iconology. In this later version (fig. 6.4), the priest is intro-

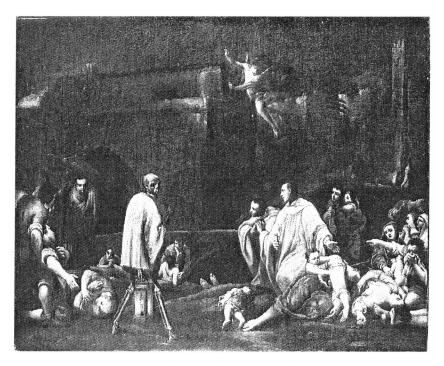

Fig. 6.4. *Blessed Bernard Tolomei Comforting Victims of the Plague,* follower of Giuseppe Maria Crespi, eighteenth century. Gemäldegalerie der Akademie der bildenden Künste, Vienna.

duced not by the customary bell-swinging acolyte but by a frightening skeleton, dressed like a ministrant, in a surplice. Not previously recognized is the fact that the unorthodox source for the eighteenth-century painting was Hans Holbein's print of the *Totentanz* series *Death and the Priest* (fig. 6.5). In the sixteenth-century woodcut a skeleton also announces the presence of the clergyman with a bell. Although not in accord with Tridentine teachings, that the life-giving eucharistic sacrament should *not* be preceded by Death,

Der Pfarrherr.

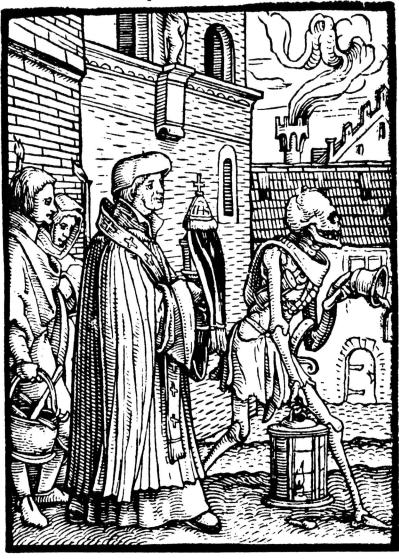

Fig. 6.5. *Death and the Priest,* woodcut, Hans Holbein, before 1538.
Graphische Sammlung der Albertina, Vienna.

the theme of *memento mori* seems to have resurfaced in this protoromantic painting.[212] Since we have no record of this particular commission, one has to assume that a later variant would have been displayed in a private setting or possibly in a sacristy.

Plague scenes north of the Alps differed from the Italian plague paintings primarily in their function. In the transalpine regions the topic appeared only in locations bordering Protestantism, such as Switzerland, France, Germany, Austria, Bohemia, Hungary, and the Spanish Netherlands. For that reason these religious scenes took on an additional meaning. They addressed polemic subjects in an effort to defend Catholic doctrines against the heretical teachings of the "Others." Catholic Spain, for example, isolated from the Protestant controversies, did not commission plague scenes. Furthermore, the lacuna of even profane plague paintings in Protestant Germany, the northern provinces of the Netherlands, Scandinavia, and England is enlightening. I will return to this observation later.

During the Counter-Reformation, Catholics chose the subjects most fervently disputed by the reformed churches for representation in their combat to regain some of the lost territories that had rejected the pope. This political aspect of plague subjects has not been stressed in literature, yet it was the focus on theological issues that gave the plague pictures their *raison d'être*. Although not numerous, plague altars painted north of the Alps are a significant part of this investigation. Created almost exclusively by Italian-trained Catholic artists, they highlighted the Church's sphere of influence in the north. The first choice in the countries outside Italy was the seemingly rejected French design by Pierre Mignard. *St. Charles Administers the Viaticum to a Plague Victim* apparently encapsulated the very ideals of the Counter-Reformation. Versions of this work still exist in Switzerland, France, Germany, Belgium, and above all in the former Habsburg territories of Austria, Bohemia, and Hungary. In fact, one could say that St. Charles was the politically correct choice for Catholic centers friendly to the imperial house. Altarpieces of St. Charles can be found in the most vulnerable enclaves in the Habsburg satellite states: Prague, Sloup near Brünn, and Olmütz (Bohemia), Leibach (Slovenia), and Papa (Hungary). All these cities had a long history of Protestant and even Muslim interventions. Shown here is one of the last, large plague altarpieces, painted in 1785, Josef Zirckler's version still in situ in St. Stephen's church in Papa (fig. 6.6). In Austria the renditions of *St. Charles Administers the Viaticum to a Plague Victim* were displayed in some of the most prestigious religious institutions.[213]

The danger of Protestant infiltration was also strong in the Spanish

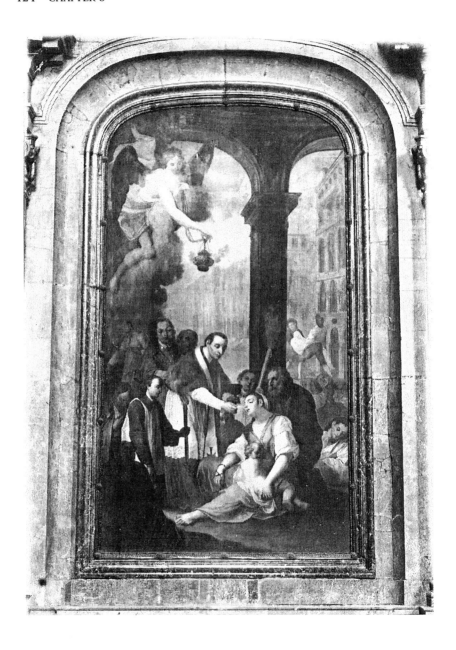

Fig. 6.6. *St. Charles Administers the Viaticum to a Plague Victim,* Josef Zirckler, 1785.
St. Stephen, Papa. Intendance des Monuments Historique de la Hongrie.

Netherlands. Versions of *St. Charles Administers the Viaticum to a Plague Victim*, showing the polemical subject of communion in one species, are found in a number of Flemish churches. However, the Catholic provinces, by and large, preferred their own saints to the Italian cardinal. For example, Jacob van Oost the Younger painted a large altarpiece *St. Macarius of Ghent Administers the Viaticum*, now displayed in the Louvre in Paris.

Baroque plague allegories of the seventeenth century can appear in many different formats. Sometimes—but by no means always—they include allegorical personifications. Although the allegories discussed below portray a physical disease, the images as a whole convey a spiritual message. After the Protestant Reformation, Catholic literature frequently used plague as a simile for heresy. Accordingly, these allegorical paintings need to be read metaphorically instead of being interpreted on their descriptive level.

I discovered two seventeenth-century examples—others may yet be found—that equate the disease of the body with a heretical corruption of the soul. The first painting, by an anonymous master, is entitled *Allegory of the Jesuit Order* (fig. 6.7); the second is Peter Paul Rubens's famous *The Miracles of St. Francis Xavier* (fig. 6.8). Both canvases date c. 1617, and although their pictorial language could not be any more disparate, the same Counter-Reformational spirit prevails. Moreover, the two had been created in Antwerp's Jesuit milieu, so they portray the society's saints and were commissioned in preparation for Francis Xavier's beatification and canonization campaigns.[214]

The formal qualities of the two paintings give evidence that at the beginning of the seventeenth century considerable discrepancies in rhetorical expression existed in paintings of the Spanish Netherlands; yet both artists employed similar semiotics. In fact, analysis of the *Allegory of the Jesuit Order* sheds light on the content and meaning of Rubens's altarpiece.

Allegory of the Jesuit Order is an unassuming canvas; its conceit was most likely the invention of an Antwerp rhetorician who proudly signed the lengthy Latin inscription on the bottom of the painting:

> Still ye dare, infernal plagues, feathered Heresy, furious Calumny, to insult the Society of Jesus, floating on a cloud of tribulation over a cross of adversity; heavenly protection surrounds. Stretch the bow, half-beastly Paganism; pull the string, foxlike Duplicity. On yourselves the missiles will come back, repelled by adamantine shields of patience with which veteran gladiators, Ignatius and Xavier, equip their own family; dedicated by Judocus van der Gheylen, Rhetorician. 1617.[215]

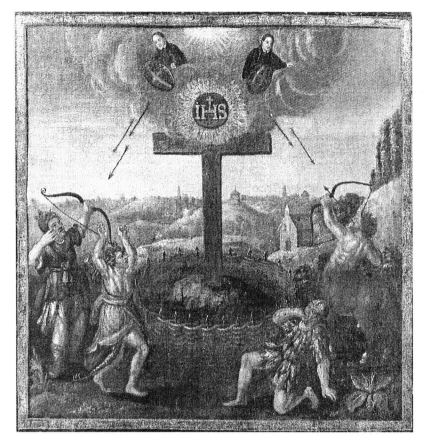

Fig. 6.7. Detail of *Allegory of the Jesuit Order,* unknown artist, 1617.
St. Ignatius, Antwerp. House of the Jesuits (photo by author).

The images in the *Allegory of the Jesuit Order* correspond closely to its rhetorical text; it is truly a word picture. The composition is dominated by a large cross in the very center of the painting. It is planted firmly in a circular enclosure of a primitive wattle fence and surrounded by a landscape with a cordon of chapels and small churches which must allude to "heavenly protection surrounds." The emblem of the Society of Jesus appears on the cross. The phrase "a cross of adversity" most likely refers to the opening words of the Jesuit Constitution, which reads, "Whoever desires to serve as a soldier of God beneath the banner of the Cross in our society." Ignatius and Francis Xavier, whose names appear in the text, display golden rays above their heads to indicate their status of Blessed (although somewhat premature for Francis

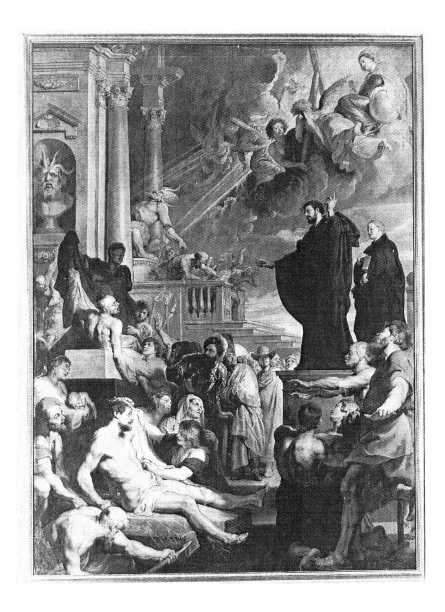

Fig. 6.8. *The Miracles of St. Francis Xavier,* P. P. Rubens, 1617.
Kunsthistorisches Museum, Vienna.

Xavier). Dressed in black cassocks, the *patres* are partially covered by a dark cloud, "the Society of Jesus on a cloud of tribulation." The semantics of the term indicate eschatological connotations. The two Jesuits do not carry weapons; however, their "shields of patience" repel the arrows of their opponents, and the fathers effectively reverse the stream of arrows that two bowmen fire from below. As the Latin text explains, "On yourselves the missiles will come back, repelled by adamantine shields of patience with which veteran gladiators, Ignatius and Xavier, equip their own family."

The arrows supply the transition from the heavenly zone to earth, where the four pestiferous heresies are characterized as non-Christians. On the right appears a classical centaur who represents "half-beastly Paganism," and on the left, a male figure sporting a fox pelt, Hercules-style, over his head and shoulders. The proverbial "untrustworthy fox" (in Dante's *Purgatory*, the symbol of heresy) is translated in the text as "pull the string, foxlike Duplicity." In the foreground next to Duplicity appears "Furious Calumny," a half-naked old hag with serpents in her hair, similar to Ripa's image of Heresy. To her right, "feathered Heresy" is represented by a figure crouched in a pinwheel pose. His flesh is spotted with red sores and most of his body is covered with feathers. The trope's meaning is found in similar images depicting indigenous people in the Americas. It was not at all uncommon for provincial workshops to indicate "Indians" as wearing feathers, whether they came from the New World or from Asia. Since the artist was not very steadfast in geography, he may have copied the rashlike symptoms from illustrations depicting native Americans infected with smallpox. This epidemic disease killed a major portion of the native population.[216]

The Miracles of St. Francis Xavier, on the other hand, gives the viewer the illusion of being an eyewitness to the missionary's activities. In Rubens's cosmopolitan studio the emphasis was placed on authenticity of costumes, accouterments, and ethnic features. Although his painting lacks an explanatory text, we are informed about the artist's literary sources for the Antwerp altar painting. It has been suggested that Rubens had knowledge of the biography *De vita Francisi Xaveri* and that he kept abreast of current investigations in the canonization procedure.

The Miracles of St. Francis Xavier shows the saint and his acolyte elevated on a pedestal from which the missionary addresses a multitude of people. Francis Xavier extends his right hand and points his left toward heaven where *Fides Catholica* appears on a cloud. The female allegory of the Catholic Faith topples a large pagan idol with a lightning bolt. Since Rubens chose to depict a symbolic divine intervention, the whole scene takes on an allegorical character.

Although the events in *The Miracles of St. Francis Xavier* seem to take place in a superb architectural setting, Rubens had not intended to show unified action. Rather, the crowd represents a sampling of Francis Xavier's thaumaturgical gifts, such as the resurrection scene and the healing of a blind man, cripples, and others. The apostle of the Far East had been credited with curing a throng of sick and converting them by making the sign of the cross. I have argued elsewhere that the prominent foreground figure, a reclining man on the brink of death, whose armpit is being examined by women, depicts a bubonic plague victim. The artist repeated the scene verbatim as the "plague-stricken" in *St. Francis of Paola*. Hence it can be assumed that the seventeenth-century viewer associated this gesture, exposing the underarm region for observation by health personnel, with bubonic plague.

In *The Miracles of St. Francis Xavier* the prominence of the plague victim also might emphasize his metaphorical significance. The man's placement within the picture is paralleled by convulsed men and women in the altar's pendant. *The Miracles of St. Ignatius of Loyola* was painted by Rubens at the same time to be displayed in the Jesuit church on alternating feast days. According to seventeenth-century beliefs, people possessed by demons needed to be exorcised to regain their physical and spiritual health. Similarly, heretical views needed to be recanted before the plague victim could be healed. Thus, in both canvases, the artist uses tangible symptoms to describe a state of mind. Rubens's plague patient is characterized as a sick "Other," a non-Catholic, about to be brought into the Church; hence he was miraculously healed of this deadly disease. A. Lynn Martin, in his excellent book, *Plague? Jesuit Accounts of Epidemic Disease in the 16th Century,* on the involvement of the Society of Jesus during European health crises, proved that the order frequently attributed such visitations to heresy.[217]

Although pestilence and heresy seem to be factors in both allegories, the formal treatment is different. Rubens's *The Miracles of St. Francis Xavier,* for example, includes the plague victim in a realistically conceived scene; the metaphor for the disease is expressed in body language and gestures. In contrast, the unknown Antwerp master's dry and archaizing approach of the *Allegory of the Jesuit Order* presents us with a pictorial riddle. Nonetheless, both works were inspired by Jesuit rhetoric concerning the body politic, using pestilence as a simile for heresy. The two paintings proclaim that calamities, like plague, can be overcome only by the true Roman Catholic faith and that the Jesuit saints can guide the way to everlasting life.

Aside from the art propagated by and for the Catholic Church, Nicolas Poussin, an independent artist in Rome, chose the topic of the *Plague at*

Ashdod, in 1630–31, years when most of Italy was infected with bubonic plague (see fig. 3.2). To Poussin's contemporaries, the timely subject appeared as a realistic plague scene. The painter based the iconography on 1 Samuel 5:4–6; the text spoke of "tumors" that punished the Philistines for capturing the Ark of the Covenant (see appendix).

Poussin presented the two incidents in his *Plague at Ashdod* as one scene; the sick, victims of God's wrath, appear in the foreground. The stricken are characterized by their individual responses to the disease: despair, stoicism in the face of death, and escapism. The events in the temple, on the other hand, take place somewhat farther back. As discussed in chapter 3, the passage in the book of Samuel had never before been associated with bubonic plague. Sixteenth-century scriptural commentaries had suggested that the disease the Philistines experienced was dysentery.[218]

Since the subject of Poussin's canvas was unique, the meaning of the *Plague at Ashdod* is enigmatic. The artist's original title, *The Miracle of the Ark in the Temple of Dagon*, signifies that Poussin had an alternate reading in mind when he painted "the miracle of the Ark in Dagon's temple." As I have demonstrated above, the destruction of pagan cult figures by heavenly mediation generally alluded to heretical activities. We are reminded of Rubens's fallen idol in *The Miracles of St. Francis Xavier*, which Poussin most certainly would have known from prints. He also must have been aware of the association of plague with heresy. I proposed in 1991 that the key to Poussin's painting can be found in the tiny background figures that have been ignored in art historical literature. Their extreme reduction in size indicates the late mannerist convention of interpolating a related scene separated in time and place. I identified this "third" scene, the woman carrying a child and hurrying toward a distant obelisk, as referring to Mary on her flight into Egypt. Several observations support my interpretation. The artist himself had described his painting as "Miracle of the Ark," and the Virgin—who appears close to the sacred object—has been called the "New Ark of the Covenant."[219] In Poussin's painting, mother and child are about to pass pagan statuary. In medieval typology the "Fall of Dagon"—Poussin's subject—was always paired with the "Fallen Idols of the Flight into Egypt." Moreover, the artist alluded to the House of David by placing a lush green tree in front of a palatial structure. Several men are standing on a balcony. We can identify Zadok, the priest in David's court, who is dressed in sacerdotal white and overlooks the destruction in the foreground. Next to him, King David glances at Mary below. Apart from the typological symbols, the painting's color scheme, too, helps us interpret the scene. The plague victims in the

foreground are described in muted tones; on the other hand, the brightly lit obelisk promises a radiant future. Raphael, in his *Plague of Phrygia,* which Poussin quoted extensively in his plague scene, had expressed an analogous duality in the themes of destruction and hope. This juxtaposition has been identified as characteristic of seventeenth-century definition of history.[220]

Thus Poussin seems to have selected the *Plague at Ashdod* not only for its medical subject but also for its theological significance to create an allegory of history. The erudite artist must have been aware that the miracle in the temple of Dagon represented a turning point in the history of the Jews and that the Ark found its permanent resting place in Solomon's Temple in Jerusalem. The annotated *Anchor Bible* describes that section of the Old Testament as follows: "The books of Samuel and Kings display a relentless march of history toward not only David, the chosen king, but also Jerusalem, the chosen city, and along with the latter, Zadok of Jerusalem, the chosen priest."[221] The importance for King David's plague altar site and Jerusalem has been discussed at length in chapter 2. The association of the Old Testament king and pestilence adds to the dialectic complexity of Poussin's *Plague at Ashdod.* I contend that the artist intended to illustrate more than the two related biblical passages quoted above. The painting represented "the power of the Ark," implying a divine plan governing history by epitomizing the chain of events that foreshadowed the future of the Jews and that of Christianity as well.

In plague votives after the Council of Trent neither the schemata and functions of votive paintings nor their iconological meanings changed appreciably since these images first appeared in the fourteenth century. Two seventeenth-century examples, however, should demonstrate the subtle differences expressed in Tridentine theology and in Baroque paintings.

A work of art that attests to a continuing iconographic tradition of plague processional banners was Guido Reni's *Pallione del Voto* (fig. 6.9). Bologna's senate had commissioned it in the fateful year of 1630. It is one of the few masterpieces known to have been executed during an epidemic. The *Pallione del Voto,* as did so many plague votives before, "gave voice to the citizens of Bologna to plead with God, through the intercession of the saints and Mary, to end their plight."[222]

The *Pallione del Voto* depicts the Virgin, seated on a cloud, resting her feet on a rainbow; she and her son are framed by an aureole of angels. The Christ child holds an olive branch and raises his right hand in blessing. The Madonna type can be identified with the apocalyptic woman of John's vision, as Raphael had shown in his *Madonna di Foligno.* The similarities

between the two famous paintings are striking and exceed mere formal influences. However, Reni's less cerebral gonfalon did not include cosmic symbols, the ominous comet, because such scientific additions would have been frowned upon by the Catholic authorities, who demanded images that could be understood even by the illiterate. Below the divine pair, seven male saints intercede for the city—among them the newly canonized Jesuit saints, Ignatius and Francis Xavier.[223] The scene closest to the viewer at the bottom of the painting is executed in much broader, sketchier brush strokes, reminiscent of earlier, folkloric votive panels. Reni added some anecdotal touches in the depiction of Bologna with its famous twin towers; biers and horse-drawn pest carts are seen in front of the city's walls, a feature derived from fifteenth-century plague images of Benedetto Bonfigli and others. This confirms the tenacity of the iconographic tradition.

The second example of a Tridentine plague votive is Luca Giordano's *St. Gennaro Frees Naples from the Plague* (see fig. 1.7), discussed in chapter 1. The altar was commissioned to commemorate the liberation from the epidemic of 1656 and was executed for the church of Santa Maria del Pianto in Naples. Both the building and the altar were consecrated in 1662 to sanctify the grotto, where during the recent visitation countless Neapolitan plague victims found their final resting places.

In this work Giordano translated the traditional plague vocabulary into an expressive and pervasive pictorial language. The earthly zone is filled with nude corpses piled high, carelessly dumped by criminals hired to clear the streets of decaying flesh. Death renders the beautiful and the ugly bodies anonymous. Giordano, who had experienced the epidemic firsthand, depicted with singular verism the repulsive sores of the dead, defying all laws of decorum. As stated earlier, the Roman Catholic Church forbade or at least discouraged disfiguring realism when dealing with the human body. Since it is the only Italian plague painting of the seventeenth century known to me that depicts the physical symptoms of bubonic plague, I concluded that the artist had a reason for his breach with convention.[224]

I believe that theologically speaking, Giordano's disregard of the decrees on decorum and the neglect of pious funerals in his *St. Gennaro Frees Naples from the Plague* do not imply a decline in religious practices; on the contrary, the artist merely voiced the expendability of the physical body after death and stressed the importance of the immortal soul. The dichotomy between body and soul, which manifested in the macabre imagery of the *transi*, is revived in Giordano's repulsive cadavers.[225] Reading the altar painting, one experiences a veritable *danse macabre,* although social classes are no longer

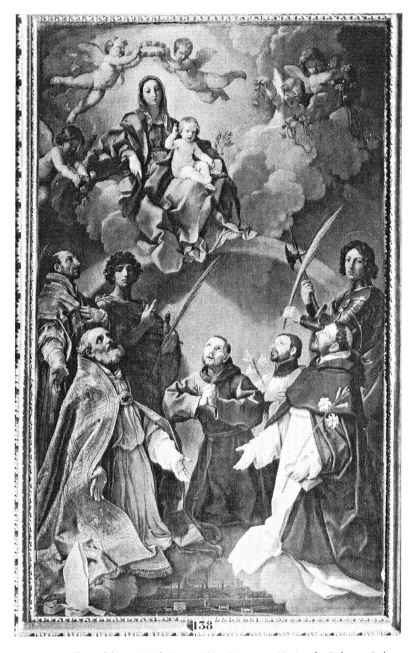

Fig. 6.9. *Pallione del Voto,* Guido Reni, 1630. Pinacoteca Nazionale, Bologna, Italy.
Alinari/Art Resource, New York.

stressed in the seventeenth century. An invisible "Grim Reaper" has spared neither old nor young, neither male nor female. We see the traditional group of the deceased mother with her surviving son. The child's distorted facial features force us to relive his tragic loss.

The painting symbolizes that the souls of individuals who had been deprived of a grave in sacred ground were not lost or forgotten. Most important, the Baroque master's altarpiece presents a heavenly vision of the Savior carrying his cross. This goes back to the theme of satisfaction through suffering, as seen in so many medieval plague paintings. However, Christ's gentle features are no longer reminiscent of the stern judge in earlier periods. Mary and the plague saint Gennaro also intercede for the stricken below. The angel sheathing the sword sends a hopeful message. Moreover, the gigantic canvas's upper portion is a tour-de-force in brilliant, sensuous colors. The heavenly realm is bathed in the most glorious, "divine" light; only the aesthetics of the celestial region make bearable the agonizing view of human suffering below. Giordano's rhetoric conveys the Church's perspective on life after death: suffering on earth guarantees that salvation awaits the souls in heaven. In an ex-voto such as *St. Gennaro Frees Naples from the Plague* one can justifiably speak of a revival of medieval piety, although the style and, above all, the sentiments are unmistakably those of the reformed Catholic Church. Similar commemorative works continue into the nineteenth century.

Iconological interpretations of Tridentine plague images confirm that in the seventeenth century the theme of plague became a metaphor for social, political, and religious issues. The initial purpose of plague art—to establish a dialogue between suffering humanity and the Divine—that began in the late Middle Ages and continued throughout the Renaissance, was expanded to preach more mundane messages. This holds true for pictorial narratives as well as allegories. Many of the Baroque history paintings were ecclesiastical or governmental commissions rather than private donations. The images politicized the plague subject and fulfilled a polemic function in religious territorial fights against Protestantism. Additionally, the Catholic Church used religious plague paintings as "image makers" to promote the new nursing orders and support certain saints in campaigns for their canonization.

In summing up the theological issues, I suggest that the mainspring of Tridentine art is not found in art treatises but in the revised catechetical teachings. Since the clergy, patrons, viewers, and the artists had been taught the same codified doctrines, scenes describing a "good death" could be universally understood by the public. Artists followed the Church's guidelines, and their plague paintings were no exception. The painters made legibility

their top priority, which led to the stereotyping of motifs, such as the inclusion of the dying mother and her child. The masters reduced realism; they generally avoided depicting the buboes so as to conform to the Church's demand for decorum, and they highlighted their visual sermons with rhetorical gestures and appropriate facial expressions.

Although the doctrinal plague paintings appear to take a documentary approach, they portray an idealized world. The clergy is depicted as wearing festive liturgical garments when in reality they had been ordered to abandon these vestments during an epidemic for hygienic reasons. Furthermore, the plague scenes stressed the saints' status of priesthood by representing them with richly decorated *ciboria*, ignoring the requirement of a simple *pyxis* with lid to safeguard the blessed sacrament when it was carried to the dying. In altar paintings the clergy is never portrayed holding "communion tongues," which were instruments designed to avoid direct contact with the sick. Moreover, these history paintings with religious content also conveyed an idealized picture of family support and impeccable ethical behavior, such as offering care and refraining decorously from pipe smoking, a method commonly used as a disinfectant by sanitary workers. Above all, the crowd seemed to accept death without fear. The beholder is never overwhelmed by pity for the plight of the victims. Although Tridentine images depicted disease and dying, they exuded a sense of optimism. Their meaning was not death but the promise of eternal life.

The analysis of allegories, on the other hand, helps clarify the disparity in interpretations of seventeenth-century plague images. During that period, plague iconography represented two incompatible iconological concepts, yet both types were employed to serve the Roman Catholic Church in propagating the faith. The plague images need to be read within the context of their ambience. For example, similes that referred to the "Other"—recognizable by missionary settings and fallen idols—related to the metaphor of heresy. Frequently such esoteric tropes were commissioned by the Jesuits, who differed in their outlook from nursing orders because their premier mission was to teach Catholic doctrine. The Society of Jesus frequently explained the epidemics as being caused by heretical activities.[226] Thus the plague allegories the Jesuits encouraged have to be distinguished from the more numerous didactic narrative scenes, which portrayed pious Christians in preparation for their final hour.

The votive tradition, on the other hand, showed fewer changes. Although the visual vocabulary evolved over the centuries, the function of the ex-votos remained the same. Different saints were chosen to represent doctrinal views

more compatible with Tridentine teachings on how to achieve grace and salvation. Nevertheless, the Roman Catholic Church continued to promote attendance at mass, the sacraments, fasts, prayers, the intercession of saints, the acquisition of indulgences, and active participation through good works such as donations of art. By studying these images, we get a glimpse of how people wrestled with tribulations during an era beset with bubonic plague and plagued by religious strife and controversies.

Chapter 7

Revival of Plague Themes and Modern Reverberations (1776–1990s)

Bubonic plague subsided in Europe after 1721; only isolated cases were recorded later on the continent. The disease was—and still is—thoroughly entrenched in Asia. However, the land borders were protected against Eastern infiltration, and stringent quarantine laws saved European harbors from transmission by sea. With the immediate threat of pestilence greatly reduced, only a few Catholic regions commissioned ex-votos or plague altars. Yet museum pieces that lacked specific functions and prints remained popular. News of major Asian epidemics and the resulting discovery of the plague bacillus *Y. pestis* in 1894 might have been responsible for a revival of plague themes. At the fin de siècle, European artists displayed a penchant toward apocalyptic topics such as pestilence.

Baudelaire's definition of Romanticism may serve as an introduction for the plague pictures discussed in this chapter. The French art critic summarized ideas that had permeated the European art world for some time when he wrote in 1846 that the Romantic movement represented diverse ideas to the individual artists. Baudelaire cited as the most important criteria of Romanticism the choice of historic, moral, or religious subjects, plus sentiments touching the infinite and the sublime. Modern art historians have added the nostalgic longing for faraway places or times as another characteristic feature of that widespread movement. All of these criteria fit the visual descriptions of the horrific disease which no longer posed a real threat to European society. Artists appropriated suitable pictorial traditions to present anew the old topic of pestilence.

The Romantics retained some of the traditional themes and metaphors, showing the disease's overwhelming power and human vulnerability. Within

Western art, France holds an isolated position in regard to the depiction of plague themes. It is the only country where, in the late eighteenth and throughout the nineteenth centuries, such images were plentiful. Above all, the reasons France remained interested in plague imagery need to be investigated. First and foremost, the country's expansionist policies and colonialism prolonged the threat of potential epidemics well into the twentieth century. Even with the observance of rigid quarantine laws, the reprieve from epidemic diseases was short-lived. Since the 1830s, cholera had replaced the old affliction. Cholera and yellow fever gained entrance through the same ports that, in earlier years, had admitted bubonic plague.

Additionally, since plague topoi were primarily Roman Catholic subjects, and the French government—except for the brief period during and after the Revolution—staunchly supported religious art projects, French artists kept the old tradition alive. Moreover, the centralized French Academy and the annual juried shows, the salons of Paris, provided a national forum for artists to explore further these traditional themes.

What were the decisive influences on French artists who created plague scenes after the actual danger of infection had ceased? Who commissioned such paintings, and what were their functions? Since the French Revolution had destroyed many church interiors, it is difficult to reconstruct regional prototypes. Perhaps precisely because of these losses, France kept producing religious art at an age when the rest of Europe had turned to other subjects. Also, because of the comparatively recent epidemic in the south of France, there was a market for votive paintings. For example, in 1781, sixty years after the last outbreak, Jacques L. David produced his commemorative *Madonna of SS. Roch and Anthony*, for a chapel of the sanitary commission in Marseilles.[227]

Antoine-Jean Gros, David's student, created the last plague scene painted in the grand manner. His brilliant execution of *Napoleon in the Pesthouse of Jaffa* gained him a permanent place in history (fig. 7.1). The 7.5-meters-long canvas was a triumph at the Salon of 1804. Napoleon, who had commissioned the grandiose exhibition piece, showered the young artist with honors. The canvas relates the outbreak of bubonic plague during the Egyptian campaign and portrays General Bonaparte in 1799 after the sack of the ancient city of Jaffa. Throughout his Eastern expeditions Napoleon had followed his dream of Alexandrian conquests until the old scourge had stopped him in his tracks. His discouraged troops needed a morale boost; therefore Napoleon was willing to risk even his life to convince the soldiers that plague was not the contagious disease it was made out to be. The official

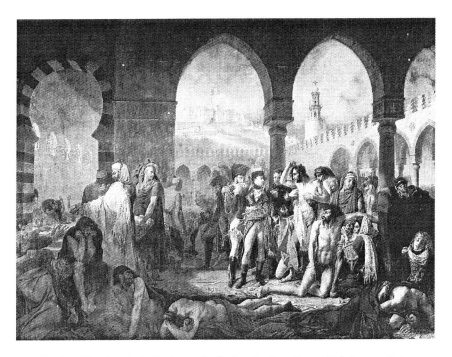

Fig. 7.1. *Napoleon in the Pesthouse of Jaffa,* Antoine-Jean Gros, 1804. Louvre, Paris.
Giraudon/Art Resource, New York.

prognosis was that the febrile malady attacked only patients who lacked
courage and feared the illness—hence the commander-in-chief's dramatic
visit to the temporary hospital ward. The Salon brochure, the *livret,* printed
the title, *Bonaparte, général en chef de l'armée, où moment où il touche une
tumeur pestilentielle en visitant l'hôpital de Jaffa.* The text of the Salon cata-
logue explains that the morale-raising effects of Napoleon's death-defying
valor had "special healing powers." However, the general's personal physician
did not agree with the then current medical opinion, and, again quoting the
livret, "Doctor Desgenettes wanted to prevent his leader from prolonging the
dangerous visit among the sick and dying."[228]
 We can follow the evolution of the painting through the study of several
drawings, dated c. 1802, and a large oil sketch. The works on paper reveal
that Gros's first impulse was to record the historic events of Napoleon's visit
to Jaffa's plague house on 11 March 1799: the commander-in-chief, uncon-
cerned with his own safety, was reported to have helped carry a soldier with
an open plague sore. However, the oil study shows already the same figural

composition as the final version, presenting the incident in a more heroic way.[229]

The viewer of *Napoleon in the Pesthouse of Jaffa*, then as now, becomes thoroughly convinced of experiencing a great moment in history. Gros's tableau vivant introduces a number of historic persons. The stage—reminiscent of Tintoretto's spatial expanse—presents Bonaparte surrounded by his somewhat reluctant staff. He stands confidently near the center of the colonnaded room; his left hand is raised to touch the chest of the patient, whose elevated arm reveals an inflamed axillary bubo.[230] This gesture has appeared in art since the fifteenth century. To dispel any doubts that we are dealing with bubonic plague, some attendants cover their noses with handkerchiefs. Not so their leader, who is about to move on to yet another victim attended by a Turkish surgeon.

In this interpretation of a historic event, *Napoleon in the Pesthouse of Jaffa* conjures up a sense of immediacy and the feeling that this is an eyewitness account. Not all scholars agree on the exact location where the visit took place or whether the reconstructed background is accurate. Yet these considerations are of little consequence when compared to the impressive Islamic architecture and the renderings of the different ethnic groups. Above all else, we can call *Napoleon in the Pesthouse of Jaffa* the first "orientalist" painting, although Gros had only traveled as far as Rome before embarking on this venture.

In Italy, Gros must have become aware of the power of the Baroque plague tradition, the emotionally charged Tridentine art discussed in the previous chapter. Gros's canvas reminds one of earlier treatments of the subject: he adheres to stereotypes such as the topographic description of the city, the plague-stricken strewn across the foreground, the officer holding his nose, and a pipe-smoking Muslim's attempt to prevent contagion. The different psychological responses, too, had been presented before, particularly the sick resting in the left-hand corridor resemble earlier types gesturing in despair, despondency, and stoicism.[231] The brilliant red, black, and white of the costumes also suggest the palette of earlier plague scenes. The dark foreground with *contre-jour* lighting, the corpses, and the deathly ill men all become but a foil for Napoleon's courageous action.

Napoleon was well aware of art as a propaganda tool, and he used the power of the image most effectively. The implied meaning in *Napoleon in the Pesthouse of Jaffa* needs to be examined within the context of the political situation of 1804, when the upstart Bonaparte, not to be outranked by the Holy Roman Emperor, had crowned himself Emperor of France. The main

reason, however, why the former general chose to commission Gros to paint the plague scene may have been the persistent rumors, exploited by the British press, that Napoleon had ordered the cold-blooded extermination of Jaffa's Turkish garrison and the mercy killings of his own infected soldiers.

Although *Napoleon in the Pesthouse of Jaffa* is a secular painting, it has religious innuendos. The central group reverses the traditional images of "Doubting Thomas and Christ." Moreover, the original French title of the work reads "the very moment Bonaparte touches the pestilential tumor," which alludes to Christ and the saints' "healing by laying on hands." Napoleon's ambition to compare himself with the old regime is obvious in the parallels that can be drawn between the legendary thaumaturgical powers of the French kings, in particular the sainted Louis IX, a venerated plague patron. Also, the late Louis XVI commissioned in 1761, for the church in St. Louis in Versailles, *St. Roch in a Plague Hospital Healing by Laying on Hands,* which proves that religious plague scenes were popular with the Bourbon kings (unfortunately, the painting is now lost). *Napoleon in the Pesthouse of Jaffa,* too, creates the allusions of a superhuman act which was intended to evoke faith in the viewer, similar to the mystique of religious works. In fact, the painting exudes the same confidence as Tridentine plague scenes: the focal point in religious scenes had been the intercessors—here they are replaced by Napoleon Bonaparte. On the other hand, at least one scholar has suggested that the commander-in-chief's use of his left hand to touch the wounds, among other clues, indicates that Masonic coded messages were implied.[232]

Recent insights into iconological interpretations of *Napoleon in the Pesthouse of Jaffa* have uncovered yet another layer of allusions. Napoleon's pose resembles that of the *Apollo of Belvedere,* the famous statue that was part of the Italian war booty brought to Paris. This likeness was not merely a vain attempt on the artist's part to flatter the new emperor but hints at the medical powers of the Greek god—healer of plagues. In addition, the Apollonian reference connected Napoleon with Louis XIV, the Sun King. Finally, the fact that Gros's work was exhibited along with Philippe-Auguste Hennequin's *The Battle of Quiberon* shows Bonaparte's intent to present himself as the logical compromise between Royalist tyranny and Republican anarchy.[233] Once again, a plague scene was chosen to depict a turning point in history.

Later in the nineteenth century, the pictorial tradition first developed for bubonic plague was adopted for infectious diseases. In 1854, 143,000 cholera victims died in the French capital. Although there is no direct mention of the "new plague," it is possible that Jean-Léon Gérôme's *Belsunce Making a*

Vow to the Sacred Heart during the Plague in Marseilles was conceived as a votive painting. The mural is dated 1854 and was commissioned by the municipality of Paris for a chapel in the venerable church of St. Severin (fig. 7.2).

Gérôme would have known about the eighteenth-century epidemic in Marseilles from both literary and visual sources. The painter alludes to the institution of the new feast in *Belsunce's Vow* by depicting in the heavenly zone a radiant angel who holds a flaming heart. The darker angel, next to him, sheathes his sword in a reconciliatory gesture indicating that the Lord is pleased with the bishop's action. The romantic aura of Gérôme's *Belsunce's Vow* is derived in part from the return to the medieval text of the *Golden Legend,* which had been republished in French in 1843. The two divine messengers float above the congregational procession, suggesting images of the good and bad angels. The bishop raises his arms imploringly. Behind the fervently praying crowd appears a scene of death and destruction; a number of victims have expired. Unfortunately, many features in Gérôme's mural appear to be merely clichés except for the foreground where a woman accusingly presents her dead baby to the bishop. This figure group is reminiscent of Pietro da Cortona's mother in *St. Charles Leads the Procession of the Holy Nail,* discussed in chapter 6. However in the case of the Baroque painting, the woman confidently placed a living infant into the care of the saint. In contrast, Gérôme emphasizes the human tragedy, the mother's loss of her child.[234] It seems that the artist asked the age-old question that Camus also addressed in *La Peste:* If God is love, why does evil exist? Tridentine art would never raise such an objection. Undoubtedly, in the case of Gérôme's work the beholder feels empathy for the mother; Cortona, on the other hand, tells the story from the point of view of the Catholic Church.

It is uncertain if the continuous threat of cholera and the epidemic of 1865 inspired Jules-Elie Delaunay's *Plague in Early Christian Rome* of 1869 (fig. 7.3). With this painting we come full circle in the discussion of plague iconography. Delaunay had been inspired by *St. Gregory's Procession* in San Pietro in Vincoli, in Rome (see chapter 3). The *livret* quotes the Sebastian legend's text pertaining to the good and evil angels marking the plague victims' houses. The two heavenly emissaries approach the entrance to a pagan sanctuary; the fair angel holds the sword and the *mauvais ange* uses the scabbard to pound on the door of the temple. Delaunay's *Plague in Early Christian Rome* touches on yet another traditional topic, heresy. The cross, victorious symbol of Christ, heads the papal procession on the left. It indicates that the saint would successfully convert pagan Rome. On the antique

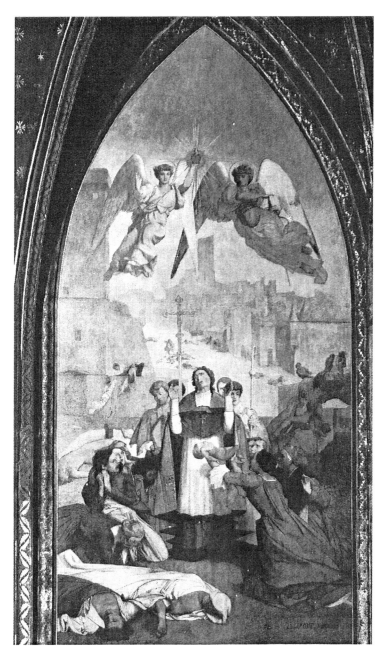

Fig. 7.2. *Belsunce Making a Vow to the Sacred Heart during the Plague in Marseilles,* Jean-Léon
Gérôme, 1854. St. Severin, Paris. Phototèque des Musées de la Ville de Paris.

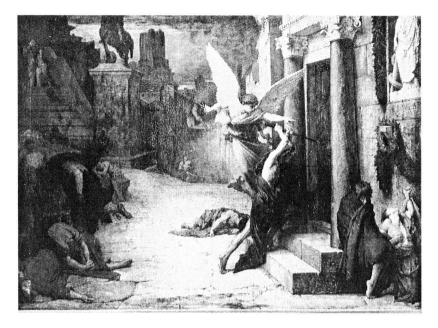

Fig. 7.3. *Plague in Early Christian Rome,* Jules-Elie Delaunay, 1869. Musée d'Orsay, Paris.
Erich Lessing/Art Resource, New York.

temple facade, placed on the right, the statue of the healer Aesculapius
becomes partly visible. Delaunay must have remembered Ovid's description
in the *Metamorphoses* of how the son of Apollo came to Rome. Staff and
snake mentioned in the text, along with the Latin inscription, leave no doubt
about the sculpture's identity. Offerings of flower garlands are draped below
the ancient god of medicine. On the steps of the heathen edifice sits a forlorn
figure wrapped in a blanket; next to him kneels a desperate woman, who
seems to vent her anger and frustration as she curses the powerless pagan
idol. It has been observed that *Plague in Early Christian Rome* was a passion-
ate revival of faith in an age when religious belief was challenged from every
aspect.[235] Although Delaunay's message that Christian faith will triumph
over heresy is traditional, his formal achievements make his canvas one of the
very last innovative French plague scenes.

In contrast to the abundant religious art commissioned in France, Protes-
tant England had refrained throughout the centuries from creating even secu-
lar plague paintings. The reason for this cannot be established with any
certainty. One can speculate that in puritan England, so opposed to religious
art, plague themes stressing charitable deeds and saintly interventions smacked

of popery. Another reason might have been that Catholic literature associated pestilence with heresy. Protestantism and any deviation from Catholic rites had frequently come under attack and were addressed as "plague" or "pestilence of the soul," as discussed in chapter 6.[236] Although countless English authors have written about the harrowing epidemics of the sixteenth and seventeenth centuries, the fine arts neglected the plague theme; only illustrated flyers and broadsheets were produced. Even when in 1665 London was depopulated by bubonic plague, which a year earlier had devastated the Netherlands, the events were recorded only in literature. Moreover, London's epidemic had been followed by a catastrophic fire in the ensuing year of 1666. The dual scourge was interpreted by many as the Lord's special castigation of that city. Numerous books addressed the meaning and the reason for the bane. Some authors accused the poor of having brought the disease on themselves. In fact, most of the rich and the court had left the city at the outset of the illness. In contrast to earlier times, when the whole community was believed to be guilty, English writers blamed the shortcomings of individuals.[237]

However, in the late eighteenth century, British artists began to produce for the first time memorable plague topics. A revival of interest in the "Great Plague of London in 1665," of which no painted record existed, provided the artists with a new subject. Lacking the traditional plague iconography, but equipped with a wealth of contemporary documents in literature and printed images, the painters were free to create without burdensome stereotypes.

William Blake, in 1793, transcended mere illustration of London's plight in his *Pestilence* or *The Great Plague of London*, also known as *Plague* or *The Bellman* (fig. 7.4). The relief etching has the pious phrase "Lord have mercy" in large letters in the background, framed by a stylized door. A cross is affixed below; similar signs marked every quarantined house in London as a warning not to enter the premise. On the right side of the print a woman pleadingly extends her arms; she embodies literally a cry to heaven. The somber figure of the bell ringer, a man who generally preceded the death carts calling out in the night, "bring out your dead," appears in the print as ominous as Death itself. In the foreground a husband lovingly supports his wife. Her limp body and frozen features suggest that she is about to expire. The figure types are traditional, yet Blake achieves in this print the articulation of inconsolable anguish. Nothing in this work exudes hope; it depicts unadulterated human pain and suffering. The economy of line seems to anticipate the expressive powers of Pablo Picasso's *Guernica*.

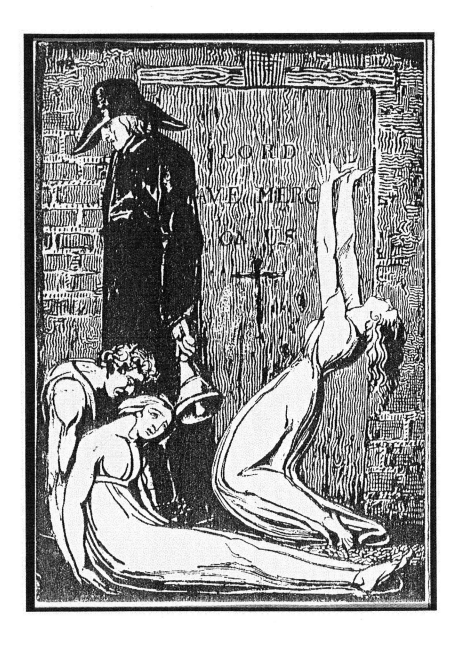

Fig. 7.4. *The Great Plague of London,* relief etching, William Blake, 1793.
Glasgow University Library, Department of Special Collections.

Blake drew numerous preparatory sketches for his *Pestilence*, yet none comes close to the eloquence of the printed version. Some of the multifigural compositions describe the disastrous conditions in the city, including streets littered with dead animals. The drawings' narrative details, however, detract from the immediacy of expression found in the relief etching.

Although Blake objected to organized religion, he used the subject of plague in its original biblical context.[238] Apocalyptic themes appeared in Blake's oeuvre as early as 1784. It has been established that Blake's *Pestilence* is related to two watercolors which he had exhibited at the Academy: *War Unchained by an Angel* and *Fire, Pestilence and Famine Following* and *Pestilence, or the Great Plague of London* (both are lost). His idiosyncratic plague subjects were based on personal convictions of doom. It has been suggested that Blake intended these works to represent God's wrath upon the English nation as a sign that the apocalypse was at hand.[239]

Instead of the austere message conveyed in Blake's *Pestilence*, Frank W. W. Topham's *Rescued from the Plague, London 1665* is imbued with very different sentiments (fig. 7.5). The painting is signed and dated 1898, almost exactly one hundred years after Blake had treated the same subject and the very year Dr. Simond published his findings on bubonic plague transmission. Topham's main literary source was an excerpt taken from Samuel Pepys's famous *Diary*.[240] The entry on 3 September 1665 tells about a complaint brought against a saddler who had lost all but one daughter to the plague. Despairing for her life, because he and his wife had been shut-ins in their quarantine house, he arranged for the rescue of his child. Although this was against the law, he engaged the help of an out-of-town friend and his daughter to bring uncontaminated clothes and to provide a new home for the young girl.

Without the benefit of knowing the story, the action described in *Rescued from the Plague, London 1665* cannot readily be understood; the viewer is somewhat at a loss how to interpret the scene. The canvas depicts an angelic-looking blond child being lowered from a balcony window into the street. Her mother releases the "stark naked" little girl ever so gently into the arms of a tall gentleman, dressed in black. The eyes of mother and daughter meet in a last farewell. The father watches, mindful of the rescue operation. In the street, next to the gentleman, stands an older girl. She too plays her part in the attempt to save a life, since she carries a new set of clothing.[241]

The severity of the situation is underscored by the figure of a young woman cowering in the street. She seems to have collapsed on the doorstep and brings to mind Defoe's description of the plague-stricken: "These were

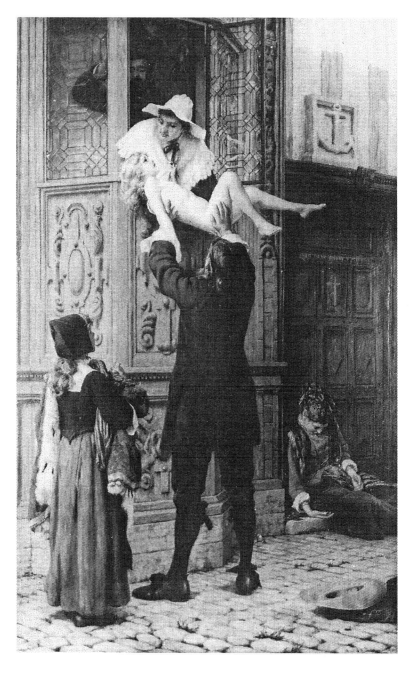

Fig. 7.5. *Rescued from the Plague, London 1655,* Frank Topham, 1898.
Guildhall Art Gallery, Corporation of London.

the people that so often dropped down and fainted in the streets...till on a sudden they would sweat, grow faint, sit down at the door, and die."[242] On the entrance door, above the victim, appears a cross similar to those that marked every infected house. Another religious emblem, an anchor, is carved in stone on the wall. The scene symbolizes the three Christian virtues: Faith indicated by the cross, Hope represented by the anchor, and Charity embodied by the rescue action. During the tribulations of the sixteenth and seventeenth centuries, even iconophobic, Protestant England depicted on official bills of mortality or health-rule flyers allegorical figures such as Faith, Hope, Charity, Religion, Repentance, Humility, and others. Thus, Topham drew on a local tradition.

The history painter in his *Rescued from the Plague, London 1665* was intent on reconstructing the time period by observing carefully the costumes, the carved panels, and the leaded window panes. The fact that the girl needed to be lowered from a window, as so many plague corpses had been depicted earlier in engravings, hints at the tragic imprisonment of the quarantined family. Topham even rendered weeds growing in the cobblestoned street to indicate abandonment of the thoroughfares that normally would have been filled with the hustle and bustle of trade. This detail conveys the general feeling of loneliness and isolation similar to a town under siege. Despite the careful and sensitive descriptions, the scene seems to lack substance. This Hollywood-like version of London's plague, painted in pastel colors, appears to the twentieth-century viewer contrived and sentimental.

Topham's choice of depicting this event leaves room for speculation. Most likely it was the charm of the human interest story about the fate of the nymphet and the story's happy ending. We can see *Rescued from the Plague, London 1665*, painted at the time of the pathogen's discovery, as a positive response to a momentous medical breakthrough. As noted earlier, the rescue of children had been a traditional plague theme since Raphael's *Plague of Phrygia*.

The late 1890s, with news about scientific developments in the fight against bubonic plague and the growing millennial movement—almost all centuries close with the expression of some trepidation—may have inspired artists from other countries, namely Germany and Switzerland (Dr. Yersin was Swiss), to create plague images. Arnold Böcklin worked on an apocalyptic series in 1898 and Max Klinger on a cycle of Death from 1898 to 1909.

The aged Böcklin painted an impressive plague subject, which is dated the same year as Topham's plague scene, 1898. In Böcklin's *Plague*, Death, characterized as the Grim Reaper, swings his scythe. He rides a monster

whose poisonous breath envelops the scene like a gas cloud, killing the people in the foreground. The knowledge of legendary fatal miasmic air seems to have survived even though Yersin had discovered the real culprit several years earlier.

The Swiss painter conceived the idea of a medical allegory earlier when he and his wife had contracted cholera. The subject *Cholera* is preserved only in drawings, however. The first impetus in the development of *The Plague* derives from *Dragon*, a drawing sketched in 1886. Although Böcklin never finished his canvas *The Plague*, its dramatic effects were fully appreciated by contemporary artists. In 1904, probably triggered by Fauvism, this visionary work was admired for the intense colors. Other authors have responded to the image as a symbol of hopelessness and declared the forward sweeping movement of this dinosaurlike monster to be a threat to all humanity.[243] Böcklin's painting is devoid of any religious connotations apart from the fact that it, too, belongs to an eschatologic series. Its pendant *War* shows a skeleton with the scythe reminiscent of Dürer's *Apocalyptic Riders*.

Max Klinger's *Plague* (fig. 7.6) is part of his second series on death and is dated 1903. The etching invites the observer into the surreal scene of a hospital ward. The barren room holds rows of beds filled to capacity. The emaciated patients resemble corpses or holocaust survivors. The large windows are open, and gusts of wind stir the curtains. The disease is invisible, yet blackbirds, as menacing as Hitchcock's, flap in the breeze, awaiting their chance to pounce on the dead. In the foreground a nun swings her rosary to chase away the scavengers; a large cross throws an ominous shadow on the wall.

The prints of the first part of Klinger's cycle *Death*, begun in 1898, deal with the physical reality of an unexpected death, but the later works of the series treat the final departure from earth more symbolically.[244] In *Plague*, impotent, powerless humans are exposed to a dark, indefinable force. The Christian symbols do not inspire hope as in Topham's *Rescued from the Plague*, but rather refer to the futility of faith in religion. Patients pray in their beds but there is no indication that anyone will heed their pleas. Klinger used plague as a metaphor for a force beyond human control. Throughout most of the twentieth century the topic of pestilence was not explored until the AIDS crises made people aware that incurable infectious diseases are still with us.

Although innumerable diseases threaten modern society, only AIDS adapts the visual rhetoric of plague imagery. In the 1980s, when AIDS became a major public health issue, verbal and visual comparisons were drawn between the phenomena of the bubonic plague and the new epidemic.[245]

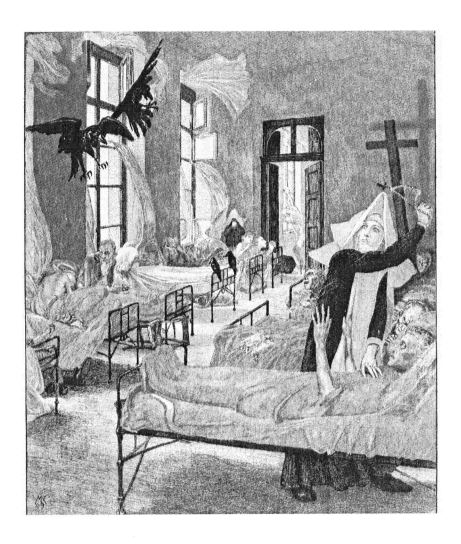

Fig. 7.6. *Plague,* from "On Death, Part II," print, Max Klinger, 1903.
Philadelphia Museum of Art, Smith Kline Beckman Corporation Fund.

With an increasing public awareness, the interest in historic epidemics developed, and the news media responded by reporting on earlier disasters, primarily on the morbid imagery of the Black Death. Books and museum displays made traditional plague subjects readily available to modern artists. They studied images of old masters, such as Albrecht Dürer's plague drawing *Death on Horseback* and Hans Holbein's *Death and the Gambler* (Dance of the Dead Series). Therefore, in the 1980s, analogous death symbols appeared in the AIDS posters. For example, the New York Health Department issued a stern warning: DON'T LET AIDS DEAL YOU A LOSING HAND—KNOW THE FACTS: *"Don't Shoot Drugs or Share Needles."*[246] It shows the Grim Reaper dealing a deck of cards; opposite him a human hand holds four playing cards, which spell out the word AIDS.

Another plague-inspired AIDS image shows the influence of Nicolas Poussin. It is likely that Hwan Young Gu did know the famous *Plague at Ashdod* when he designed his imagery sometime before 1989. His composition compares the two diseases. The center shows in bold print "THE PENALTY OF GOD." The words PEST and AIDS are juxtaposed diagonally in two corners. The Korean artist also constructed a pictorial parallel between images of alluring lips and rodents. He seems to blame them for the spread of the afflictions—lips because AIDS is primarily sexually transmitted, and rats because we now know that their infected fleas are responsible for bubonic plague.[247]

More recent studies by social scientists show that the most effective strategies to inform the public are not scare tactics, but a message delivered in a positive way. This may be why we now find fewer images portraying death, and more examples of human compassion; the image of St. Sebastian, for example, gained renewed importance in our century. For the propagation of faith, Tridentine art created images emphasizing human kindness. For example, Tanzio da Varallo's *St. Sebastian Tended by the Women*, painted around 1625, a work displayed in the National Gallery of Art in Washington, D.C., stresses not the martyr's suffering but the loving care Sebastian received from the Roman women. An anonymous modern designer appropriated the Baroque painting and added a new motto: LOVE AIDS PEOPLE, a plea not to ostracize the sick.[248]

The art of the postplague period retained many of the traditional subjects. Although in the 1890s science was about to make a decisive discovery and end an era of mass casualties due to disease, most artists showed little confidence in medicine. Rather, the nostalgic paintings refer back to medieval sentiments, *memento mori*. In many instances established *topoi* were utilized.

Delaunay's *Plague in Early Christian Rome* represented heresy; Böcklin and Klinger alluded to the apocalypse and the universal triumph of death that renders humans powerless. At least superficially, Gérôme's *Belsunce Making a Vow to the Sacred Heart during the Plague in Marseilles* returned to the Tridentine tradition, but the sentiments transmitted to the beholder do not instill hope. Gros combined in his *Napoleon in the Pesthouse of Jaffa* many established conventions, although he used the plague as a political rather than religious propaganda topic. Because England had no viable plague tradition, Topham's *Rescued from the Plague* did not adhere to established iconography. The painter chose a novel scene based on obscure sources in English literature. His religious symbolism is in keeping with Puritan allegories depicted in London's plague pamphlets. Most of the artists' fascination with pestilence derived from their interest in the frailty of the human condition. Romanticizing plague images derived from the individuals' desire to glorify human suffering as the means to a higher state of existence. Since artists of the nineteenth and twentieth centuries were their own agents and no longer spokespersons of official patronage, they applied tropes to underscore their personal feelings. The situation changes again in the cases of didactic AIDS posters, which project messages of civic responsibility.

Chapter 8

Plague Imagery, Past and Future

Over the centuries diverse attitudes and changing responses toward epidemic disease and its victims were recorded. The debate over whether pestilence is the result of natural causes or punishment from the heavens is as old as the illness itself and is frequently addressed in plague literature. Early writers such as Homer and biblical authors saw pestilence as divine intervention. Yet even in the ancient world, voices such as Thucydides, Hippocrates, and Galen attributed infectious epidemic diseases to natural causes. However, for most of the artworks mentioned in this book, the concept that sickness and sin are closely related is of the utmost importance.

When considering disease and the human condition, it is important to remember that an epidemic was regarded as a collective experience rather than as individual ailments. Most literary commentators duly noted that pestilence slew all people, regardless of age, sex, race, or religious persuasion. Biblical precedents were significant for the understanding of epidemics. King David's offense against God's law affected all Israelites. Therefore, plague victims were rarely accused of personal misconduct. In contrast, from time immemorial lepers have been ostracized and regarded as paradigms of sin. This attitude was based in part on discussions of lepers in the Old and New Testaments. Leprosy was considered "the disease of the soul" and its symptoms the outward manifestations of a sinner's castigation.[249] Although both illnesses showed decay of the body, society treated the plague-stricken very differently.

As pestilence was often blamed on the collective sins of a community, religious plague pamphlets admonished citizens to live a moral life so that they would not jeopardize communal health. During the medieval period, when medical science was in its infancy, acceptance of "the Will of the Lord" was expected of the faithful and pleas to God were the only recourse for the

pious.[250] To promote virtue and placate the Lord, the Roman Catholic Church, in the tradition of King David, recommended donations of religious buildings, liturgical objects, and alms for the poor. Acts of devotion were considered beneficial: fasts, prayers of petition, reception of sacraments, and pilgrimages, but above all, since the time of Pope Gregory I, penitential processions. Many of the plague images tried to relate a then current health crisis to earlier experiences of pestilence.

However, beginning in the sixteenth century, a dichotomy between the dictates of science and faith became evident. Secular and religious authorities often disagreed when weighing medical efficacy against the hope of relief through divine help. The moral resolution to conduct group rituals, which required blind faith, gradually faded over the centuries as the nature of infectious diseases became better understood. Historic documents show that at any given time people had conflicting expectations about strategies they deemed advantageous or detrimental to public health. For example, in the early sixteenth century the chronicler Giovanni Cambi profoundly objected to the Florentine health magistrate's ban on civic processions because the edict might offend God. Similarly, Cardinal Archbishop Charles Borromeo, against the warnings of the health department, insisted on conducting the customary propitiatory rites during the 1576 outbreak in Milan—albeit with the proviso that women and children should not be exposed to the danger of infection. Yet his cousin, Frederico Borromeo, who was archbishop in the same city during the epidemic of 1630, had to be persuaded—against his better judgment—to carry his sainted cousin's sarcophagus in a public procession through the streets. Giuseppe Ripamonte, one of Frederico Borromeo's officials, criticized the pomp displayed by the Milanese during this event and pondered why the contagious epidemic accelerated after this demonstration of religious fervor. Ripamonte quoted differing opinions that were voiced at that time in Milan: "It was divine retribution" or "The foolish blamed God—who simply could not control the plague."[251]

In 1681, an Austrian physician praised the local bishop for his enlightened decision to forbid gatherings for religious purposes. At that stage, reason had resolved the moral dilemma between religious duties and medical obligations. At about the same time, the Jesuit Athanasius Kircher (1601–80) came closest to the truth when he stated that bubonic plague was a natural infectious process caused by living organisms: he thought he actually saw tiny animals moving under the microscope; other doctors refuted his claim. His ideas were pondered seriously by the French doctor J. B. Bertrand during the 1720–21 crisis in Marseilles, when, for the last time, this horrendous

disease tested European nations.[252]

At the end of the eighteenth century, when several generations of Europeans had been spared the experience of bubonic plague, Napoleon's physicians proposed that the illness was psychosomatic and it attacked only those who feared the disease.[253] The nineteenth-century discovery of the true cause of bubonic plague and its reverberations are discussed in chapter 1. Although *Y. pestis* infections remain, terror of them has subsided because epidemics can be curbed with antibiotics and insecticides.

The iconological review of plague images resulted in similar findings which concerned primarily religious art. This book stresses theological aspects in the depiction of plague because through the ages religious images have far outnumbered secular works. Yet, in spite of a dominance of sacred themes, few topics have yielded as much information on other contemporary issues.

During the early epidemics of the fourteenth and fifteenth centuries, at a time when religion permeated all of life's activities, most plague art took the form of votive gifts. *Ex-votos* served a special function in *ars sacra,* and art relating to plague was commissioned in direct response to specific epidemics. After the fifteenth century, people abandoned naive expectations that they would gain complete protection from the dread disease by special prayers. The change in people's attitudes also affected the form and function of early plague prints, which lost some of the amulet properties that superstitious individuals had ascribed to them. Disappointment with various plague saints has been recorded, which may have been why over the centuries so many different intercessors were petitioned. Since the subject of pestilence in the visual arts is closely related to death and dying, the images frequently dealt with expectations in the next world. Until the Reformation, the Christian doctrine of salvation depended on the concept of satisfaction for human sin, offered to God through Christ's self-sacrifice on the cross. Therefore, following the Black Death, depictions of suffering frequently appeared in Christological and saintly plague images. Well into the early Renaissance, very literal translations of the *Golden Legend* were featured in plague subjects.

Beginning with the sixteenth century, people seem to have become resigned to the cyclical return of bubonic plague, and responses to actual outbreaks of the disease were less immediate. In fact, individual benefactors and well-endowed plague confraternities commissioned prophylactic plague art to ward off future visitations. These artworks were intended to protect communities from possible harm and to help prepare individuals for unexpected death. Apocalyptic subjects and related iconography were common

throughout the Renaissance. However, pestilence then was deemed less as punishment than as a test of faith or a form of purification through suffering. In some cases, such as Vasari's altarpiece, the illness alluded to a providential divine plan governing history.

After the Council of Trent, a caesura ensued in plague iconography and iconology. Many of the scenes depicting pestilence were no longer intended as votive gifts. The canvases portrayed the disease for a number of other reasons; for example, the scourge was depicted to instruct the masses in the correct execution of sacred rituals and to serve as a reminder of religious duties. Plague subjects were chosen to highlight the rigorous reforms the Catholic Church had implemented. Catechisms taught new ways to search for salvation: the canon of justification was no longer concerned with suffering, but became more closely linked to grace obtained by performing charitable works and honoring the sacraments. In plague images, the wrathful God of an earlier time was replaced with a more positive vision. Furthermore, the spiritual needs of the plague-stricken were considered more important than the health of their physical bodies. Religious nursing orders were charged chiefly with helping patients receive the sacraments rather than with performing the impossible task of healing terminally ill patients. Many plague paintings emphasized the nobility of the priests' sacred calling. The Roman Catholic clergy and other interest groups commissioned innovative and didactic works of art to promote religious orders and influence canonization campaigns. At the same time, plague subjects became politicized and served as polemic art. The rhetoric of the imagery was exploited in the service of the propagation of the faith, particularly in Catholic defense against Protestantism. In a few cases, plague allegories presented the disease as a metaphor for heresy.

With the rise of the Enlightenment, profane themes gained importance, and by the time bubonic plague epidemics declined in Europe, the subject had become rare. In a nostalgic nineteenth-century revival of interest in plague images, individual artists, no longer restricted by Church censorship, expressed doubt in medicine and at times even in religion. During the greater part of the twentieth century few plague subjects were created until AIDS evoked anew the old topic.

Traditionally, artists identified the theme of pestilence by depicting such well-understood symbols as arrows sent by God, the plague angels, and emblems of the Last Judgment. At times Christ, the Madonna, or plague saints interceded to protect the victims. Iconography also showed plague's prey as corpses or as suffering from the dread disease with the illustration, in some cases, of the symptomatic swellings, or buboes. The most characteristic

plague tableau is the depiction of a dying mother with her infant; the figure group is surrounded by people who protect themselves against contagion by covering their noses. Other idiosyncratic gestures and postures help identify this morbid subject. Allegorical figures personifying pestilence appear in numerous plague scenes.

Innovative iconological interpretations of plague art began with Emile Mâle's seminal analysis of theological and political implications expressed through the plague medium. Since the 1960s, Henri Mollaret and Jacqueline Brossollet have explored medical aspects.[254] By the 1980s, Elisabeth Schröter and Louise Marshall offered original perspectives, and their insightful explanations have set plague research on a new course.

Although we now have an excellent database of detailed studies, scholars with profound knowledge of a specific period rarely applied this information to another era.[255] Therefore, an imminent need for an overview of the subject arose, and I decided to scrutinize plague images from the fourteenth century to the present. Although my holistic approach may warrant some justifiable objections, it results in new factual information.

The reason for choosing breadth in this book is to demonstrate that plague themes of all periods share the same literary sources as well as strong oral and pictorial traditions. Through the process of comparing and contrasting imagery of different periods, the iconological changes become apparent. Some of the recurring themes that use pestilence as a metaphoric vehicle are artworks that reflect the "doctrines on salvation," "eschatology," "eucharistic ideologies," and "heresy." In addition to categorizing plague *topoi*, I analyzed emblematic signs and discovered a previously neglected indicator of pestilence—clouds. Although Roman texts already mention Apollo in conjunction with "plague clouds," and Christian plague scenes allude to Christ's coming on a cloud, the cloud as hallmark of pestilence has gone unnoticed. Likewise, other symbols—such as wind and the fig tree, which also predicted the Last Judgment—are seldom mentioned in the literature.

Equally important is the revisionist proposition that death imagery, the *transi*, and even the *danse macabre* were *not* initiated by the frightening experiences of bubonic plague. A number of authors, in addition to myself, attest that depression was not necessarily the psychological response of the survivors who commissioned works of art after the passing of a cataclysmic event. Louise Marshall observes: "In setting up hierarchical relationships of mutual obligation between worshiper and image, those who lived during the pandemic were not neurotic and helpless, but were taking positive—and in their eyes effective—steps to regain control over their environment."[256] In other

words, religious art produced in catastrophic times was cathartic, was far from expressing negative feelings, and in effect restored hope to people and helped them overcome the ravages of an epidemic without lasting psychological damage. The theory that a feeling of empowerment, even imaginary, helps overcome post-traumatic stress disorder (PTSD) has been confirmed recently by Daniel Goleman.[257] From our perspective, all attempts to fight the sickness without the benefit of modern science seems futile and destined to failure. Nevertheless, one fact remains abundantly clear: Europeans perceived bubonic plague as the most devastating of all ailments. For that reason, they depicted the illness's physical symptoms in countless sculptures and paintings in an effort to appease God.

Why were no images of pestilence recorded during the Justinian pandemic, whereas the Renaissance and Counter-Reformation cultivated this subject? The answer is as complex as plague art is diverse. However, some of the reasons have become evident during this investigation. The depiction of epidemic diseases was not a topic of interest during the early Christian period.[258] The sudden reemergence of bubonic plague on the European continent coincided with the humanist movement of the fourteenth century, when the Western Renaissance began. A profound interest in science made illness a discipline worth investigating for all scholars, including physicians, philosophers, theologians, poets, and artists. By the fifteenth century most of the literary sources (reprinted in the appendix) became commonly available to all intellectuals. The invention of plague prints helped create a pervasive language that was as universal as the experience of the disease itself. Devotional art for centuries served a meaningful function in people's lives and was closely related to the Roman Catholic Church's views on Purgatory and the cult of intercessory saints. However, religious beliefs changed radically after the Christian schism of the sixteenth century. Although the plague commissions of the Catholic Reformation are quite extraordinary, Protestant territories reacted against these politically charged images by avoiding the pestilence topos for centuries.

In order to suggest new venues for research, this inquiry studied medical evidence, theological doctrines, literary sources, and art theory, along with reports from various disciplines. The book presents methods that can more accurately interpret the complex iconology of images dealing with epidemics. As we enter the third millennium, epidemiology is an invaluable field of research since medical science is continuously challenged by new "plagues" that threaten our civilization.[259] Have we seen the last of plague imagery?

Appendix

Plague Texts That Influenced Visual Art

Henri de Belsunce de Castelmoron (1671–1755)
Sermon written in Marseilles, 28 October 1720, as quoted in Jean Battiste Bertrand, *A Historical Relation of the Plague at Marseilles in the Year 1720*, trans. A. Plumptre, introduction by J. N. Biraben (London, 1805; reprint, Farnborough, Hants: Gregg, 1973), 355–62.

> Woe woe! to you and to ourselves, my dearest brethren, if all that we have seen, all that we have experienced, for a long time past, from the anger of a God the avenger of guilt, shall not be able in these times of dreadful mortality to make us turn our eyes inward upon ourselves, and, in the anguish of our souls, take a retrospect of our past lives;...to do honor to Jesus Christ in his holy sacrament, in order to repair the outrages it has received from unworthy and sacrilegious communions, and the irreverences he has experienced in the mystery of his love to mankind; to make him loved by the faithful committed to our care; and finally, in hopes of atoning for the crimes which have drawn down the divine vengeance upon us; that we have established, and do establish throughout our diocese, the feast of the sacred heart of Jesus, which shall hereafter be celebrated every year.

The Bible

Old Testament

1 Sam. 5:4–6

> But the next morning early, when they [the people of Ashdod] arose, Dagon lay prone on the ground before the ark of the Lord, his head and hands broken off and lying on the threshold, his trunk alone intact. For this reason, neither the priests of Dagon nor any others who enter the

temple of Dagon tread on the threshold of Dagon in Ashdod to this very day; they always step over it. Now the Lord dealt severely with the people of Ashdod. He ravaged and afflicted the city and its vicinity with hemorrhoids. [He brought upon the city a great and deadly plague of mice (rats) that swarmed in their ships and overran their fields—this last section is frequently omitted.] (NAV)

2 Sam. 24:10–25 (story also related in 1 Chron. 21:1–28)

Afterward, however, David regretted having numbered the people, and said to the Lord: "I have sinned grievously in what I have done. But now, Lord, forgive the guilt of your servant, for I have been foolish." When David rose in the morning, the Lord had spoken to the prophet Gad, David's seer, saying: "Go and say to David, 'This is what the Lord says: I offer you three alternatives; choose one of them, and I will inflict it on you.'" Gad then went to David to inform him. He asked: "Do you want a three years' famine to come upon your land, or to flee from your enemy for three months while he pursues you, or to have a three days' pestilence in your land? Now consider and decide what I must reply to him who sent me." David answered Gad: "I am in very serious difficulty. Let us fall by the hand of God, for he is most merciful: but let me not fall by the hand of 'man.'" Thus David chose the pestilence. Now it was the time of the wheat harvest when the plague broke out among the people. [The Lord then sent a pestilence over Israel from morning until the time appointed, and seventy thousand of the people from Dan to Beer-sheba died.] But when the angel stretched forth his hand toward Jerusalem to destroy it, the Lord regretted the calamity and said to the angel causing the destruction among the people, "Enough now, stay your hand." The angel of the Lord was then standing at the threshing floor of Araunah the Jebusite. When David saw the angel striking the people, he said to the Lord: "It is I who have sinned, it is I, the shepherd who have done wrong. But these are sheep; what have they done? Punish me and my kindred." (NAV)

On the same day Gad went to David and said to him, "Go up and build an altar to the Lord on the threshing floor of Araunah the Jebusite." Following Gad's bidding, David went up as the Lord had commanded. Now Araunah looked down and noticed the king and his servants coming towards him while he was threshing wheat. So he went out and paid homage to the king, with face to the ground. Then Araunah asked, "Why does my lord the king come to his servant?" David replied, "To buy the threshing floor from you to build an altar to

the Lord, that the plague may be checked among the people." But Araunah said to David: "Let the lord my king take and offer up whatever he may wish. Here are oxen for holocausts, and threshing sledges and the yokes of the oxen of wood. All this Araunah give to the king." Araunah then said to the king: "May the Lord your God accept your offering." The king, however, replied: "No, I must pay for it, for I cannot offer to the Lord my God holocausts that cost nothing." So David bought the threshing floor and the oxen for fifty silver shekels. Then David built an altar there to the Lord, and offered holocausts and peace offerings. The Lord granted relief to the country, and the plague was checked in Israel. (NAV)

New Testament, eschatological references

Matt. 24:7

Nation will rise against nation, one kingdom against another. There will be famine and pestilence and earthquakes in many places. (NAV)

Mark 13:24–30 (parallel to Matt. 24:29–33 and Luke 21:25–31)

During that period after trials of every sort the sun will be darkened, the moon will not shed its light, stars will fall out of the skies, and the heavenly hosts will be shaken. Then men will see the Son of Man coming in the clouds with great power and glory. He will dispatch his angels and assemble his chosen from the four winds, from the farthest bounds of earth and sky. Learn a lesson from the fig tree. Once the sap of its branches runs high and it begins to sprout leaves, we know that summer is near. In the same way, when you see these things happening, you will know that he is near, even at the door. (NAV)

Rev. 10:1–3 (see also Rev. 6:1–17; 8:1)

I saw another mighty angel come down from heaven wrapped in a cloud, with a rainbow about his head; his face shone like the sun... in his hand he held a little scroll which had been opened. (NAV)

Rev. 16:2 (see also Rev. 15:1–2; 18:8)

The first angel went out, and when he poured out his bowl on the earth, severe and festering boils broke out among men.... (NAV)

Rev. 21:9

...filled with the seven last plagues.... (NAV)

Giovanni Boccaccio (1313–75)

The Decameron, trans. G. H. McWilliam (London: Penguin Books, 1995), 5–14.

I say, then, that the sum of thirteen hundred and forty eight years

has elapsed since the fruitful Incarnation of the Son of God, when the noble city of Florence...was visited by the deadly pestilence. Some say that it descended upon the human race through the influence of the heavenly bodies, others that it was a punishment signifying God's righteous anger at our iniquitous way of life. But whatever its cause, it had originated some years earlier in the East, where it had claimed countless lives before it unhappily spread westward, growing in strength as it swept relentlessly on from one place to the next.... Such was the multitude of corpses...that there was not sufficient consecrated ground for them to be buried in.... So when all the graves were full, huge trenches were excavated in the churchyards, into which new arrivals were placed in the hundreds.

Daniel Defoe (1660–1731)
A Journal of the Plague Year, introduction by A. Burgess (London, 1722; reprint, London: Penguin English Library, 1966), 220.

These were the people that so often dropped down and fainted in the streets; for so oftentimes they would go about the streets to the last, till on a sudden they would sweat, grow faint, sit down at the door and die. It is true, finding themselves thus, they would struggle hard to get home to their own doors, or at other times would just be able to go into their houses and die instantly; other times they would go about till they had the very tokens come out upon them, and yet not know it, would die in an hour or two after they came home, but well as long as they were abroad. These were the dangerous people; these were the people of whom well people ought to have been afraid; but then, on the other side, it was impossible to know them.

Giovanni Pietro Giussano (1548–1623)
The Life of St. Charles Borromeo, trans. and ed. E. C. Manning, 2 vols. (London, New York: Burns and Oates, 1884), 1:392.

Round his [St. Charles's] neck he bore a rope like the halter of a condemned criminal; in his hand he carried a crucifix on which he kept his eyes fixed throughout the whole way. He considered himself to bear upon his shoulders the burden of the sins of the people...this was in imitation of holy King David...[and] as he passed along, made the streets re-echo "Mercy!" All the canon and clergy wore garb of penance of their own, the appearance of the city was that of a people whose hearts were full of contrition.

Homer (before 700 B.C.)
The Iliad, trans. Samuel Butler, ed. L. Loomis (New York: Walter J. Jack, Inc., Classics Club, 1942), book 1, 8–9.

> Thus did he [Chryse] pray, and Apollo heard his prayer. He came down furious from the summits of Olympos, with his bow and his quiver upon his shoulder, and the arrows rattled on his back with the rage that trembled within him. He sat himself down away from the ships with the face dark as night, and his silver bow rang death as he shot his arrows in the midst of them. First he smote their mules and their hounds, but presently he aimed his shafts at the people themselves, and all day long the pyres of the dead were burning.
>
> For nine whole days he shot his arrows among the people....
>
> Thereon the seer spoke boldly. "The god," he said, "is angry.... He will not deliver the Danaens from pestilence till Agamemnon has restored the girl without fee or ransom to her father and has sent a holy hecatomb to Chryse. Thus we may perhaps appease him."

Ovid (43 B.C.–A.D. 8)
Metamorphoses, trans. Rolfe Humphries (Bloomington: Indiana University Press, 1955).

Book 7, 169–72

The Plague of Epirus (Aegina)
> A dreadful plague came on our people...
> In the beginning
> Was darkness, and a murk that kept the summer
> Shut in the sullen clouds, four months of summer,
> For months of hot south wind, and deadly airs,
> Fountain and lakes went dry, serpents came crawling
> Over deserted fields, thousands on thousands,
> Tainting our streams with poison. The animals
> Went first, the dogs and birds, the sheep and cattle,
> The beasts of the wild woods...
> ... A life of death
> Seizes them all. In woods and fields and highways
> Lie bodies rotting, and the air is all
> One smell of death...
> Contagion thickens, and the plague grew stronger,
> Fasten on men, on the walls of the great city.

Men's vitals seem to burn: the proof is given
By a red flush and difficulty to breath; the tongue
Thickens, and lips are cracked and dry; the sick
Can not lie still in bed, they cannot bear
The weight of covers over them; they try
To get some coolness from the ground, and lie there,
And get no coolness from the ground, which burns,
Itself the heat of their fever. Even our doctors
Fare as the others do...
So, with no compunction,
They lie in the spring, the streams, any basin of water,
In rabid thirst, cured only by death, not drinking.
And many too feeble to rise, die in the water
And others drink that water. In delirium
Many poor souls leap from their beds, and stagger
Too weak to stand, and others, too weak for leaping,
Roll out on the ground. They flee their household gods,
Since no man's home is sacred. Each man's home
Seems to him Death's abode. Since no man knows
The cause, he blames his little habitation.
You could see them walking along the roads, half lifeless,
As long as they could totter; you could see them
Sobbing and lying on the ground, and rolling
Their dull eyes upward with the last weak effort;
You could see them holding their arms to heaven,
Breathing their last wherever death had seized them...
You see Jove's temple, from the great stairs rising?
Who did not come there, bringing his silly incense?
How many times a husband for his wife
Prayed there, or father for son, and even in prayer
Gone down to death before the prayer was finished,
The incense in the dying hand still smoking!...
The temple doors
Were choked with corpses, and the very altars
Reeked with death's hateful smell...
No one buried
The dead the old way; there were too many.
They lay on the ground, or high on funeral pyres
Were stacked all honorless. there was no honor

By now for dead men; people fought for pyres,
Stole fire to burn them with; there were no mourners...
There was no more room
For graves, there was no more wood for pyres.

Book 15, 384–88

The Story of Aesculapius
And now, O Muses, helper of poets, ... aid the telling
of how an island in the Tiber's channel
Brought the god Aesculapius to Rome.
In the old days a deadly pestilence
Infected Latium's air, and bodies wasted
Pale with bloodless sickness. Men were weary
Of caring for the dead,...
so they went to Delphi,...
"Apollo cannot
Lessen your troubles, but Apollo's son
Has power to help you. Go, with all good omens,
And call on him...."
Then Aesculapius seemed,
In dream, to stand before the Roman's couch,
Even as in his temple, with the staff
In his left hand, his right forefinger stroking
His flowing beard. He spoke, or seemed to, calmly:
"Be not afraid; I shall come, and leave my statues,
But see this serpent, as it twines around
The rod I carry: mark it well, and learn it,
For I shall be this serpent, only larger,
Like a celestial presence...."
He entered Rome, the capital of the world,...
Here the serpent-son [Aesculapius],
Apollo's offspring, came to land, put on
His heavenly form again, and to the people
Brought health and end of mourning.

Samuel Pepys (1633–1703)
Diary: 3 September 1665, quoted from Richard D. Altick, *Paintings from Books: Art and Literature in Britain, 1760–1900* (Columbus: Ohio State University Press, 1985).

Of a complaint brought against a man in town taking a child of a very able citizen of Gracious (i.e., Gracechurch) Street, a saddler, who had buried all the rest of his children of the plague; and himself and his wife now being shut up, and in despair of escaping, did desire only to save the life of his little child. They prevailed to have it received stark naked into the arms of a friend who brought it, having put it into new clothes, to Greenwich.

Cesare Ripa (1560–1623)
Iconologia (Padua, 1611; reprint, New York: Garland Press, 1976).
Peste ouero pestilentia, trans. C. M. Boeckl (from Italian)

Pestilence is a woman, dressed in dark colors, with a frightening pale face. Her forehead is wrapped, yet her arms and legs are exposed. Her clothes are open on the side through which one can see a badly soiled and filthy shirt, one can also see her dirty, aging breasts which are covered by a transparent veil and at her feet rests a wild wolf. The plague is a contagious disease, caught by breathing corrupted air. One could say that without a doubt, praying to God and entertaining no other thought than of the Holy Scripture pertaining to God's wrath is the only recourse for man. The wolf signifies plague because according to Philostrat, the Palamedians were helped on God's holy mountain, by making sacrifices to Apollo, hoping to avoid the danger of pestilence, because during the time of plague there are ordinarily fewer wolves in the country.

The frightening, old woman is yellow complected and her hair is unkempt. Dark clouds crown her head like a garland. She is dressed in an off-white shroud of yellowish vapors. She stands on skins of male and female sheep as well as on other animal skins, holding in her hand a flagellum with blood-stained cords. She is as ugly to look at as the brutal plague. Her melancholic, emaciated appearance of yellowish flesh is as horrible as the infection itself with the yellow pus of the buboes. She shows little sign of life. The clouds show that the disease is sent from heaven and they are yellowish like the sky during a plague epidemic. The animal skins signify mortality and that its putrid air infects people and domestic animals alike. The scourge affects everyone, pardons no age or sex, pities no one, regardless of their station in life.

Virgil (70 B.C.–A.D. 19)
 The Aeneid, trans. Patrick Dickinson (New York: Mentor Books, The New American Library, 1961), book 3, 57–58

The Plague of Phrygia

When suddenly from some poisonous region of heaven
A pestilence fell upon our wretched frames,
A killing blight on man and crop and tree,
And that year death was the only yield we had.
The people died, they surrendered their sweet souls,
or dragged their wasted bodies just alive,
And the Dog Star shriveled the fields to barrenness;
The grasses withered, the blighted crops denied us
our sustenance...
...It was night;
And every living creature upon earth
Was in the grip of sleep. But in my sleep
The sacred figures of the gods of Troy
Which I had carried off the midst of flames
Seemed to appear standing before my eyes,
Clear-cut in the flood of light the full moon poured
In through the window slits, and they spoke to me
And with their words relieved me of my cares:
We are here at Apollo's bidding...
do not flinch from the long
And grinding toil of exile. You must move
your habitation—it was not these shores
Apollo of Delos commended nor did he bid you
Settle in Crete—there is a place the Greeks
Have called the Hesperia—the western land—
An ancient country powerful in war
And rich of soil...
There lies your true home....

Jacobus de Voragine (1230–98)

The Golden Legend: Reading on Saints, 2 vols., trans. W. Granger Ryan (Princeton, N.J.: Princeton University Press, 1993).

Vol. 1, 100–101, "St. Sebastian"

> After all this, the prefect denounced Sebastian to the emperor Dio-
> cletian, who summoned the saint and said to him: "I have always had
> you among the first in my palace, and all this time you have been acting
> secretly against my welfare and offending the gods." Sebastian: "I have
> always worshiped God who is in heaven and prayed to Christ for your
> salvation and the good estate of the Roman Empire." But Diocletian
> gave the command to tie him to a post in the center of the camp, and
> ordered the soldiers to shoot him full of arrows. They shot so many
> arrows in his body that he looked like a porcupine, and left him for
> dead. Miraculously set free, he stood on the steps of the imperial palace
> a few days later and, as the emperor came out, firmly reproached them
> for their cruel treatment of the Christians. "Isn't this the Sebastian
> whom we ordered to be shot to death?" the emperor exclaimed. Sebas-
> tian answered: "The Lord deigned to revive me so that I could meet you
> and rebuke you for the evils you inflict on the servants of Christ!" The
> emperor then ordered him to be beaten with cudgels until he died, and
> had his body thrown into the sewer to prevent the Christians from hon-
> oring him as a martyr. The following night St. Sebastian appeared to St.
> Lucina, revealed to her where his body was, and asked that it be buried
> near the remains of the apostles, which was done. Sebastian suffered
> under the emperors Diocletian and Maximilian, whose reign began
> about the year of the Lord 287.
>
> … In the *Annals of the Lombards* we read that during the reign of
> King Gumbert all Italy was stricken by a plague so virulent that there
> was hardly anyone left to bury the dead, and this plague raged most of
> all in Rome and Pavia. At this time there appeared to some a good angel
> followed by a bad angel ["demon" in an earlier translation] carrying a
> spear. When the good angel gave the command, the bad one struck and
> killed. And when he struck a house, all the people in it were carried out
> dead. Then it was divinely revealed, that the plague would never cease
> until an altar was raised in Pavia in honor of St. Sebastian. An altar was
> built in the church of St. Peter in Chains and at once the pestilence
> ceased. Relics of St. Sebastian were brought to Pavia.

Vol. 1, 173–74, "St. Gregory"

The Tiber once overflowed its banks so far that it came over the city walls and demolished a large number of houses. The river carried a great many serpents and a huge dragon down to the sea, but the waves smothered the beasts and tossed them onto the shore. The stench of their rotting bodies bred a deadly pestilence called the bubonic plague, and people seemed to see arrows coming from heaven and striking this one and that one. The first to be stricken was Pope Pelagius, who died within hours, and the plague swept through the population so fatally that many houses stood empty in the city. The Church of God, however, could not be without a head, and the people unanimously elected Gregory to be their bishop, although he made every effort to dissuade them. He had to be consecrated to be bishop of Rome, but the plague was causing havoc in the city, so he preached to the people, organized a procession, and had litanies recited, exhorting everyone to pray zealously to the Lord. Even while the entire population pleaded with God, however, in any one hour ninety men died; but Gregory continued to urge all to pray until the divine mercy should banish the plague.

When the procession was finished, Gregory tried to flee from Rome... and they carried him back to Rome and consecrated him as supreme pontiff.... The plague was still raging in Rome, and Gregory ordered the procession to continue to make the circuit of the city, the marchers chanting the litanies. The image of Blessed Mary ever Virgin was carried in the procession. It is said that the image was still in the church of St. Mary Major in Rome, that it was painted by St. Luke, who was not only a physician but a distinguished painter, and it was a perfect likeness of the Virgin. And lo and behold! The poisonous uncleanliness of the air yielded to the image as if fleeing from it and being unable to withstand its presence: the passage of the picture brought about a wonderful serenity and purity of the air. We are also told that the voices of angels were heard around the image, singing "Queen of Heaven, rejoice, alleluia / Because he whom thou didst bear, alleluia / Has risen as he said, alleluia!" to which Gregory promptly added: "Pray for us, we beg God alleluia!"

Then the pope saw an angel of the Lord standing atop the castle Crescentius, wiping a bloody sword sheathing it. Gregory understood that put an end to the plague, as indeed happened. Thereafter the castle was called the Castle of the Holy Angel [Castel Sant'Angelo].

Vol. 1, 285–86, "The Greater Litany"

The first litany has three names. Greater Litany, Septiform Procession and Black Crosses. It is called the Greater Litany for three reasons: the first, the one who constituted it, namely, Pope Gregory the Great; the second, the place where it was instituted, namely, Rome,... the third, the occasion for its institution, which was a widespread and deadly pestilence. The Romans, having lived a continent and abstentious life throughout Lent and having received the Body of the Lord at Easter, afterwards threw off all restraints in feasting, in games and in voluptuous living. Therefore God, offended by these excesses, sent a devastating plague upon them—a malady called *inguinaria* because it caused swelling or abscess in the groin. The plague was so virulent that people died suddenly while walking in the street or at table or at play or just talking to each other. It frequently happened that someone sneezed; one quickly said, "God bless you!"

Vol. 2, 202–203, "St. Michael"

We read that the third apparition took place in Rome during the reign of Pope Gregory. The pope had instituted the Greater Litanies because of the inguinal plague raging in the city, and he was praying devoutly for the people when he saw, above the castle that in the past was called the Tomb of Hadrian, an angel of the Lord who was wiping a bloody sword and returning it to its sheath. St. Gregory understood from this that his prayers were heard by the Lord, and he built a church there in honor of the angels; the castle is still called the Castle of the Holy Angel.

Notes

1. The Library of Congress lists six titles under the subject "Plague and Art," one of which is *Images of Plague and Pestilence*. However, two exhibition catalogues published in the 1990s should not appear under this heading. Leonard C. Bruno's *Selected Images Reproduced in the Tradition of Technology* reproduces a "death-bed scene" from a fifteenth-century edition of Ars Morendi which is most definitely not a plague scene (it is the intention of this book to clarify the distinction of plague iconography from death images). *Catalogue of Japanese Art in the National Gallery, Prague* has no connection with our subject at all, and the words "Plague" and "Prague" must have been confused in the cataloging process.

CHAPTER 1: MEDICAL ASPECTS OF BUBONIC PLAGUE

2. For the discussion of the different manifestations of *Yersinia pestis* and the description of buboes, see Thomas Butler, M.D., "Yersinia Species (including plague)," in *Principles and Practices of Infectious Diseases*, by Gerald L. Mandell, R. Douglas, and J. Bennett, 4th ed. (New York: Churchill Livingstone, Inc., 1995), 2070–78; and nn. 17, 34 below. Also see A. Lynn Martin, *Plague? Jesuit Accounts of Epidemic Disease in the 16th Century*, Sixteenth Century Studies, vol. 18 (Kirksville, Mo.: Truman State University Press, 1996), 5, tables 1 and 2, and n. 25 below. The word bubo derives from the Greek word for groin. Bubonic plague is one of the four internationally quarantined diseases; the others are cholera, smallpox, and yellow fever. See also http://www.cdc.gov/travel/diseases/plague.htm and http://www.cdc.gov/ncidod/dvbid/plagdiagnosis.htm.

3. Medical historians, who have researched earlier pandemics, have eliminated the possibility that some of the ancient diseases—such as the Athenian Plague (Plague of Thucydides in 430 B.C.)—were caused by *Y. pestis*. For an overview, see *Encyclopedia of Plague and Pestilence*, ed. George Kohn (New York: Facts on File, Inc., 1995).

4. Butler, "Yersinia Species," 2071.

5. Charles Gregg, *Plagues: The Shocking Story of a Dread Disease in America Today* (Albuquerque: New Mexico University Press, 1985), 39.

6. Henri Mollaret and Jacqueline Brossollet, *Alexandre Yersin, 1863–1943* (1985; reprint, Paris: Belin, 1993). Mistakenly for almost a century, Dr. Yersin had to share the honor of having isolated the causative organism with another scientist, Shibasaburo Kitasato. See also M. Ogata, "Über die Pestepidemie in Formosa," *Zentralblatt für Bakteriologie, Parasitenkunde und Infektionskrankheiten* 21 (n.p., 1897): 769–77. Independently from Prof. Ogata, Dr. P. L. Simond studied fleas as carriers of the plague bacillus. He published his findings in 1898 in the *Annales de l'Institut Pasteur* which made world news (see chap. 7,

n. 241). The bacillus can be transmitted by other insects feeding on infected carcasses. Modern scholars suspect, for example, that mosquitos and flies seem to play a role in the spreading of the disease. For an illustrated history of plague research, see Jacqueline Brossollet and Henri Mollaret, *Pourquoi la Peste? Le rat, la puce et le bubon* (Paris: Gallimard, 1994).

7. Napoleon had already had his military doctors experiment by inoculating his soldiers in Egypt. An earlier method of guarding against plague infections was sucking pus from buboes of the deceased, although this rather unappetizing procedure was not recommended in official medical treatises. Hilde Schmölzer, *Die Pest in Wien* (Vienna: Österreichischer Bundesverlag, 1985), 124, "Als Gegengift galt auch Buboneneiter."

8. Butler, "Yersinia Species," 2076. Production of the vaccine is now discontinued.

9. Martin, *Plague?* 12, cites a Greek document reporting that in 1348–49 rats, along with dogs and horses, died; no further mention in texts of animal deaths can be traced until the seventeenth century. By that time, however, a number of authors reported animals dying as an indication of an approaching epidemic. A preacher, Abraham à Sancta Clara, *Mercks Wienn* (Vienna: P. P. Vivian, 1680), interpreted this phenomenon as a special warning from God. Another, J. W. Mannagatta, a physician, accepted an explanation then current in the scientific community. He attributed the epidemic to the numerous corpses of animals left to rot in the streets, causing "miasmas," which induced bubonic plague; Ferdinand Olbort, "Die Pest in Niederösterreich von 1653–1683" (Ph.D. diss., University of Vienna, 1973), 20. Although some people may have been aware that animals died, particularly at the onset of an epidemic, such observations may have been largely ignored because they were incompatible with most of the theoretical explanations on causes of bubonic plague. Sheldon Watts, *Epidemics and History: Disease, Power, and Imperialism* (New Haven, Conn.: Yale University Press, 1997), vol. 4, states that "Neoplatonic theories posited that all living things were linked in a Great Chain of Being. In this chain noble mankind came next after the angels…and was separated by many links from lowly rats." The Chinese, on the other hand, called the disease "rat pestilence"; see Ogata, "Formosa," 769. For a summary of the scholarly debate on rats in Poussin's *Plague at Ashdod*, see Christine M. Boeckl, "A New Reading of Nicolas Poussin's *The Miracle of the Ark in the Temple of Dagon*," *Artibus et Historiae* 24 (1991): 143 n. 12. For a sixteenth-century illustration of dead animals, see fig. 1.8; also see n. 12 below.

10. For the latest publication on dismissing bubonic plague as the primary cause of the Black Death, see David Herlihy, *The Black Death and the Transformation of the West*, ed. Samuel K. Cohn, Jr. (Cambridge, Mass.: Harvard University Press, 1997), 6 and nn. 25, 26.

11. For a thorough summary of the scholarship establishing that a variety of infectious diseases was present in Europe, see Martin, *Plague?* introduction, 1–27, esp. 10–11, 18–19; he warns against the hazards of applying medical knowledge to historic accounts of epidemics. I fully concur with Martin's argument that many of the reported epidemics could have been influenza, typhus, dysentery, smallpox, etc. Also see n. 12 below. Diseases mimicking plague buboes are tularemia, ergotism, and other mycotoxicoses; however, they have different transmission patterns and a lower fatality rate.

12. Few scientists accept Graham Twigg's anthrax theory as a viable alternative to Yersinia inflections (Herlihy, *Black Death*, 30). Although medieval chronicles do not mention a large number of dead rats at the outset of an epidemic, neither do modern clinical reports on bubonic plague. A case in point is the article written by M. Ogata in 1897 when he

investigated the outbreak of bubonic plague in Formosa. The scientist wrote, "During my stay in Taihoku I had six dead rats at my disposal; two were given to me by a physician, I found two in the street, one came from the barracks, and one was brought by a medical orderly" (Ogata, "Formosa," 770). Although he reports that the natives warned him about the danger of infected dead rodents, his account does *not* imply that there was a sea of carcasses in public places. Prof. Thomas Butler, M.D., Chief of the Division of Infectious Disease at Texas Tech University (see n. 20) answered some of my questions about the visibility of dying rats. In his letter, dated 23 March 1998, Dr. Butler wrote about his own experience in Vietnam and conveyed to me that many rodents, dying from bubonic plague, would be found under houses or in pipes and sewers (they stay out of public view but close to a food supply), rather than out in the street. "In this regard, I find Camus's description unrealistic…apparently fleeing their homes in panic and dying suddenly in flight. Moreover, dogs and cats will eat them" (an observation confirmed by another Vietnam veteran). Herlihy, *Black Death,* 26 and n. 19, on the other hand, cites twentieth-century Asian sources which indicate that thousands of rats had been gathered; however, his information is not very specific. Additional evidence, published in 1998, indicates that "the infectious agent of the Black Death was indeed today's bubonic plague, at least from the sixteenth century onward. Urban construction projects in southern France had recently uncovered two mass graves known from historical evidence to contain victims of quarantine hospitals for what was then called 'plague.' To avoid possible contamination by any other source, the French team pulled teeth that had never emerged from the jaws of these 'plague' victims and extracted the DNA in the dental pulp within these teeth. Seven of the twelve teeth tested showed DNA that matched the DNA of the modern bubonic plague bacillus. When the scientists applied the same procedures to the teeth similarly extracted from a medieval grave in Toulon, France, where there was no historical evidence of plague, none of the teeth revealed plague DNA. The case that the 'plague' victims were infected with *Yersinia pestis* is strong.

"These techniques should now be applied to plague victims of the fourteenth century. According to Herlihy, many well-to-do people about to die from the Black Death willed that their remains be interred in the floor or walls of their favorite church. If several such crypts could be located and opened, it might be possible to identify the genome of the infectious agent by DNA analysis. The French team suggested that five of the dozen teeth they tested from plague victims may not have revealed bubonic plague DNA because the marker sequences had been degraded. The risk of DNA degradation would be even higher for remains from the fourteenth century"; see Joel E. Cohen, "The Bright Side of the Plague," *The New York Review* 46, no. 4 (4 March 1999): 26–28, n. 3. On the transmission of bubonic plague epidemics, Herlihy, *Black Death,* 24, correctly observed that "contact with water ignites its [bubonic plague's] latent powers." Documents mentioned a variety of names: "pest," "plague," "contagious disease," "pestilence," and many others, often trying to avoid the Latin word *pestis* for fear of frightening the population.

13. For a discussion of the most prominent epidemics and their depictions, see chap. 6. The "Borromean" plague, 1575–78, for example, was most likely a *Y. pestis* infection because so many facts concur with modern research: one, many different countries, from Albania to western Europe and from Greece to Spain, reported heavy losses of lives due to epidemics; two, the likelihood that the diseases spread by fleas is proven by the fact that, despite close contact with the infirm, neither Charles Borromeo nor anyone in his

entourage died. The Milanese archbishop insisted on draconic health measures. His rigorous medical precautionary procedures included carrying vinegar-soaked sponges, changing clothing immediately after each contact with the outside world, etc. For a more thorough discussion on St. Charles, see chaps. 3 and 6.

14. The latest hypothesis to support the bubonic plague theory comes from modern research on mutation genes (people of European descent react differently to the AIDS virus; see chap. 8 n. 259).

15. On immunity of animals, see Ogata, "Formosa," 776: "Pigeons, chickens, and dogs do not respond to inoculation with the bacilli." The immunity of dogs to plague also is reported by Lien-Teh Wu, J. W. H. Chun, and R. Pollitzer in *Plague: A Manual for Medical and Public Health Workers* (Shanghai: Weishenshu National Quarantine Service, 1936), 145. The most recent studies report cases from the United States of people having contracted the plague from their pets. In numerous case studies only the cats died, while dogs seemed to be unharmed by their infected flea population. Colin McEvedy, "The Bubonic Plague," *Scientific American* 258 (February 1988): 123, suggests "that a new species of plague bacillus, *Yersinia pestis,* may have evolved that was less virulent than the previous strain... and it might have acted like a vaccine." On fleas, see Carlo Cipolla, *Fighting the Plague in Seventeenth-Century Italy* (Madison: Wisconsin University Press, 1981), 12. On losses of animals during epidemics, Brossollet and Mollaret, *Pourquoi la Peste?* 134–35, mention under the heading of "false animal plagues caused by viruses" that the so-called bovine, as well as swine and horse pests, are caused by a virus and should not be confused with bubonic plague infections.

16. William Hubert, W. McCulloch, and P. Schnurrenberger, *Diseases Transmitted from Animals to Man,* 6th ed. (Springfield, Ill.: Charles C. Thomas, Publisher, 1975), 160–61, write in the subchapter "Detection of the Reservoir" about variations of host species: "These examples serve to show that no hard-and-fast rule has yet emerged that can be applied in all natural foci to identify the basic reservoir host species... but the important role of resistant species as essential components of a reservoir complex does not, in the present stage of our knowledge, supply the complete picture.... Each region has its ecologically equivalent set of small mammalian species which, together with appropriate species of vector fleas, constitute the plague reservoir." Virulence factors are important in the development of immunity against *Y. pestis.* See Christopher Wills, *Yellow Fever, Black Goddess: The Coevolution of People and Plagues* (Reading, Mass.: Addison-Wesley Publishing Co., 1996), who discusses the ecological relationships between climate and virulence.

17. See nn. 1, 12 above; see also Butler, *Yersinia Species,* 2070–76, esp. 2073: "The majority of patients with bubonic plague do not have skin lesions; however, about one-fourth of the patients in Vietnam did show varied skin findings. The most common were pustules, vesicles, eschars, or papules near the bubo or in the anatomic region of skin that is lymphatically drained by the affected lymph nodes, presumably representing sites of flea bites. When the lesions are opened, they usually contain white cells and plague bacilli. Rarely, these skin lesions progress to extensive cellulitis or abscesses. Ulceration, however, may lead to a larger plague carbuncle. Another kind of skin lesion in plague is purpura, which is a result of the systematic disease. The purpuric lesions may become necrotic, resulting in gangrene of distal extremities, the probable basis of the epithet 'Black Death'.... These purpuric lesions contain blood vessels... resulting in hemorrhage and necrosis."

18. Martin, *Plague?* 11, reminds his readers that some scholars established that plague buboes are not the *only* known inflammations of the lymph glands; see n. 11 above.

19. Sudden deaths were reported during the first pandemic by Gregory of Tours. Medical historians have suggested that at the beginning of the second pandemic many persons died of highly contagious *Y. pestis* infections, because Boccaccio described in his *Decameron* that people rose healthy in the morning and had died by nightfall. For illustrations of sudden deaths, see chap. 4. "Mortality rates give the proportion of deaths to total population. Fatality rates relate those who die to the infected"; see Carlo Cipolla, *Christofano and the Plague: A Study in the History of Public Health in the Age of Galileo* (London: Collins, 1973), 104.

20. Wu, Chun, and Pollitzer, *Manual*, 321–22, report that babies under five months of age have a higher survival rate than any other age group. This medical phenomenon is still unresolved.

21. On health boards, see Robert S. Gottfried, *The Black Death: Natural and Human Disaster in Medieval Europe* (New York: The Free Press, 1983), 123. On changes in the status of surgeons, see 118.

22. Louise Marshall, "Waiting for the Will of the Lord: The Imagery of the Plague" (Ph.D. diss., University of Pennsylvania, 1989), 25 n. 64, writes that Jews and other scapegoats such as lepers, the poor, and even pilgrims were accused of spreading the disease; see also Scott Tenner and Andrew Schaamess, "Pandemic, Medicine, and Public Health: *Yersinia pestis* and Fourteenth-Century European Culture," *The Pharos* 56, no. 4 (Fall 1993): 6–10, esp. 8. On the mistrial in Milan, see A. Manzoni, *The Column of Infamy: Prefaced by Cesare Beccaria's Of Crimes and Punishments* (London: Oxford University Press, 1964). For an illustration of *Jews Being Burnt in Time of Plague*, woodcut by Hartmann Schedel, 1493, see Watts, *Epidemics and History*, ill. 3.

23. Jacobus de Voragine, *The Golden Legend: Readings on Saints*, trans. William Granger Ryan, 2 vols. (Princeton, N.J.: Princeton University Press, 1993), 1:286.

24. Elisabeth Schröter, "Raphaels *Madonna di Foligno* ein Pestbild?" *Zeitschrift für Kunstgeschichte* 50 (1987), 47–87, esp. 55–57.

25. Jürgen Grimm, *Die literarische Darstellung der Pest in der Antike und Romania* (Munich: W. Fink, 1965), 44–54, esp. 46. For the importance of clouds in religious and secular plague images, see chap. 3.

26. The theory of miasma or miasm, infectious or disease-causing air, goes back to ancient texts that explained many illnesses, especially epidemics, to be caused by polluted air from decaying organisms. Not until the 1880s, when Louis Pasteur and Robert Koch discovered specific microbes that cause tuberculosis and cholera, were these ideas revised. Susan Sontag, *Illness as Metaphor and AIDS and Its Metaphors* (New York: Doubleday, 1990), 130, maintains that some of the vestiges of the belief in miasmas still color our medical perceptions.

27. Marsilio Ficino, *Consigliocontro la pestilenza*, ed. E. Musacchio, with an introduction by G. Morgaglia (Bologna: n.p., 1983); also Grimm, *Darstellung*, 46–47.

28. On protective garments, see Brossollet and Mollaret, *Pourquoi la peste?* 54–55; bird masks probably were chosen because of the species' immunity to plague; on fleas, see Cipolla, *Fighting the Plague*, 12.

29. Duane J. Osheim, Plague Project, University of Virginia: http://jefferson.village.virginia.edu/osheim/intro.html.

30. The word quarantine derives from the word forty—the number of days Christ stayed in the wilderness. Schmölzer, *Pest in Wien*, 148–52, esp. 151, writes in the chapter "Der immerwährende Pestkordon" that the "ceaselessly existing plague cordon" was established five years after the last outbreak of bubonic plague in Vienna when Emperor Charles VI decided to build a frontier against disease as well as against Turkish invasions. The sanitary cordon stretched from the Carpetian Mountains to the Adriatic Sea. At the beginning of the nineteenth century, the project employed between five thousand and eleven thousand [!] men, depending on the danger factor, i.e., how many deaths of bubonic plague were reported in the neighboring eastern regions. The effectiveness of this border watch has been debated in twentieth-century literature. Schmölzer quotes Georg Sticker as discounting the efficiency of the cordon, even saying that it had no value at all; however, she rebuts that there had been several eighteenth-century epidemics reported east of the demarcation zone which did not spread into central Europe; also see Nikolaus von Preradovich, *Des Kaisers Grenzer* (Vienna: Fritz Molden, 1970), 226–28.

31. On the theory of humors, see Gottfried, *Black Death: Disaster*, 106.

32. Theriac; the word also sometimes describes an antidote. On the medicinal association of fig leaves warding off illness and plague, see Deborah Markow, "Holbein's Steelyard Portraits, Reconsidered," *Wallraf-Richartz Jahrbuch* 40 (1978): 39–47, esp. 45; see chap. 3 on the fig tree and clouds.

33. For illustrations of other diseases, see Robert Herrlinger, *Geschichte der medizinischen Abbildung von der Antike bis um 1600*, 2 vols. (Munich: H. Moos Verlag, 1967–72), vol. 1. Since at least A.D. tenth century, skin covered with spots had been the mark of lepers; later centuries indicated syphilitics and smallpox victims also with dots. For syphilis illustrations, see Jon Arrizabalga, John Henderson, and Roger French, *The Great Pox: The French Disease in Renaissance Europe* (New Haven, Conn.: Yale University Press, 1997). For the moral distinction between the different diseases, see chap. 8.

34. Butler, *Yersinia Species*, 2072–75, lists five plague syndromes: bubonic, septicemic, pneumonic, cutaneous, and meningitis (including some mutants not relevant for this discussion), each featuring a variety of symptoms. See nn. 19 above and 42 below. For more illustrations of historic renderings of physical symptoms, see Henri Mollaret and Jacqueline Brossollet, "La peste, source méconnue d'inspiration artistique," *Jaarboek Koninklijk Museum voor Schone Kunsten Antwerpen*, 1965, 3–112; see also Brossollet and Mollaret, *Pourquoi la Peste?* and for textbook plates, see Butler, *Yersinia Species*, figs. 3–5.

35. The photograph, figure 1.1, was donated by the Fond H. H. Mollaret and J. Brossollet. I am very grateful for the opportunity to publish it here for the first time. Figure 1.2 depicts a detail from Josse Lieferinxe's *St. Sebastian Intercedes during the Plague*; for more information on the painting, see chap. 4, fig. 4.2.

36. St. Sebastian Chapel, Lanslevillard, Savoy. On the gesture of the raised arm exposing an axillary bubo, see Christine M. Boeckl, "Plague Imagery as Metaphor for Heresy in Rubens' *The Miracle of St. Francis Xavier*," *Sixteenth Century Journal* 27 (1996): 989.

37. I am grateful to Dr. Thomas Butler for granting me permission to reproduce the two photographs, figs. 1.4 and 1.6, from his photo archives.

38. Martin, *Plague?* 5, table 1, shows that the femoral bubo is still the most frequently found glandular swelling. For three illustrations of St. Roch's thigh bubo (including C. Crivelli's painting in L'Accademia, Venice, c.1487), see Brossollet and Mollaret, *Pourquoi la peste?* 52–53.

39. For fig. 1.6, see Butler, n. 37 above.
40. The print *St. Roch Cured by an Angel*, title page of Maldura's *Vitam S. Rochi contra pestem Epidemia* (c. 1480); see discussion in chap. 3. The print is illustrated in Christine M. Boeckl, "Baroque Plague Imagery and Tridentine Church Reforms" (Ph.D. diss., University of Maryland, 1990), fig. 5.
41. For a more thorough discussion of Luca Giordano's altar, see chap. 6.
42. In the preface, Mme. Brossollet mentioned artists who illustrated the pustules where the original flea bite had occurred (French: *charbon*, Italian: *carbone*). Janssens's painting is illustrated in Mollaret and Brossollet, "La peste, source méconnue," plate 71. For a medical textbook plate, see Butler, *Yersinia Species*, fig. 5 (unfortunately, these physical symptoms are difficult to reproduce successfully in print).
43. See chapter 4. On manifestations, see n. 34 above.
44. Fig. 1.8, *Plague Victims*, was published in Francesco Petrarca, *Artzney Bayder Glück* (Augsburg, 1532), 116. The woodcut is an adoption from the original Catholic version of c. 1520 which featured in the upper left-hand corner SS. Sebastian and Roch (see Boeckl, "Baroque Plague Imagery," fig. 10). The plague saints were later obliterated, most likely to please a Protestant clientele. Numerous prints dating from the fifteenth and sixteenth centuries show the characteristic protective gesture against breathing miasmic air. The earliest version known to me is *Visit to a Plague-Stricken Man*, 1493–95, illustrated in *Venezia e la Peste, 1348–1797*, 2d ed. (Venice: Marsilio Editori, 1980), 38–39.
45. The sickbed scene, fig. 1.9, is taken from a medical book, *Fascicul medicine te Antwerpen*, published in 1512. Cesare Ripa, *Iconologia* (Padua, 1611; reprint, New York: Garland Press, 1976), describes "Plague" as an old woman with her head bandaged; for Ripa's text, see appendix.
46. Muslim influence on medical science in the Christian West needs further study. In 1348, Pope Clement VI was believed to have survived the Black Death because he spent weeks in isolation, sheltered by open charcoal fires.
47. On Lingelbach, see R. Trnek, *Die Niederländer in Italien* (Salzburg: Residenz Verlag, 1986), 123–26, who dates *The Carnival in Rome*, because of its distinct signature, immediately after the artist's return from Rome in the early 1650s. However, because of the history of the illness, I propose a date after 1656, when Rome was devastated by bubonic plague. Assuming that this painting postdates that epidemic, it may refer to the traditional complaint by the Roman Catholic Church that indiscretions committed during carnival season can be blamed for the rise of plague epidemics. Thus Lingelbach might have varied the old theme "Carnival and Lent," although he treated the topic rather tongue-in-cheek. The Lingelbach literature has not taken notice of the plague theme in the painting.
48. On Spadaro, see James Clifton, "Images of the Plague and Other Contemporary Events of Seventeenth-Century Naples" (Ph.D. diss., Princeton University, 1987), 147.
49. Wu, Chun, and Pollitzer, *Manual*, 311, reported that at the onset of the disease "pregnant women almost always abort"; see also Rosemary Horrox, trans. and ed., *The Black Death*, Manchester Medieval Source Series (Manchester: Manchester University Press, 1994), 22. Gabriele de Mussis's *Historia de morbo* states that "numberless women [died], particularly those who were pregnant."

CHAPTER 2: LITERARY SOURCES OF PLAGUE ICONOGRAPHY

50. The problem of translating historic documents accurately derives from the multiple use of the words *plague* and *pestilence* (Latin: *pestis, pestilentia, lues; loimos* in Greek; *deber* in Hebrew). *Webster's New Collegiate Dictionary* (Springfield: G. & C. Merriam Co., 1961) defines "pestilence" as any contagious or infectious epidemic disease that is virulent and devastating; specifically the bubonic plague, the pest, and the "plague" as an acute virulent disease caused by a bacterium (*Pasteurella pestis* or *Y. pestis*). "Plague," which may be derived from the Latin word *plaga* (stroke, wound), has long been applied metaphorically. Procopius called Emperor Justinian "worse than the plague." In English usage, for example in 1513, the disease also meant a social disorder: "'pestilent' is injurious to religion, morals, or public peace"; and, in 1531, it suggested being morally baneful or pernicious. Also, in the sixteenth century, Petrus Canisius, S.J., and other Catholic authors used pestilence specifically as a metaphor to describe heresy. See discussion on heresy in chap. 6.

51. Jürgen Grimm, *Die literarische Darstellung der Pest in der Antike und Romania* (Munich: W. Fink, 1965), gives an invaluable survey of plague authors and the development of the different *topoi*. For many centuries, the Mediterranean basin was by far the most productive region in creating plague pictures. The lacuna of plague images in Protestant territories will be discussed at length in chaps. 4 and 7.

52. G. H. McWilliam, introduction to Giovanni Boccaccio, *The Decameron*, trans. G. H. McWilliam (London: Penguin Books, 1995), xiv, writes that Boccaccio's descriptions are heavily dependent on Paul the Deacon's plague accounts. Also, "there is no external evidence to support Boccaccio's contention that he was an eyewitness to the terrible suffering to which the Florentines were subjected." McWilliam proposes that Boccaccio lived during the end of 1347 and 1348 in Ravenna and Forli. He also suggests that many of the details that Boccaccio claimed to have heard from a "reliable source" could have come from letters of Boccaccio's father, who was a Florentine Minister of Supply.

53. Introduction to *Oedipus the King* in Sophocles, *The Three Theban Plays: Antigone, Oedipus the King, Oedipus at Colonus*, trans. R. Fagles (New York: Penguin Classics, 1984), 131–53.

54. Thucydides, *History of the Peloponnesian War: A New Translation, Background and Contexts, Interpretation* (New York: W. W. Norton & Co., 1998), 2:47–59. For the plague sermon, see Jean Battiste Bertrand, *A Historical Relation of the Plague at Marseilles in the Year 1720*, trans. A. Plumptre (London, 1805; reprint, with an introduction by J. N. Biraben, Farnborough, Hants: Gregg, 1973), 356.

55. Grimm, *Darstellung*, 60–61.

56. Procopius of Caesarea, *History of the Wars*, trans. H. B. Dewing, *The Loeb Classical Library: Greek Authors* (London: Heinemann, 1914–22), vols. 1–4; Paul the Deacon, *History of the Langobards*, trans. W. D. Foulke (Philadelphia: University of Pennsylvania Press, 1907); Gregory of Tours, *History of the Franks*, trans. O. M. Dalton, 2 vols. (Oxford: Clarendon Press, 1927).

57. Jacqueline Brossollet, "Pétrarque a-t-il diffamé Guy de Chauliac?" *Annales de Chirurgie* 52, no. 7 (1998): 657–59.

58. In Cesare Ripa, *Iconologia* (Padua, 1611; reprint, New York: Garland Press, 1976), 421–22, the personification "Peste ouero Pestilentia" was *not illustrated*. For the two paragraphs of text, see appendix. Mason Tung, *Two Concordances to Ripa's Iconologia* (New

York: AMS Press, 1993), 216, compares five different versions of the texts (Italian 1603, 1624; Dutch 1644, 1677; and French 1644). However, even in different languages, the description of a "pale ugly old woman" is very consistent (sometimes the color of her dress varies). Also uniform is the description of Peste in the first paragraph as having her head bandaged, but—more important—in the second paragraph she is described as wearing a "wreath of clouds" (occasionally prints inspired by Ripa's text show her crowned by clouds).

59. For Defoe's literary sources, see Henri Mollaret, "Préface au *Journal de l'année de la peste de Daniel Defoe*" (Paris: Gallimard, coll. Folio, 1982), 1–25.

60. Jean Louis Schefer, *The Deluge, the Plague—Paolo Uccello*, trans. Tom Conley (Ann Arbor: University of Michigan Press, 1995). For analogies drawn between Noah's Flood and pestilence, see Christine M. Boeckl, "Vienna's *Pestsäule:* The Analysis of a Seicento Plague Monument," *Wiener Jahrbuch für Kunstgeschichte* 49 (1996): 46–47 and n. 17.

61. *Eerdmans Bible Dictionary* (Grand Rapids, Mich.: Eerdmans, 1987), 818, lists all quotes that mention the word pestilence.

62. For David's transgression, see chaps. 3 and 5.

63. Paul L. Weinmann, M.D., M.P.H., "The Tenth Plague-Death of the 'New Born'?" *The Pharos* (Fall 1993), 20–24.

64. On chiliastic movements, see Robert E. Lerner, "The Black Death and the Western European Eschatological Mentalities," in *Black Death: The Impact of the Fourteenth-Century Plague*, Papers of the 11th Annual Conference of the Center for Medieval and Renaissance Studies, ed. Daniel Williman, introduction by Nancy Siraisi (Binghamton, N.Y.: Center for Medieval and Renaissance Studies, 1982), 77–105. For the symbols, see chap. 3 n. 85.

65. For Poussin literature, see Christine M. Boeckl, "A New Reading of Nicholas Poussin's *The Miracle of the Ark in the Temple of Dagon*," *Artibus et Historiae* 24 (1991): 119–45; also see *Nicolas Poussin: 1594–1665*, exhibition catalogue, Galeries nationales du Grand Palais, ed. Pierre Rosenberg (Paris: Réunion des musées nationaux, 1995), 200–202.

66. Voragine, *Golden Legend*. Originally known as *Legenda Sanctorum*, it was first published around 1260. Voragine appropriated the vivid description of the early Christian martyr as having been pierced by such a barrage of arrows that he resembled a hedgehog from an earlier publication, St. Sebastian's fifth-century *Passio*. The *Golden Legend* also quoted from Paul the Deacon's *History of the Langobards*; in fact, the compilation consists of about one hundred thirty textual sources from the second to the thirteenth centuries. For our discussion, the accounts of the outbreak in Rome as described in the *Golden Legend*, when Gregory I (the Great) was elected pope, are very important. Although no contemporary, sixth-century art alludes to the Justinian pandemic—rather, later, *after* the Black Death—Pope Gregory I became the subject of numerous plague scenes.

67. *Acta Sanctorum*, Antwerp, 1643–1925; *Biblioteca Sanctorum*, 12 vols. (Rome: Institutio Giovanni XXIII della Fraternitatis, 1961–87).

68. A conservative estimate of the number of plague saints would be in the hundreds; see also chap. 3. Henri van de Waal, *Iconclass, an Iconographic Classification System, Bibliography* (Amsterdam: Nord Holland Publishing, 1973), 1043, enumerates only a few of the most frequently depicted saints. Equally helpful for researching plague topics is Andor Pigler, *Barockthemen*, 2 vols. (Budapest: Ungarische Akademie der Wissenschaften, 1956).

69. *Thasei Caecili Cypriani, De Moralitate*, trans. M. L. Hannan, The Catholic University of America, *Patristic Studies 36* (Washington, D.C.: Catholic University of America Press, 1933), 21. On the "Plague of Cyprian," see *Encyclopedia of Plague and Pestilence*, ed. George Kohn (New York: Facts on File, Inc., 1995), 270.

70. As quoted in Louise Marshall, "Waiting for the Will of the Lord: The Imagery of the Plague" (Ph.D. diss., University of Pennsylvania, 1989), 17.

71. Marshall, "Waiting," 17–18. On papal indulgences, see Boeckl, "Baroque Plague Imagery," 60 n. 28.

72. Gregory of Tours, *History of the Franks*, 2:426–28.

73. Norman Cohn, *Noah's Flood: The Genesis Story in Western Thought* (New Haven, Conn.: Yale University Press, 1996), 37, speaks of the long tradition "parallel to the typological/allegorical" interpretations of the Flood.

74. Abraham à Sancta Clara, *Mercks Wienn* (Vienna: P. P. Vivian, 1680); another plague sermon is preserved in Portugal, published by Heinz Willi Wittschier, *Antonio Vieiras Pestpredigt* (Münster, Westfalen: Aschaffendorff, 1973), which was based on biblical quotes and the example of St. Roch. It is one of the few literary sources originating in the Iberian Peninsula.

75. Bertrand, *A Historical Relation*, 362.

76. Bertrand, *A Historical Relation*, 361–62. For partial text, see appendix. Already the Romans had introduced new religious rites as a response to plague and famine.

77. On Eucharist, see Miri Rubin, *Corpus Christi: The Eucharist in Late Medieval Culture* (Cambridge: Cambridge University Press, 1991), 233.

78. For the rituals, see *Rituale sacramentorum ac aliarum ecclesiae ceremoniarum ex rituali juxta decretum synodi* (Rome, 1584–1602), abbreviated as *Rituale Sanctorum Gregori XIII* or *Rituale Romanum*, most commonly referred to as *Rubric*; also see Rev. James O'Kane, *Notes on the Rubrics of the Roman Ritual* (New York: P. O'Shea, 1882).

79. A collection of hand-colored facsimiles, *Pestblätter des 15. Jahrhunderts*, was published by P. Heitz and W. L. Schreiber (Strasbourg: Heitz und Mundel, 1901). Until the sixteenth century, the hope that specific prayers could prevent infections made them very popular items. However, by the seventeenth century, only a few devotional prints were commissioned. I presume people lost faith in the prayers or even in some of the saints, but, more important, some people suspected that paper transmitted the disease.

80. On Le Fèvre, see Michael Camille, *Master of Death* (New Haven, Conn.: Yale University Press, 1996), 158. The Parisian *Dance of the Dead* was destroyed in 1786. The motif in the *Dance of the Dead* of a skeleton parading as an "equalizer" may have been utilized, at times, to commemorate a plague epidemic, as well as other disasters such as famines, etc. Yet, a link between a specific outbreak of plague and individual fresco cycles is difficult to prove. The documents for Basel's *Totentanz*, for example, are too sketchy to establish irrefutably that the Council of Basel (1431–49) had commissioned the famous mural to commemorate pestilence.

CHAPTER 3: VISUAL SOURCES OF PLAGUE ICONOGRAPHY

81. Cataloguing these images and classifying them in an orderly fashion has been a formidable task, particularly since many works included more than one motif and could be codified under various headings.

82. Avraham Ronen, "Gozzoli's St. Sebastian Altarpiece in San Gimignano," *Mitteilungen des*

Kunsthistorischen Institut Florenz 32 (1988): 77–126, esp. 91–95.

83. Voragine, *The Golden Legend*, 1:173.

84. More on that subject appears in chap. 4

85. For the different symbols, see Schröter, "Raphaels *Madonna*," 47–87; on comets, 55–61; on eschatology, 63–75; on fig trees, 73. On clouds, see chap. 1 n. 25. Since A.D. second century, Apollo was associated with plague clouds: "Longhaired Phoebus dispels the cloud of Pestilence," as quoted from *Martianus Capella and the Seven Liberal Arts*, vol. 2, "The Marriage of Philology and Mercury," trans. William Harris Stahl and Richard Johnson (New York: Columbia University Press, 1977), 13 n. 40. For the Christian concepts of "plague clouds," see Boeckl, "Vienna's *Pestsäule*," 41–56, 295–302, esp. 50–51. On the fig tree, see chap. 1 n. 32.

86. See Marshall, "Waiting," 67, on *ostentatio vulneris* and on satisfaction of divine justice; see also chap. 4.

87. For one of the latest examples depicting an underarm bubo, see chap. 7, J. A. J. Gros's *Napoleon in the Pest House of Jaffa*, fig. 7.1. See also Jacqueline Brossollet, "Saint Roch et la pudeur," *La Clinique* 16 (1971): 225–29. For figures covered with sores, see chap. 1 n. 33 and chap. 6.

88. Raphael may have seen medical illustrations demonstrating plague gestures—people covering their noses; see figs. 1.8, 1.9. For depiction of sudden deaths, see chap. 4.

89. For a more extensive discussion of Raimondi's print, see chap. 5.

90. Nicolas Poussin repeated the same gesture of protecting the breath against miasmas in his *Plague at Ashdod*. Joachim von Sandrart, friend of Poussin, applauded the painter's attempt to describe realistically a bubonic plague scene by indicating the "appropriate gesticulations." Joachim von Sandrart, *Teutsche Academie der Edlen-, Bau-, Bild und Mahlerey-Kunste* (Nurnberg, 1675), 367–68: "samt allerlei zu diesem Stück gehörigen Affekten die Nase zu halten." The changes in the depiction of buboes—or neglecting to show the symptoms—will be discussed in chap. 6.

91. More on the Mignard tradition appears in chap. 6.

92. Boeckl, "Baroque Plague Imagery," plates 22–24, 28, 35–41, 46, 47, 48–50.

93. An example is Raphael's plague *gonfalone* of 1500 for Città di Castello. It represented the Seat of Mercy on the one side, while on the back of the banner appeared the Creation of Eve.

94. In the Middle Ages, life on earth was conceived as a struggle between light and dark forces; in Hebrew lore, demons are responsible for all the evil in the world.

95. The increasing popularity of the devotion to the Virgin as plague intercessor has been noted by several scholars. Martin, *Plague?* 202, writes, "Jesuit piety was always Christocentric, but in the midst of epidemics Jesuits also turned to the Virgin Mary and to the saints." The Holy Family with Anne and Joachim are also known to have been associated with plague.

96. Some of the earliest plague intercessors were those of the sixth-century Justinian plague: Barbara, Christopherus, Valentin, Adrian, and Nicasius; in 680, St. Sebastian was added to that list.

97. A possible connection between the shapes of centralized plague churches and early Christian *martyria* needs to be investigated.

98. On King David, see chaps. 2 and 5. Most important for the production of religious art was his story's interpretation: David's punishment and his redemption through sacrifice

was seen by the Roman Catholic Church as the proper response, once fourteenth-century bubonic plague became reality in Europe. King David's example inspired rich devotional offerings in the form of churches, liturgical objects, and other votive gifts. Today the connection between David's altar and the building of Solomon's Temple is no longer common knowledge as it was for Baroque patrons and artists. For example, Santa Maria della Salute in Venice, a plague votive church built in 1630, is often referred to as "Temple."

99. Marshall, "Waiting," 66–67 n. 60, quotes Leo Steinberg.

100. For Sebastian and heresy, see chap. 4; on St. Sebastian in general, see Marshall, "Waiting," 53–131.

101. "Sebastian in the twentieth century" would be an interesting study.

102. Voragine, *Golden Legend*, 2:201–11. St. Michael, the archangel, is the most important celestial host in plague iconography. According to the *Golden Legend*, St. Michael was responsible for the plagues of Egypt; the archangel also played a part in the eschatological events (he would put Antichrist into Hell). Furthermore, St. Michael cured people, consoled them when they were in need, and received souls of the saints to lead them to Paradise.

103. On St. Roch, see Marie Schmitz-Eichhoff, *St. Rochus: Iconographische und medizinisch-historische Studien*, Kölner medizin-historische Beiträge, 3 (Cologne: F. Hansen, 1977); Irene Waslef, "The Role of St. Roch as a Plague Saint: A Late Medieval Hagiographic Tradition" (Ph.D. diss., The Catholic University of America, 1984); also see Marshall, "Waiting," 168–95.

104. B. L. Maldura's title page of St. Roch's biography, *Vitam San Rochi contra pestem epidemia*, published c. 1480, showed a composition very similar to a Roman mural. I am quite aware that the Pompeian painting could not be known to fifteenth-century artists; however, a similar image could have served as a model for the Renaissance artist. For the visual comparison with a classical prototype, see Boeckl, "Baroque Plague Imagery," figs. 5 and 88.

105. For Charles Borromeo's iconography, see Carlo Bascapé, *De vita et rebus gestis sancti Caroli* (Ingoldstadt, 1592; reprint, Milan, 1965), and Giovanni Pietro Giussano, *The Life of St. Charles Borromeo*, trans. and ed. E. C. Manning, 2 vols. (London: Burns & Oates, 1884); also see Roger Seiler, *Zur Ikonographie der religiösen Pestdenkmäler des Kanton Graubünden*, Extra Druck der medizinischen Reihe 177 (Zurich: Juris, 1985), and Boeckl, "Baroque Plague Imagery," 108–16. For his ecclesiastic politics, see San Carlo Borromeo, *Catholic Reform and Ecclesiastic Politics in the Second Half of the Sixteenth Century*, ed. J. M. Headley and J. B. Tomaro (Washington, D.C.: Folger Books, 1988).

106. On the *quadroni*, see Gian Alberto Dell'Acqua, *La pittura del Duomo di Milano* (Milan: Nuove Edizioni Duomo, 1985), 24–54. The pictorial series was commissioned in preparation for Charles Borromeo's canonization campaign while he was still considered a *beato*.

107. During an outbreak of bubonic plague in 1624, St. Rosalia's body was found near Palermo and her iconography developed, largely by Anthony van Dyck. For the study of her iconography, see Paolo Collura, *Santa Rosalia nella storia e nell'arte* (Palermo: Santuario del Montepellegrino, 1977).

108. *Tau*, also called St. Anthony's Cross, is discussed in the chapter of Saint Michael; see Voragine, *Golden Legend*, 2:206.

109. For examples of plague votives, also see chaps. 4, 5, and 6. Some were executed during an

epidemic; for example, in 1630, Guido Reni painted his *Pallione del Voto* in Bologna. However, in the case of Van Dyck, the artist fled the infected city of Palermo in 1624 and finished his commission in 1627 in Genoa. See Christopher Brown, *Van Dyck* (Oxford: Phaidon, 1982), 78–81; the painting is illustrated on plate 68.

110. For terminology, see Anabet Thomas, *An Illustrated Dictionary of Narrative Painting* (London: J. Murry in association with the National Gallery Publications, 1995), esp. ix–xii.

111. Henri van de Waal, *Iconclass*, now also available in a computer version, lists a number of classical plague subjects. The most famous of these secular paintings was Michael Sweerts's *Plague in an Ancient City* (or *Plague in Athens*, the title under which the painting was recently auctioned off for around three million dollars). Alexander Rothaug's *Apollo Sending Plague Arrows into a City*, Österreichische Staatsgalerie, Vienna, one of the few twentieth-century plague paintings, shows a continued interest in the classical theme.

112. Gerard Audrans's print—after Mignard—can be dated into the third quarter of the seventeenth century. Since the scene is typical of many different epidemics, it was not difficult to alter the third and fourth states of the engraving to represent the biblical scene of *King David's Remorse*. For that purpose, the image of Apollo's sister Diana, pouring miasmas from the clouds onto the city below, was replaced by that of a plague angel sheathing his sword. The two engraved versions and their different titles have contributed to considerable confusion in plague literature. See "Pest, Pestheilige, Blutwunder und andere Begebenheiten aus der Geschichte der Bakteriologie," *Jahrbuch 1991 der Deutschen Akademie der Naturforscher Leopoldina (Halle/Saale)*, Leopoldina (R. 3) 37 (1992): 211–38.

113. During an epidemic, corpses frequently were thrown into a river or the sea. However, since people in the Middle Ages believed that it was essential for their resurrection to be buried in hallowed ground, Pope Clement VI, during the Black Death, consecrated the Rhône River to serve as the final resting place for many plague victims. For a change of attitude toward the relationship between body and soul, see chaps. 4 and 6.

114. J. D. Clifton, "Images of the Plague and Other Contemporary Events of Seventeenth-Century Naples" (Ph.D. diss., Princeton University, 1987), 148. Also see Wendy Wassyng Roworth, "The Evolution of History Painting: Masaniello's Revolt and Other Disasters in Seventeenth-Century Naples," *The Art Bulletin* 75 (1993): 219–34; Christopher R. Marshall, "'Causa di Stravaganza': Order and Anarchy in Domenico Gargiulo's *Revolt of Masaniello*," *The Art Bulletin* 53 (1998): 478–97.

115. The eighteenth-century print depicts a basilisk, which to my knowledge is unique in plague art.

116. More on Rubens's allegories appears in chap. 6.

117. On plague sculpture and its intricate iconography, see Boeckl, "Vienna's *Pestsäule*."

CHAPTER 4: THE BLACK DEATH AND ITS AFTERMATH

118. According to Benedict XII's predictions, two judgments are involved—one at death, the other at the end of time. His views stand in contrast to those of John XXII who favored the principles of the Eastern Church, which assume that the dead rest until Judgment Day. On the Eastern influence, see Caroline Walker Bynum, *The Resurrection of the Body in Western Christianity, 200–1336* (New York: Columbia University Press, 1995), 282.

119. The best account of Pope Benedict's religious publications is found in Friedrich Wetter,

Die Lehre Benedikts XII: Vom intensiven Wachstum der Gottesschau (Rome: Gregorian University, 1958). His research is based on the Vatican manuscript (Latin Codex 4006) *De statu animarum sanctorum ante generale judicium,* which most likely was written after 1332. *Benedictus Deus* was published 29 January 1336.

120. Bynum, *Resurrection,* on *Benedictus Deus,* 246, 278, 283, 285, 288. See *The New Catholic Encyclopedia* (New York: McGraw-Hill Book Co., 1967–96), 13:452, which states, "The Christian concept of spiritual soul created by God and infused into the body at conception to make man living whole is the fruit of a long development in Christian philosophy."

121. For the latest literature and dating of the painting, see Christine M. Boeckl, "The Pisan *Triumph of Death* and the Papal Constitution *Benedictus Deus,*" *Artibus et Historiae* 36 (1997): 55–61. The *Triumph of Death* has been attributed to both Buonamico Buffalmacco and to Francesco Traini. The motif of the "Three Living and the Three Dead" was known at least since the end of the thirteenth century. See Herlihy, *Black Death,* 23–28, for the description of how the bubonic plague spread from Asia into Europe and a brief history. Herlihy, *Black Death,* 12, also states that in the fourteenth century, the scythe was a fairly new farming tool.

122. On the *transi,* see Roger Seiler, "Pest und die bildende Kunst," *Gesnerus* 47, pts. 3, 4 (1990): 263–83, esp. 280. On the different semantics of *corpus* versus *cadavre,* see Jacques Chiffoleau, *La comptabilité de l'au-delà: Les hommes, la mort et la religion dans la région d'Avignon à la fin du Moyen Age, vers 1320–vers 1480* (Rome: Ecole française de Rome, 1980), 112–13. Also see Michael Camille, *Master of Death* (New Haven, Conn.: Yale University Press, 1996), 56.

123. Marcia Hall, "Michelangelo's *Last Judgment*: Resurrection of the Body and Predestination," *The Art Bulletin* 58 (1976): 85–92, proves that in the sixteenth century the debate over the "immortal soul" (dogma in 1521) and "the resurrection of the body" was far from over. See Hall, "Michelangelo's *Last Judgment,*" 87, for the Tertullian text *de resurrectione carnis,* published in 1521, as a commentary on Paul's 1 Cor. 15.

124. Hans Belting, "The New Role of Narrative in Public Paintings of the Trecento: *Historia* and Allegory," *Pictorial Narrative in Antiquity and the Middle Ages, Studies in the History of Art* 16 (1985): 151–66, esp. 157.

125. Millard Meiss, *Painting in Florence and Siena after the Black Death* (Princeton, N.J.: Princeton University Press, 1951), 74, dated the work c. 1350. Although at least ten authors have suggested a date prior to the Black Death, Meiss's attractive theory that the *Triumph of Death* mirrors the sudden recurrence of bubonic plague is difficult to purge from non-art-historical discussions. The most plausible date for the painting is 1336–40; see n. 121 above.

126. Boccaccio describes the horrors of the epidemic and the inability of people to cope (see appendix). His descriptions of the disease's symptoms have helped identify the Black Death as bubonic plague; however, his dependency on previous plague topics is obvious. As mentioned in the introduction, a growing number of scholars have recently expressed doubts that the Black Death was caused by bubonic plague; also see chap. 1 nn. 11, 12, 18.

127. On emergency confessions, see Horrox, *The Black Death,* 272.

128. The special status of the clergy and the power of the keys will become plague topics after the Council of Trent (see chap. 6).

129. Chiffoleau, *Comptabilité*; see esp. 391–93, 402–9, 411.

130. Samuel K. Cohn, Jr., *The Cult of Remembrance and the Black Death: Six Renaissance Cities in Central Italy* (Baltimore: Johns Hopkins University Press, 1992), 5. On sumptuary laws, see Sharon T. Strocchia, *Death and Ritual in Renaissance Florence* (Baltimore: Johns Hopkins University Press, 1992), 62; on secondary funerals, see 58. In early plague scenes, in Northern and Southern art alike, the concern for the physical body—after death—is expressed in the depiction of coffins and burials.

131. A similar mural was painted after an epidemic in the Palazzo Sclafani (now in the galleria regionale), Palermo, Sicily. The fresco shows people being killed by plague arrows.

132. Louise Marshall, "Manipulating the Sacred: Image and Plague in Renaissance Italy," *Renaissance Quarterly* 47 (1995): 487, takes a stand against the theory that "the survivors were prey to anxiety and despair"; also see chap. 8.

133. For Benedict XII's views on purification after death, which alleviated the danger of total damnation, see Wetter, *Die Lehre Benedikts*, 10. However, earlier in the pope's career, Benedict had debated Purgatory, defending the doctrine against folkloric legends. Also see Jacques Le Goff, *The Birth of Purgatory*, trans. A. Goldhammer (Chicago: University of Chicago Press, 1984), who talked about Purgatory as "the Third Place" (between Heaven and Hell). Chiffoleau, *Comptabilité*, 391–93, 402–9, 411, describes the development of the cult of Purgatory in France. He has established that the first confraternity devoted to *les âmes du Purgatoire* was founded in 1343 in Avignon. This event is pre-plague *and* took place at the temporary seat of the papacy in France.

134. Avraham Ronen, "Gozzoli's St. Sebastian Altarpiece in San Gimignano," *Mitteilungen des Kunsthistorischen Institut Florenz* 32, no. 1/2 (1988): 77–126; see 77. The altar is illustrated in fig. 12. Herlihy, *Black Death*, 75–76, pointed out that, presumably as a protective measure, after the Black Death the choice of plague saints' names as given Christian names increased.

135. Marshall, "Waiting," 153.

136. Marshall, "Manipulating the Sacred," 486–87.

137. On art production, see Cohn, *Cult of Remembrance*, esp. 277.

138. On satisfaction of Christ, see *The New Catholic Encyclopedia*, 12:1095: "The mode of operation proper to Christ's satisfaction for sin is not a matter of divine and Catholic faith." The concept traces its history back to Anselm of Canterbury; on him and his teachings in the Middle Ages, see John Bossy, *Christianity in the West, 1400–1700* (Cambridge: Cambridge University Press, 1968), 3–4.

139. Marshall, "Waiting," 133 n. 18. On plague Passion plays, see Jacqueline Brossollet, "Le 'jeu de la Passion' à Oberammergau," *Notre Histoire* 31 (1992): 52–55.

140. The image is illustrated in Marshall, "Manipulating the Sacred," fig. 1. On Sebastian's arrows, see Marshall, "Waiting," 511.

141. Marshall, "Waiting," 66; see ill. 22.

142. Charles Sterling, "Josse Lieferinxe," *La Revue du Louvre* (1964), 1–22.

143. Voragine, *Golden Legend*, 2:207, writes that every man is given two angels—"the bad one to test him and the good one to protect him."

144. Voragine, *Golden Legend*, 1:99–100.

145. Ronen, "St. Sebastian Altarpiece," 77–126. I have mentioned in chap. 3 that votive paintings were frequently executed during an outbreak of plague.

146. Ronen, "St. Sebastian Altarpiece," 86.

147. On the *Misericordia*, see Ronen, "St. Sebastian Altarpiece," 89; Marshall, "Waiting,"

209–59; also see Jacqueline Brossollet, "La Vierge au manteau protecteur contre les flèches de pestilence," *Médecine de France* 218 (1971): 15–20. The origin of the Mercy-type Madonna is still a subject of debate. The image existed in Italy by the end of the thirteenth century. The adaptation of the "Plague Madonna of Mercy" goes back at least to the 1370s. The *Misericordia* was believed to shelter mankind against plague arrows and was popular for centuries in painting, sculpture, and prints until the cult was suppressed by the Council of Trent (Ronen, "St. Sebastian Altarpiece," 89). This constraint may have been caused by the conflicting messages that the image of the Mother of God conveyed to the beholder because she protected her devotees and seemed to undermine the absolute power of the Creator. However, the late medieval worshippers would have been cognizant of the fact that the Madonna was part of the workings of the celestial hierarchy. On the diverse messages sent from God the Father and Christ, see Ronen, "St. Sebastian Altarpiece," 86–87.

148. On the deaths of the three brothers from bubonic plague, see Camille, *Master of Death*, 240. On questions of division of hands and dating, see *The Très Riches Heures of Jean Duke of Berry*, introduction by J. Longnon and R. Cazelles, preface by Millard Meiss (New York: George Braziller, 1989).

149. The four images of the *Belles Heures* are illustrated in color in Jacqueline Brossollet and Henri Mollaret, *Pourquoi la Peste? Le rat, la puce et le bubon* (Paris: Gallimard, 1994), 22–25. A woman in labor, if I read the incident correctly, lies in the foreground, seemingly assisted by another person. Such a portrayal would be read, at least in any other context, as a birthing scene. Knowledge that pregnant women miscarried—and frequently died when infected with bubonic plague—may have been well known (see medical discussion, chap. 1 n. 49).

150. Voragine, *Golden Legend*, 1:288.

151. The preplague movement of flagellants or *disciplinati* started in 1260 in Italy and soon spread throughout Europe. The members believed that by practicing self-flagellation they could participate in Christ's sufferings and thus incur merit for themselves and the communities. They were banned during the Black Death, because of their excesses, persecution of Jews, and opposition to Church rules. Pope Clement VI issued a papal bull in 1349 against public penance and pilgrimages under threat of excommunication. See Philip Ziegler, "Germany: The Flagellants and the Persecution of the Jews," in *The Black Death a Turning Point in History?* ed. W. Bowsky (New York: Holt, Rinehart and Winston, 1971), 65–79. The confraternities of *disciplinati* continued in Italy into the fifteenth century and in some regions into the sixteenth. They frequently commissioned plague altars, often with apocalyptic symbols. See Marshall, "Waiting," 214, 225. John Harthan, *The Book of Hours* (New York: Park Lane, 1982), 150–53; flagellants also are included in the Gregorian Procession in the *Soane Hours*, c. 1500 (fols. 136v–37); also see chap. 5.

152. Camille, *Master of Death*, 240.

153. Even before the sixteenth-century Reformation, theologians debated the merits as well as the problems associated with religious sculpture. Apart from my own research, plague literature has not recognized the subject of heresy. See chap. 6, discussion of plague as metaphor for heresy.

154. Horrox, *The Black Death*, 98.

155. Voragine, *Golden Legend*, 2:202. The flags and crosses are also described in 1:287–88.

156. Nicholas of Tolentino (1245–1305) became an oblate at a young age. In 1269 he was ordained as a priest, living mostly in Tolentino as an ascetic and urban hermit. Although Nicholas lived before the Black Death, he earned a reputation as a healer, based on his miraculous vision of the Virgin and St. Augustine, who advised him during an illness to partake of fresh bread dipped in water. After eating the miraculous bread, Nicholas recovered and with the leftovers he healed a number of other sick people. This miracle will be discussed in n. 158 below. For more literature, see Marshall, "Waiting," 147–67. Also see Cohn, *Cult of Remembrance*, 263; testaments after 1348 frequently bore the name of the not-yet-canonized Nicholas of Tolentino.

157. Also see chap. 6 n. 192.

158. To refer to Christ as the divine healer is common; see Horrox, *The Black Death*, 149. On the "Body of Christ," see Miri Rubin, *Corpus Christi: The Eucharist in Late Medieval Culture* (Cambridge: Cambridge University Press, 1991); on plague, see 233–35: "Corpus Christi fraternities often combined charity and eucharistic practices...taking the viaticum to the sick and dying" (235). Also, the healing power, attributed to the blessed, *not* consecrated, bread (*Eulogia* in the Eastern Church) may have originated in the West with Nicholas of Tolentino's miracle. The saint was shown in seventeenth-century Venetian art as distributing blessed bread after mass for the sick at home.

159. Culmacher's plague treatise, *Regimen wider die Pestilenz*, was printed in Leipzig by Martin Landsberg; however, there is no firm publication date (c. 1480–1500).

160. Bynum, *Resurrection*, 279.

161. Marshall, "Manipulating the Sacred," 529.

162. Seiler, "Pest und die bildende Kunst," 280, "Monokausale Erklärungsmuster der Wechselwirkungen von Pest und Kunst dürften der vielschichtigen Wirklichkeit kaum gerecht werden."

Chapter 5: The Sixteenth-Century Renaissance

163. See Adriano Prosperi, "The Religious Crisis in Early Sixteenth-Century Italy," in *Lorenzo Lotto: Rediscovered Master of the Renaissance* (New Haven, Conn.: Yale University Press, 1997), 23. Prosperi writes that preachers upheld the tradition of citing biblical calamities—"pestilence, hunger, war, and violent deaths of multitudes"—to predict the end of time in the near future.

164. Raphael's drawing is in poor condition; for an illustration, see David Landau and Peter Parshall, *The Renaissance Print, 1470–1550* (New Haven, Conn.: Yale University Press, 1994), fig. 122. For Raimondi, see 120–34.

165. Heinrich Wölfflin, *Gedanken zur Kunstgeschichte*, 4th ed. (Basel: Benno Schwabe & Co., 1947), 83, was the first art historian who observed that Western painters, conditioned to read from left to right, frequently gave preference to the right half of a composition. He claimed that the right side determined the mood of a picture. There cannot be any doubt that Raphael was aware of the importance of presenting the events in sequence.

166. See appendix.

167. For the overall composition, Raphael is beholden to an illustration, *Plague of Phrygia*, in the *Strasbourg Aeneid* (printed in 1502). There is a remote possibility that Pieter Bruegel was the first to quote Raphael's mother-child group in his *Triumph of Death* (1562–69). In this enigmatic masterpiece, a woman is placed prominently in the middle ground; she appears, off center to the left, behind the dying bishop. The mother seems to have fallen

to the ground, face down, and is apparently dead, yet she still clutches a wrapped infant in her arms. Behind her, the Parcae cut the thread of life with scissors; see Keith Moxey, "The Fates and Pieter Bruegel's *Triumph of Death*," *Oud Holland* 87 (1973): 49–51. Although popular articles have featured Bruegel's *Triumph of Death* to illustrate the harrowing experience of bubonic plague, scholarly research has not been able to link the canvas with this subject.

168. See Nicolas Poussin's *Plague at Ashdod* in chap. 6.

169. "They surrendered their sweet souls, or dragged their wasted bodies just alive" ("linquebant dulces animas aut aegra trahebant corpora").

170. N. Poussin, M. Sweerts, J. L. David, and many others used classical columns in religious as well as profane plague subjects. See chap. 3.

171. J. N. Biraben, *Les hommes et la peste en France et dans les pays européens et méditerranéens*, 2 vols. (Paris: Mouton, 1975). Later copies after Raimondi's *Morbetto*, e.g., Cornelis Massys (1508–84), B.112, retained the same direction, which proves that there was a demand for plague subjects even in the north. We can assume that Raimondi and other printmakers produced religious plague prints, utilizing Raphael's studies for the *Madonna di Foligno* as models.

172. Schröter, "Raphaels *Madonna*," 47–87.

173. Schröter, "Raphaels *Madonna*," esp. 66, 71–74; also see W. Lindenmann, "Was soll dieser nackte Knabe mit seinem Täfelchen," *Zeitschrift für Kunstgeschichte* 46 (1983): 307–312, esp. on "tavolo votiva," 308.

174. Schröter, "Raphaels *Madonna*," 56–61.

175. The iconography of the *Madonna di Foligno* reflects a number of site-specific features; see Schröter, "Raphaels *Madonna*," 48–50, 63, 66–68. Many of these signs have double meanings and chiliastic symbolism is common.

176. The eschatological ideas also are expressed by the angel holding a tablet (replacing the corresponding scroll of some earlier plague banners). The painting brings to mind the quote from scripture, "I saw another mighty angel come down from heaven wrapped in a cloud, with a rainbow about his head..." (Rev. 10:1). The angel standing in the foreground seems to be crowned by the clouds and a rainbow. The celestial phenomenon has been interpreted as a sign for God's Covenant with man, yet it also refers to a frequent warning in plague sermons that the Coming of the Son of Man would wipe out humankind as God had done during the flood of Noah (Matt. 24:37). The hypothesis on foreboding warning signs from heaven had been confirmed in 1456 when a comet appeared over the Mediterranean. That very year the plague broke out in Rome; worse yet, at the same time, Naples was shaken by an earthquake and the Ottoman Empire threatened Europe. Comets were sighted again in Italy in 1468, 1472, 1500, and 1511, the year before the painting was executed.

177. Schröter, "Raphaels *Madonna*," 51; the print is attributed to Giovanni Antonio da Brescia.

178. Schröter, "Raphaels *Madonna*," 72.

179. Although Schröter could have strengthened her argument by mentioning Guido Reni's *Pallione del Voto* (a votive standard and confirmed plague commission which presented the Madonna as the Apocalyptic Woman seated on a rainbow), she did not expand her discussion beyond the Renaissance period. Also compare with chap. 6 and Catherine Puglisi, "Guido Reni's *Pallione del voto* and the Plague of 1630," *The Art Bulletin* 77

(1995): 402–12.

180. Harold Wethey, *The Paintings of Titian*, vol. 1, *The Religious Paintings* (London: Phaidon, 1969–75), 109–10.

181. Paintings of plague Madonnas often depicted the Virgin surrounded by golden clouds. One wonders when observations such as the one reported by Cesare Ripa, that the sky during an epidemic has a yellowish hue, were formulated and gained general acceptance.

182. Lara Corti, *Vasari catalogo completo dei dipinti* (Florence: Cantini, 1989), 18.

183. See Elsbeth Wiemann, *Der Mythos von Niobe und ihren Kindern* (Worms: Wernersche Verlagsgesellschaft, 1986).

184. Marshall, "Manipulating the Sacred," 485–532, esp. 518–23. The predella panels are illustrated in figs. 15, 16, 17. On the implications of the site for the Israelites, see chaps. 2 and 6. On David's personal guilt, see Boeckl, "Vienna's *Pestsäule*," 41–56, 293–300, esp. 55 n. 47. For an in-depth analysis, see Christine M. Boeckl, "Giorgio Vasari's *San Rocco Altarpiece:* Tradition and Innovation in Plague Iconography," *Artibus et Historiae* 42 (2000), in press.

185. On Tintoretto, see Rodolfo Pallucchini and Paolo Rossi, *Tintoretto: L'opere sacre e profane*, 2 vols. (Milan: Alfieri, Electa, 1982), 1:40.

186. A similar gesture of a plague-stricken is depicted in *Venezia e la peste: 1348–1797*, 2d ed. (1979; reprint, Venice: Marsilio Editore, 1980), ill. 35, Hieronymus Brunschwig's woodcut (*Liber pestilentialis de venis epidemie*: Das Buch der Vergift de Pestilentz), published around 1500.

187. Ulrich Thieme and Felix Becker, *Allgemeines Lexikon der bildenden Künstler von der Antike bis zur Gegenwart* (Leipzig: Seemann, 1865–1922), 36:160, give a short vita of the fairly unknown yet prolific artist who painted in Palermo between the years 1557 and c. 1585. The painting is stored in Palermo's Museo Diocesano; however, I was unable to procure a photograph. Iconoclasm of the sixteenth century is a complex topic; some of the religious debates even preceded the Protestant Reformation. Books warning of the danger that religious images could be idolized and dishonor the invisible Creator date from the 1520s (Andreas Karlstadt and others).

188. Emile Mâle, *L'art religieux de la fin du XVIe siècle, du XVIIe siècle et du XVIIIe siècle, étude sur l'iconographie après le Concile de Trente, Italie-France-Espagne-Flandres* (Paris: Collin, 1932), discussed Tridentine plague pictures in the chapter "Les survivances du passé: Persistance de l'esprit du Moyen Age." I will return to Mâle's interpretation in the next chapter.

CHAPTER 6: THE TRIDENTINE WORLD

189. The *Rituale Sanctorum Gregori XIII*, also known as *Rituale Romanum* or *Rubric,* was not published until 1584–1602; it is now on microfiche. Also helpful for descriptions of post-Trent liturgical rituals is Rev. J. O'Kane, *Notes on the Rubrics of the Roman Rituals* (New York: P. O'Shea, Publisher, 1882). For a more complete discussion of source material, see chap. 2. Also, for the development of style that gave the new theology a convincing voice, see S. J. Freedberg, *Circa 1600: A Revolution of Style in Italian Painting* (Cambridge, Mass.: Harvard University Press, 1983).

190. Anthony Blunt, *Artistic Theory in Italy, 1450–1600* (Oxford: Clarendon Press, 1962), 107.

191. The seventeenth-century popes made hard-and-fast rules for artists as to how they should

depict religious scenes. The Roman Academy of St. Luke was founded in 1577. For texts of papal laws on art, see Melchior Missirini, *Memorie per servire alle storia della Romana Accademia di San Luca* (Rome, 1883), 20–21.

192. On the Canon of Justification, see *The New Catholic Encyclopedia*, 8:83. The latest revision on the subject, Grace vis-à-vis good works, indicates that modern Catholicism comes closer to Lutheran theology than in the seventeenth century. On Anselm of Canterbury, see chap. 4 n. 138.

193. During epidemics, the reception of the Eucharist *per modum viatici* or *communione infirmorum* frequently replaced Extreme Unction as the sacrament for the dying. *Pestilentiarius* was the term used for a clergyman assigned to attend to the plague-stricken.

194. In the sixteenth century, a number of Protestant communion altars were commissioned. For a representation distinguishing Protestant rites from those of Catholics, see Lucas Cranach the Younger's woodcut entitled *Unterscheid zwischender waren Religion Christi/ und falschen Abgöttischenlehr des Antichrists in den fürnehmsten stücken* (Differences between the Lutheran and Catholic Services). Wagenfeldt's *modello* was intended for the St. Jacobi Kirche in Hamburg.

195. The importance of viewing the communion wafer is stressed in Catholic and not in Protestant theology.

196. Richard Douglas, *Jacopo Sadoleto: Humanist and Reformer* (Cambridge, Mass.: Harvard University Press, 1959), 151.

197. Bertrand, *Historical Relation of the Plague,* 360.

198. On papal bulls promising indulgences during plague epidemics, see Boeckl, "Baroque Plague Imagery," 67 n. 28.

199. On the *quadroni*, see chap. 3 n. 106.

200. Mignard's preparatory drawing for the main altar of San Carlo ai Catinari in Rome shows some divergences from the oil sketch (Museum Le Havre) that clearly indicate clerical intervention and censorship. Printed versions after Mignard were executed by F. Poilly, G. Audrans, and Abraham Bossé and by a number of lesser-known printmakers.

201. The painting is still in situ; it is illustrated in Freedberg, *Circa 1600*, ill. 146. The Catholic ritual is observed in every detail: the holy water is poured from a liturgical vessel and not scooped up by hand from the baptismal font as seen in Protestant illustrations. For source books of Catholic rituals, see chap. 2.

202. Gale Feigenbaum, "Lodovico Carracci: A Study of His Late Career and a Catalogue of His Paintings" (Ph.D. diss., Princeton University, 1984), esp. 125–26 and 175–77.

203. On Landrini's painting, see M. Mojana, "Paolo Camillo Landrini detto il Duchino, pittore 'Carliano,'" *Arte Cristiana* 73 (1985): 35–49, esp. 36.

204. The sacrament of penance had been abolished by the Protestants, who were opposed to the priest's absolution, "ego te absolvo," on grounds that it was God rather than the priest who absolved the sinner (see discussion on the power of the keys in chap. 4). On the other hand, penance was an integral part of the life of a practicing Catholic. After the Council of Trent, the Church ruled that the faithful—to remain in good standing in their parishes—had to confess and take communion at least once a year. Confession in preparation for communion is sometimes implied in scenes that depict St. Charles washing the feet of plague victims—in memory of Christ washing the feet of the apostles before the Last Supper. For an illustration of a "plague" confession, see plate 7 in Boeckl, "Baroque Plague Imagery."

205. Edgar P. Bowron, "The Paintings of Benedetto Luti" (Ph.D. diss., New York University, 1970); see also Boeckl, "Baroque Plague Imagery," 146–47.

206. For interpretation of the rituals, see Boeckl, "Baroque Plague Imagery," 30–55.

207. For an illustration of the painting, see Giuliano Briganti, *Pietro da Cortona* (Florence: Sansoni, 1962), ill. 284.

208. For Gérôme, see chap. 7.

209. See n. 200 above. For a more complete discussion of the competition, see Claude Boyer, "Un cas singulier: Le *Saint Charles Borromée* de Pierre Mignard pour le concours de San Carlo ai Catinari," *Revue de l'art* 64 (1984): 23–34.

210. An illustration of Lauri's painting is found in *Venezia et la Peste: 1348–1797*, 2d ed. (exhibition catalogue, 1979; Venice: Marsilio Editore, 1980), 221. Indicative of the trends before the council were the portrayals of miraculous cures of physical afflictions. In 1549 the artist was still "free" to depict St. Roch healing a victim by the "laying on of hands" (as Christ had done). The reformed Catholic Church, however, from the 1560s until 1610, was extremely skeptical of miracles, and this attitude is expressed by the saint's blessing *gestus*, which is consonant with the demand for spirituality. Furthermore, after 1600, the depiction of nude patients was greatly reduced to conform with the demands of the *decoro del corpo et vestito*.

211. Blessed Bernard Tolomei (1272–1348) was born into a well-to-do Sienese family and retired as a young man into a Benedictine community—that later became the Olivetan order. The lay brother Bernard became abbot in 1322. During the Black Death, he nursed fellow citizens, paying with his life for this heroic act. Bernard was accepted as a martyr in the *Martiriologio Romano*. His cult developed early but was not officially recognized until 1644. Bernard Tolomei was beatified in 1768. For the iconography and iconological interpretation, see the informative discussion by John T. Spike, "The Blessed Bernard Tolomei Interceding for the Cessation of the Plague in Siena: A Rediscovered Painting by Giuseppe M. Crespi," *The John Paul Getty Museum Journal* 15 (1987): 110–16; for an illustration, see fig. 1.

212. For communion processions and the Viennese version, *Bl. Bernard Tolomei Comforting the Victims of the Plague*, see Boeckl, "Baroque Plague Imagery," 46–51 and nn. 41–44. Communion processions had appeared earlier in Giovanni Paolo's *St. Nicholas of Tolentino* (fig. 4.6); of special note are the formal changes in the *ciboria*. By the eighteenth century a number of plague scenes included skeletons (which had been absent during the seventeenth century).

213. For the political implications, see Boeckl, "Baroque Plague Imagery," 153–83.

214. This section is an excerpt from my article, Christine M. Boeckl, "Plague Imagery as Metaphor for Heresy in Rubens' *The Miracle of Saint Francis Xavier*," *The Sixteenth Century Journal* 27 (1996): 979–95 (reproduced with permission of the *SCJ*).

215. The *Allegory of the Jesuit Order* is not accessible to the general public. I am grateful to Prof. Helen Rolfson, O.S.F., for directing my attention to this painting. Also, I am beholden to Jesuit faculty, particularly to Professor Emeritus Dr. P. Lenders for letting me study the work in Antwerp. The Latin inscription was translated by Prof. Owen Cramer, The Colorado College; for its text, see Boeckl, "Plague Imagery as Metaphor," 991.

216. For earlier associations between illness and heresy, see Lieferinxe in chap. 4. Very little is written on the depiction of heretics; see Ruth Mellinkoff, *Outcasts: Signs of Otherness in Northern European Art of the Late Middle Ages*, 2 vols. (Berkeley: University of California

Press, 1993). One of her thirteenth-century images, *Crucifixion*, vol. 2, fig. 3.124, represents "heresy" by showing two similar archers whose arrows are repelled by a shield with a cross.

217. Martin, *Plague?* 95.

218. For a more thorough treatment of the subject, see Boeckl, "New Reading," 119–45. Also see *Nicolas Poussin: 1594–1665*, exhibition catalogue, Galeries nationales du Grand Palais, ed. Pierre Rosenberg (Paris: Réunion des musées nationaux, 1995), esp. 202.

219. The association of the Virgin with the Ark of the Covenant is particularly strong in Byzantine art, but Western examples also show Mary, the Annunciate, kneeling next to the Ark.

220. For a similar definition of history in Raphael's *Plague of Phrygia*, see chap. 5.

221. *The Anchor Bible: Samuel, A New Translation, with Introduction, Notes by Kyle McCarthy, Jr.* (New York: Doubleday, 1980), 64.

222. The fact that Guido Reni's *Pallione del Voto* was beholden to Raphael's *Madonna di Foligno* and the tradition of processional votive banners has recently been reaffirmed; see Puglisi, "Guido Reni's *Pallione del Voto*," 402–12. Since Puglisi was not aware of Schröter's proposition, she mentioned, rather in passing, the fact that Reni had painted the Madonna as the Apocalyptic Woman; see esp. 412 n. 48.

223. Puglisi revises the generally accepted theory that the two Jesuit saints were a later addition.

224. Although Mattia Preti and Micco Spadaro also weathered the epidemic in Naples, none of their plague victims show buboes. See also J. D. Clifton, "Mattia Preti's Frescoes for the City Gates of Naples," *The Art Bulletin* 76 (1994): 478–510.

225. For a discussion of the different concepts of body versus soul—from the late Middle Ages to the seventeenth century—see Boeckl, "Pisan *Triumph of Death*," 55–61, esp. 59.

226. See n. 217 above.

CHAPTER 7: REVIVAL OF PLAGUE THEMES AND MODERN REVERBERATIONS

227. David had studied in Rome where he would have become familiar with Giovanni Battista Gaulli's *Madonna of SS. Roch and Anthony*, c. 1665, San Rocco, Rome.

228. For a comprehensive study of this painting, see Henri Mollaret and Jacqueline Brossollet, "A propos des *Pestiférés de Jaffa* de A. Gros," *Jaarboek Koninklijk Museum voor Schone Kunsten Antwerpen* (1968): 263–308.

229. Mollaret and Brossollet, "*Pestiférés de Jaffa*," ills. 6, 7, 8.

230. The painting is now in the Louvre. The Musée Chantilly oil sketch shows a somewhat different architectural background, but, more important, the physical symptoms of the disease are more realistically depicted and Napoleon's hand touches the bubo—in the Louvre painting, only reddish tones indicate the inflamed skin, and the hand is extended toward the victim's chest in a more heroic gesture.

231. Gros's diagonal arrangement of the figures in the side aisle was quoted verbatim by Géricault in an oil study, *Plague* (Museum of Richmond), which is dated c. 1819–22; unfortunately, the artist never realized the project.

232. See Mollaret and Brossollet, "*Pestiférés de Jaffa*," 308. Francisque Millet's *St. Roch in a Plague Hospital Healing by Laying on Hands* is recorded among the Salon entries of 1761.

233. Hennequin's scene also was commissioned by the emperor and showed the 1795 battle between the Royalist and Republican armies. The depicted carnage was intended to

remind the French people that the revolutionary days were over and that the country was unified under Bonapartist rule. Some of these political ideas were expressed by David O'Brien in his paper, "A. J. Gros's *Bonaparte Visiting the Plague Stricken in Jaffa*," presented at the College Art Association meeting in San Antonio, 1995.

234. Much has been written about the years 1720 through 1721 and about the heroic deeds of Henri de Belsunce de Castelmoron. The bishop's plague sermon has been mentioned several times in this book; see appendix. Countless Baroque scenes supplied visual information on Marseilles during the epidemic. It is interesting to note that Gérôme's companion piece to the plague scenes in St. Severin is again a eucharistic theme, the *Last Communion of St. Jerome*. Since Gérôme was not a religious painter, one must assume that the subjects had been suggested to him by church officials and some pentimenti prove that the liturgical aspects of that painting had been closely supervised by theologians. For the artist's own account of the plague scene, see Gerald Ackerman, *The Life and Work of Jean-Léon Gérôme: With a Catalogue Raisonné* (London: Sotheby's Publications, 1986), 43. The artist writes about being dissatisfied with the hardness of his style; however, he thought that in *Belsunce's Vow* the young woman showing her dead child to the bishop expressed the subject very clearly.

235. The painting is now in the Musée d'Orsay; see *The Musée d'Orsay, Paris*, introduction by Michel Lachlotte (New York: Abrams, 1987).

236. For the usage of the English word plague, see chap. 2 n. 50.

237. On Defoe, see Henri Mollaret, "Préface au *Journal de l'année de la Peste* de Daniel Defoe" (Paris: Gallimard, coll. Folio, 1982): 1–25.

238. David Bindman, *William Blake, His Art and Times* (New Haven: Yale Center for British Art, 1982), 74 and 106. The print series represented a litany of miseries: Plague, Famine, Terror, Blight, and Imprisonment. These powerful images do not refer directly to Blake's text, but they provide allegorical commentaries.

239. Although it has been written that Blake's ideas were expressed in current English literature and that Blake was a participant in the millennial anxiety of English society as a reaction to the French Revolution, one has to consider that Blake had these unique and personal visions since 1884, several years before the French stormed the Bastille.

240. For the texts, see appendix. The painting (London's Guild Hall) is not generally accessible to the public; I am grateful to their officials who not only let me study the canvas in storage but also supplied me with the literary sources from their museum's file.

241. Centuries of empirical knowledge had taught the people that plague ("sticking disease") seemed to be transmitted by fabrics, wool in particular. The date of the canvas, 1898, would suggest that the news of the discovery of the plague bacillus had reached London, and possibly, also, Dr. Simond's disclosure concerning the disease's vector, the flea.

242. Daniel Defoe, *A Journal of the Plague Year* (London, 1722; reprint, with an introduction by A. Burgess, London: Penguin English Library, 1966), 220.

243. *Arnold Böcklin, 1827–1901: Ausstellung zum 150. Geburtstag*, exhibition catalogue, 2 vols. (Darmstadt, 1977) 1:132. Without wanting to detract from the merits of this masterpiece's fiery palette, similar brilliant reds, and dark shades of grays, browns, and blacks have been utilized in plague images for centuries. One wonders if the peripatetic Böcklin had become aware of this tradition during his travels.

244. J. Kirk, T. Varnedoe, and Elizabeth Streicher, *Graphic Works of Max Klinger* (New York: Dover, 1977), 90.

245. Medically speaking, the two illnesses have little in common. The former is caused by a bacillus *Y. pestis*, while AIDS is induced by a virus (HIV). Furthermore, plague symptoms appeared within a week from infection and frequently killed the stricken after a few days; the AIDS incubation period is much longer and the acute illness can last for years.

246. The AIDS posters are part of the photo collection of the National Institutes of Health, Bethesda, Md. N.I.H. poster no. 25206 quotes from Albrecht Dürer's *Death on Horseback* (inscribed *Me[m]ento Mei* and dated 1505), sketched when the artist left Nurnberg for Venice to escape the plague. Holbein's *Totentanz* was published first in 1538.

247. Illustrated in *AIDS: Images of Survival!* ed. Charles Michael Helmken (Washington, D.C.: Shoshin Society, 1989).

248. Samuel H. Kress Collection, National Gallery catalogue number 302; N.I.H. poster no. 25303. The traditional topic, "Save the children," has appeared in many plague scenes. In fact, the kind person rescuing the child from the arms of the dying mother had become synonymous with pestilence from the time of Raphael. We have to wrestle anew with analogous ethical obligations. *I HAVE AIDS, please hug me* displays a child reaching out to the viewer; the subtitle adds reassuringly, "I can't make you sick"; N.I.H. poster no. 28344. For literature, see Susan Sontag, *Illness as Metaphor and AIDS and Its Metaphors* (New York: Doubleday, 1990), 145.

CHAPTER 8: PLAGUE IMAGERY, PAST AND FUTURE

249. Saul Brody, *The Disease of the Soul: Leprosy in Medieval Literature* (Ithaca, N.Y.: Cornell University Press, 1974), 64–66, 85–86; also see Caroline W. Bynum, *The Resurrection of the Body in Western Christianity, 200–1336* (New York: Columbia University Press, 1995), 324. For further discussion, see Marshall, "Waiting," 25 n. 64.

250. Marshall, "Waiting," 1.

251. On Giovanni Cambi, see Marshall, "Waiting," 33. On Frederico Borromeo, see Giuseppe Ripamonte, *La peste di Milano del 1630* (Milan, 1641; reprint, 1945), esp. 67.

252. On the Austrian physician, Johannes Carolus Habersack, as quoted in Ferdinand Olbort's "Die Pest in Niederösterreich von 1653–1683" (Ph.D. diss., University of Vienna, 1973).

253. The more cavalier approach to bubonic plague may have been based on anecdotal stories of an inebriated bagpiper who had slept in an open mass grave without falling ill. The tale most likely originated in 1665 in London. A similar episode was reported in Vienna in 1679. On the attitude of the eighteenth century in France, see the discussion of A. J. Gros's *Napoleon in the Pesthouse of Jaffa*, chap. 7. It is interesting that all the empirical knowledge gathered over the centuries was so soon forgotten—Napoleon's doctors no longer isolated the plague-stricken from other injured soldiers.

254. Only a fraction of the numerous publications of the Pasteur research team have been quoted here.

255. Two outstanding essays on Renaissance and Baroque art are proof that a more inclusive method was needed. Elisabeth Schröter's analysis of Raphael's *Madonna di Foligno* and Catherine Puglisi's discussion on Guido Reni's *Pallione del Voto* came independently to the same conclusion that the Virgin, in the respective images, represented the Apocalyptic Woman; I have dealt with both interpretations in the relevant chapters.

256. See Marshall, "Waiting," 2.

257. Daniel Goleman, *Emotional Intelligence* (New York: Bantam Books, 1996), 233; there is

physical evidence of changes in the brains of helpless victims. "Helplessness as a wild card in triggering PTSD (post-traumatic stress disorder) has been shown in dozens of studies on pairs of laboratory rats, each in a different cage, each given mild—but to a rat, very stressful—electric shocks of identical severity. Only one rat has a lever in the cage; when the rat pushes the lever, the shock stops for both cages. Over days and weeks, both rats get precisely the same amount of shock. But the rat with the power to turn the shock off comes through without a lasting sign of stress. It is only in the helpless one of the pair that the stress induced brain changes occurred."

258. I mentioned earlier that, for example, the Vatican Virgil offered no illustration of the diseased Trojans but illuminated the story of the Phrygian plague with "Aeneas's Dream."

259. The latest threats are the ebola virus, anthrax, biological warfare, and many others. On the other hand, recent research suggests that bubonic plague may have had some beneficial effects on mutant genes. According to the *Washington Post*, 8 May 1998, "Survivors of the Black Death, which ravaged Europe in the fourteenth century, apparently bequeathed to their descendants the ability to resist infection by the AIDS virus, modern history's most lethal disease."

Bibliography

Abraham à Sancta Clara. *Mercks Wienn*. Vienna: P. P. Vivian, 1680.

Acta Sanctorum. Antwerp, c. 1613–1867. Reprint, Paris, 1875.

The Anchor Bible: Samuel, A New Translation, with Introduction, Notes by Kyle McCarthy, Jr. New York: Doubleday, 1980.

Ars Medica: Art, Medicine, and the Human Condition. Philadelphia: Philadelphia Museum of Art, 1985.

Belting, Hans. "The New Role of Narrative in Public Paintings of the Trecento: *Historia* and Allegory." *Pictorial Narrative in Antiquity and the Middle Ages: Studies in the History of Art* 16 (1985): 151–66.

Bertrand, Jean Battiste. *A Historical Relation of the Plague at Marseilles in the Year 1720*. Translated by A. Plumptre. London, 1805. Reprint, with an introduction by J. N. Biraben, Farnborough, Hants: Gregg, 1973.

Biblioteca Sanctorum. 12 vols. Rome: Institutio Giovanni XXIII della Fraternitatis, 1961–87.

Biraben, Jean-Noel. *Les hommes et la peste en France et dans les pays européens et méditerranéens*. 2 vols. Paris: Mouton, 1975–76.

Blunt, Anthony. *Artistic Theory in Italy, 1450–1600*. Oxford: Clarendon Press, 1962.

Boccaccio, Giovanni. *The Decameron*. Translated by G. H. McWilliam. London: Penguin Books, 1995.

Boeckl, Christine M. "Baroque Plague Imagery and Tridentine Church Reforms." Ph.D. diss., University of Maryland, 1990.

———. "A New Reading of Nicolas Poussin's *The Miracle of the Ark in the Temple of Dagon*." *Artibus et Historiae* 24 (1991): 119–45.

———. "Plague Imagery as Metaphor for Heresy in Rubens' *The Miracle of St. Francis Xavier*." *The Sixteenth Century Journal* 27, no. 4 (1996): 979–95.

———. "The Pisan *Triumph of Death* and the Papal Constitution *Benedictus Deus*." *Artibus et Historiae* 36 (1997): 55–61.

———. "Vienna's Pestsäule: The Analysis of a Seicento Plague Monument." *Wiener Jahrbuch für Kunstgeschichte* 49 (1996): 41–56, 293–302.

Bossy, John. *Christianity in the West, 1400–1700*. Cambridge: Cambridge University Press, 1968.

Boyer, Claude. "Un cas singulier: Le *Saint Charles Borromée* de Pierre Mignard pour le concours de San Carlo ai Catinari." *Revue de l'art* 64 (1984): 23–34.

Brossollet, Jacqueline, and Henri Mollaret. *Pourquoi la peste? Le rat, la puce et le bubon*. Paris: Gallimard, 1994.

Butler, Thomas, M.D. "Yersinia Species (including Plague)." In *Principles and Practices of Infectious Diseases,* by Gerald L. Mandell, R. Douglas, and J. Bennett. 4th ed. New York: Churchill Livingstone, 1995.

Bynum, Caroline Walker. *The Resurrection of the Body in Western Christianity, 200–1336.* New York: Columbia University Press, 1995.

Camille, Michael. *Master of Death.* New Haven, Conn.: Yale University Press, 1996.

Camus, Albert. *The Plague.* Translated by Stuart Gilbert. New York: Vintage Books, 1991.

Chiffoleau, Jacques. *La comptabilité de l'au-delà: Les hommes, la mort et la religion dans la région d'Avignon à la fin du Moyen Age, vers 1320–vers 1480.* Rome: Ecole française de Rome, 1980.

Cipolla, Carlo. *Christofano and the Plague: A Study in the History of Public Health in the Age of Galileo.* London: Collins, 1973.

———. *Faith, Reason, and the Plague in Seventeenth-Century Tuscany.* Translated by M. Kittel. Ithaca, N.Y.: Cornell University Press, 1979.

———. *Fighting the Plague in Seventeenth-Century Italy.* Madison: Wisconsin University Press, 1981.

———. *Miasmas and Disease: Public Health and the Environment in the Pre-Industrial Age.* Translated by Elizabeth Potter. New Haven, Conn.: Yale University Press, 1992.

Clifton, J. D. "Images of the Plague and Other Contemporary Events of Seventeenth-Century Naples." Ph.D. diss., Princeton University, 1987.

———. "Mattia Preti's Frescoes for the City Gates of Naples." *The Art Bulletin* 76 (1994): 478–510.

Cohn, Samuel K., Jr. *The Cult of Remembrance and the Black Death: Six Renaissance Cities in Central Italy.* Baltimore: Johns Hopkins University Press, 1992.

Collura, Paolo. *Santa Rosalia nella storia e nell'arte.* Palermo: Santuario del Montepellegrino, 1977.

Defoe, Daniel. *A Journal of the Plague Year.* London, 1722. Reprint, with an introduction by A. Burgess. London: Penguin English Library, 1966.

Douglas, Richard. *Jacopo Sadoleto: Humanist and Reformer.* Cambridge, Mass.: Harvard University Press, 1959.

Encyclopedia of Plague and Pestilence. Edited by George C. Kohn. New York: Facts on File, 1995.

Fleming, S. J. "Plague: The Medieval Scourge." *Archaeology* 39 (1986): 72–83.

Giussano, Giovanni Pietro. *The Life of St. Charles Borromeo.* Translated and edited by E. C. Manning. 2 vols. London: Burns & Oates, 1884.

Goleman, Daniel. *Emotional Intelligence.* New York: Bantam Books, 1996.

Gottfried, Robert S. *The Black Death: Natural and Human Disaster in Medieval Europe.* New York: The Free Press, 1983.

Gregg, Charles. *Plagues: The Shocking Story of a Dread Disease in America Today.* Albuquerque: New Mexico University Press, 1985.

Gregory of Tours. *History of the Franks.* Translated by O. M. Dalton. 2 vols. Oxford: Clarendon Press, 1927.

Grimm, Jürgen. *Die literarische Darstellung der Pest in der Antike und Romania.* Munich: W. Fink, 1965.

Heitz, P., and W. Schreiber. *Pestblätter des 15. Jahrhunderts.* (Einblattdrucke des 15. Jahrhunderts.) Strasbourg: Heitz und Mundel, 1901.

Herlihy, David. *The Black Death and the Transformation of the West*. Edited by Samuel K. Cohn, Jr. Cambridge, Mass.: Harvard University Press, 1997.

Herrlinger, R. *Geschichte der medizinischen Abbildung von der Antike bis um 1600*. Vol. 1. Munich: H. Moos Verlag, 1967–72.

Hind, Arthus M. *An Introduction to a History of Woodcut, with a Detailed Survey of Work Done in the Fifteenth Century*. Boston: Houghton Mifflin, 1935.

Homer. *The Iliad*. Translated by Samuel Butler, edited by L. Loomis. New York: Walter J. Jack, Classics Club, 1942. Book 1:8–9.

Horrox, Rosemary, trans. and ed. *The Black Death*. Manchester Medieval Source Series. Manchester: Manchester University Press, 1994.

Köhler, Werner. "Pest, Pestheilige, Blutwunder und andere Begebenheiten aus der Geschichte der Bakteriologie." *Jahrbuch 1991 der Deutschen Akademie der Naturforscher Leopoldina (Halle/Saale) Leopoldinca* 37 (1992): 211–38.

Le Goff, Jacques. *The Birth of Purgatory*. Translated by A. Goldhammer. Chicago: University of Chicago Press, 1984.

Lerner, Robert. "The Black Death and Western Eschatological Mentalities." In *The Black Death: The Impact of the Fourteenth Century Plague*, edited by Daniel Williman. Introduction by Nancy Siraisi. Papers of the 11th Annual Conference of the Center for Medieval and Renaissance Studies. Binghamton, N.Y.: Center for Medieval and Renaissance Studies, 1982, 107–30.

Mâle, Emile. *L'art religieux de la fin du XVIe siècle du XVIIe siècle et du XVIIIe siècle, étude sur l'iconographie après le Concile de Trente, Italie-France-Espagne-Flandres*. 1925. Reprint, Paris: Collin, 1932.

Manzoni, A. *The Column of Infamy: Prefaced by Cesare Beccaria's Of Crimes and Punishments*. London: Oxford University Press, 1964.

———. *The Betrothed*. Translated by A. Colquhoun. London: Folio Society, 1969.

Marshall, Louise. "Waiting for the Will of the Lord: The Imagery of the Plague." Ph.D. diss., University of Pennsylvania, 1989.

———. "Manipulating the Sacred: Image and Plague in Renaissance Italy." *Renaissance Quarterly* 47 (1995): 485–532.

Martin, A. Lynn. *Plague? Jesuit Accounts of Epidemic Disease in the 16th Century*. Sixteenth Century Studies, vol. 18. Kirksville, Mo.: Thomas Jefferson University Press, 1996.

McNeill, William. *Plagues and People*. Garden City, N.Y.: Anchor Books, 1976.

Meiss, Millard. *Painting in Florence and Siena after the Black Death*. Princeton, N.J.: Princeton University Press, 1951.

Mollaret, Henri, and Jacqueline Brossollet. "La peste, source méconnue d'inspiration artistique." *Jaarboek Koninklijk Museum voor Schone Kunsten Antwerpen* (1965): 3–112.

———. "A propos des *Péstiférés de Jaffa* de A. J. Gros." *Jaarboek Koninklijk Museum voor Schone Kunsten Antwerpen* (1968): 263–308.

———. "Nicolas Poussin et *Les Philistine Frappés de la Peste*." *Gazette des Beaux-Arts* 73 (1969): 171–75.

———. *Alexandre Yersin le vainqueur de la peste*. Paris: Fayard, 1985.

Neustaetter, O. "Mice in Plague Pictures." *Journal of the Walters Art Gallery* 4 (1941): 104–13.

———. *Where Did the Identification of the Philistine Plague (Samuel, 5 and 6) as Bubonic Plague Originate?* Baltimore, 1942.

The New American Bible. New York: Catholic Book Publishing, 1970.

The New Catholic Encyclopedia. New York: McGraw-Hil, 1967–96.

Ogata, M. "Über die Pestepidemie in Formosa." *Zentralblatt für Bakteriologie, Parasitenkunde und Infektionskrankheiten* 21 (1897): 769–77.

Osheim, Duane J. Plague Project. University of Virginia. http://jefferson.village.virginia.edu/osheim/intro.html (1 Nov. 1994).

Ovid, *Metamorphoses.* Translated by Rolfe Humphries. Bloomington: Indiana University Press, 1955.

Paul the Deacon. *History of the Langobards.* Translated by W. D. Foulke. Philadelphia: University of Pennsylvania Press, 1907.

Pigler, Andor. *Barockthemen.* 2 vols. Budapest: Ungarische Akademie der Wissenschaften, 1956.

Procopius of Cesarea. *History of the Wars.* Translated by H. B. Dewing. The Loeb Classical Library: Greek Authors. London: Heinemann, 1914–22, I–IV.

Puglisi, Catherine. "Guido Reni's *Pallione del Voto* and the Plague of 1630." *The Art Bulletin* 77 (1995): 402–12.

Ripa, Cesare. *Iconologia.* Padua, 1611. Reprint, New York: Garland Press, 1976.

———. *Iconologia: Baroque and Rococo Pictorial Imagery.* The Hertel edition of Ripa's *Iconologia.* Translated by Edward Maser. New York: Dover Publications, 1971.

Ripamonte, Giuseppe. *La peste di Milano del 1630.* Milan, 1641. Reprint, n.p.: 1945.

Rituale sacramentorum ac aliarum ecclesiae ceremonarum ex rituali juxta decretum synody. Rome: 1584–1602.

Ronen, Avraham. "Gozzoli's St. Sebastian Altarpiece in San Gimignano." *Mitteilungen des Kunsthistorischen Institut Florenz* 32, no. 1/2 (1988): 77–126.

Roworth, Wendy Wassyng. "The Evolution of History Painting: Masaniello's Revolt and Other Distasters in Seventeenth-Century Naples." *The Art Bulletin* 75 (1993): 219–34.

Rubin, Miri. *Corpus Christi: The Eucharist in Late Medieval Culture.* Cambridge: Cambridge University Press, 1991.

San Carlo Borromeo: Catholic Reform and Ecclesiastic Politics in the Second Half of the Sixteenth Century. Edited by J. M. Headley and J. B. Tomaro. Washington, D.C.: Folger Books, 1988.

Schefer, Jean Louis. *The Deluge, the Plague—Paolo Uccello.* Translated by Tom Conley. Ann Arbor: University of Michigan Press, 1995.

Schmölzer, Hilde. *Die Pest in Wien.* Vienna: Österreichischer Bundesverlag, 1985.

Schröter, Elisabeth. "Raphaels *Madonna di Foligno* ein Pestbild?" *Zeitschrift für Kunstgeschichte* 50 (1987): 47–87.

Seiler, Roger. *Zur Ikonographie der religiösen Pestdenkmäler des Kanton Graubünden.* Extra Druck der medizinischen Reihe 177. Zurich: Juris, 1985.

———. "Pest und die bildende Kunst." *Gesnerus* 47, pts. 3, 4 (1990): 263–83.

Spike, John T. "The Blessed Bernard Tolomei Interceding for the Cessation of the Plague in Siena: A Rediscovered Painting by Giuseppe M. Crespi." *The John Paul Getty Museum Journal* 15 (1987): 110–16.

Sterling, Charles. "Josse Lieferinxe." *La Revue du Louvre* (1964): 1–22.

Thasei Caecili Cypriani, De Moralitate. Introduction by and translated by M. L. Hannan. The Catholic University of America, *Patristic Studies 36.* Washington, D.C.: Catholic University of America Press, 1933.

Thucydides. *History of the Peloponnesian War: A New Translation, Background and Contexts, Interpretation*. Vol. 5. New York: W. W. Norton, 1998.

Tung, Mason. *Two Concordances to Ripa's Iconologia*. New York: AMS Press, 1993.

Vasari, Giorgio. *Lives of the Most Eminent Painters, Sculptors and Architects*. Translated by G. DeVere. 10 vols. Reprint, New York: AMS Press, 1976.

Vaslef, Irene. "The Role of St. Roch as Plague Saint: A Late Medieval Hagiographic Tradition." Ph.D. diss., The Catholic University of America, 1984.

Venezia e la peste: 1348–1797. 2d ed. Exhibition catalogue, 1979. Venice: Marsilio Editore, 1980.

Virgil. *The Aeneid*. Translated by Patric Dickinson. New York: Mentor Books, The New American Library, 1961.

Voragine, Jacobus de. *The Golden Legend: Reading on Saints*. 2 vols. Translated by W. Granger Ryan. Princeton, N.J.: Princeton University Press, 1993.

Waal, Henri van de. *Iconclass, an Iconographic Classification System: Bibliography*. Amsterdam: Nord Holland Publishing, 1973.

Williman, Daniel, ed. *The Black Death: The Impact of the Fourteenth-Century Plague*. Introduction by Nancy Siraisi. Papers of the 11th Annual Conference of the Center for Medieval and Early Renaissance Studies. Binghampton, N.Y.: Center for Medieval and Renaissance Studies, 1982.

Wittschier, Heinz Willi. *Antonio Vieiras Pestpredigt*. Münster, Westfalen: Aschaffendorff, 1973.

Wu, Lien-Teh, J. W. H. Chun, and R. Pollitzer. *Plague: A Manual for Medical and Public Health Workers*. Shanghai: Weishenshu National Quarantine Service, 1936.

Index

Illustrations are indicated by **bold** locators.

Z

Scripture References

See also Appendix